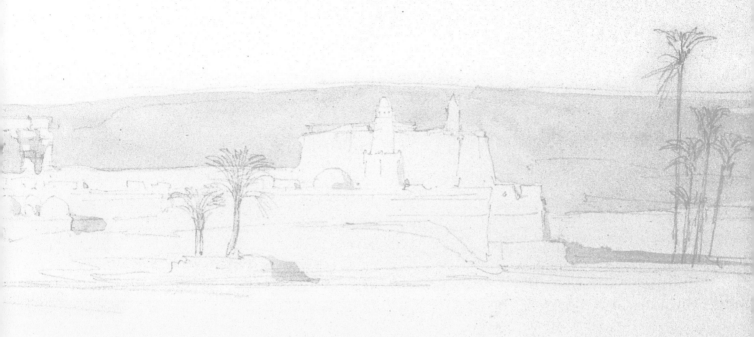

The Collector's Eye

Masterpieces of Egyptian Art from
The Thalassic Collection, Ltd.

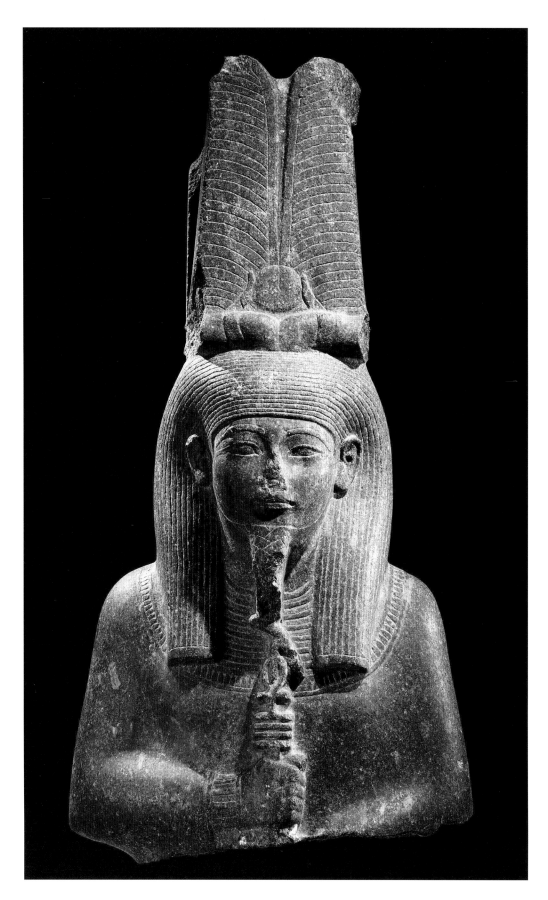

Ptah-Sokar-Osiris with the features of Amenhotep III (see cat. no. 11)

The Collector's Eye:

Masterpieces of Egyptian Art from The Thalassic Collection, Ltd.

Courtesy
Theodore and Aristea Halkedis

Edited by
Peter Lacovara and Betsy Teasley Trope
with Sue H. D'Auria

Michael C. Carlos Museum
Emory University
Atlanta 2001

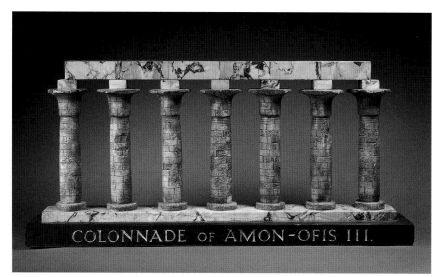

Fig. A. Model colonnade of
Amenhotep III at Luxor Temple
Nineteenth century
Siena marble and alabaster
H. 44 cm; w. 92 cm

*This piece is a model of the colonnade
at Luxor Temple built during the reign
of Amenhotep III (1390–1353 BC) and
decorated by his grandson, Tutankhamen
(1332–1322 BC). Although similar to
the Grand Tour pieces described below
(see pp. xxix–xxx), it is not true Grand
Tour as nothing like it exists on the con-
tinent. It might be better described as
Egyptomania.* ʙʙ

This exhibition was organized by the Michael C. Carlos Museum,
Emory University.
The Museum is on the Web at www.emory.edu/CARLOS.

Atlanta exhibition dates: April 21, 2001–January 6, 2002

Exhibition curated by Peter Lacovara and Betsy Teasley Trope
Manuscript edited by Sue D'Auria

Typeset in Adobe Granjon and Bernhard Modern
with Adobe InDesign 1.5.2 for Macintosh
Hieroglyphic fonts designed by Cleo Huggins,
with additional signs by Peter Der Manuelian

Typeset, designed and produced by Peter Der Manuelian

Endpapers: Graphite drawing on back of watercolor (see fig. L):
*View from the Summit of the Temple of Luxor Looking towards
Baban El Molook,* by David Roberts, 1838

Front cover illustration: cat. no. 16 and fig. D

Frontispiece: cat. no. 11

Title page: cat. no. 108

Cover design by Peter Der Manuelian

Photographic credits are listed on p. 172

Manuelian
DESIGN

Copyright © 2001 Michael C. Carlos Museum
ISBN 1-928917-02-X

Printed in the United States of America
by
Sawyer Printers, Charlestown, Massachusetts
Bound by Acme Bookbinding, Charlestown, Massachusetts

Contents

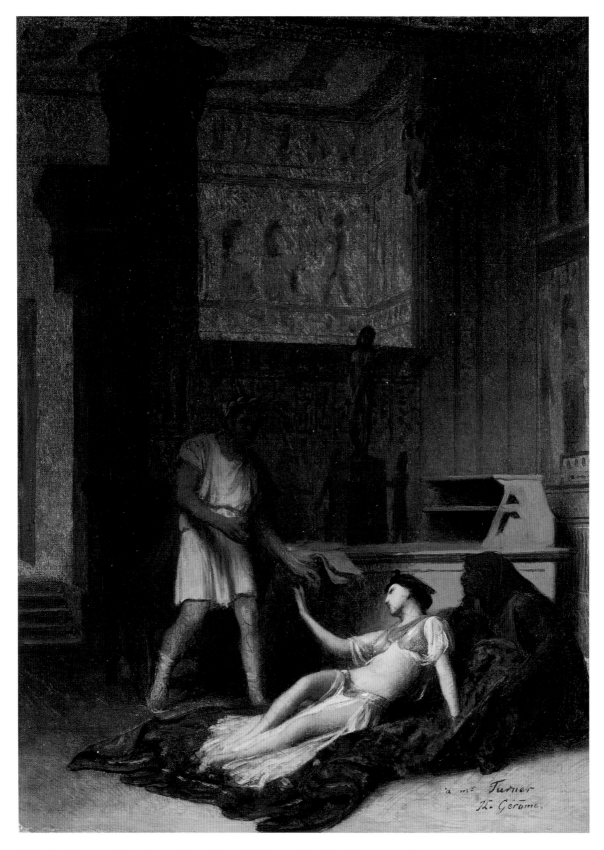

Fig. B. *Cleopatra before Caesar.* Jean-Léon Gérôme; 1864–66; oil on paper; h. 32 cm; w. 39.1 cm

Foreword

It is a great privilege for the Michael C. Carlos Museum to present *The Collector's Eye: Masterpieces of Egyptian Art from The Thalassic Collection, Ltd.* This outstanding private collection of ancient Egyptian art, one of the finest in the world, has long been known to specialists. Key works have been lent to museums over the years, but the collection has never before been exhibited or published in its entirety. Those who have not been introduced previously to the glorious works in the Thalassic Collection are now in for a treat. Those who have known selected works will be thrilled to see the entire collection, the result of years of careful study, consultation, and continuing refinement by The Thalassic Collection, Ltd., of Athens, Greece and curator/collector Theodore Halkedis.

The passion that led to the formation of this collection first manifested itself with the paintings, drawings, and lithographs of David Roberts, and continued with nineteenth-century decorative arts of Egyptian inspiration, affectionately known as *Egyptomania*. Some of the Grand Tour objects, particularly models of obelisks and sphinxes, also contributed to this love of things Egyptian. Because these modern works planted the seed that grew into the Thalassic Collection, it seems only fitting that they too would be included in the exhibition. Their presence alongside the ancient works allows one to appreciate fully the logic and sensibilities that have guided the development of the collection.

This loan exhibition could be conceived only through the great generosity of the Thalassic Collection and in particular through the efforts of Ted and Aris Halkedis. Aside from a willingness to part with this treasured collection for many months, curator Ted Halkedis has taken a keen interest in the planning of the project. He has contributed greatly to the effort, encouraging and consulting with the many authors, curators, and scholars who are credited in this volume's acknowledgments. For the unhesitating willingness to assume the costs of producing the catalogue, the Museum is deeply grateful.

Peter Lacovara, the Carlos Museum's enterprising Curator of Ancient Egyptian, Nubian, and Near Eastern Art, first suggested that the exhibition project be mounted at the Carlos Museum and campaigned for it with religious fervor. The quality of the works was such that he did not find it hard to win converts. In bringing the exhibition project to fruition, he was ably assisted by Betsy Teasley Trope, the Museum's Assistant Curator for the Permanent Collection and an Egyptologist of great promise herself. It is they who have borne the primary burden of organizing a complex project quickly, a job requiring long hours and cheerful dedication under pressure. Also at the Carlos Museum, Catherine Howett Smith, Associate Director and Director of Academic Services, provided invaluable overall supervision with her customary resourcefulness, planning ability, and good sense.

We owe a great debt of thanks to Sue D'Auria, who served as editor of the project, and to all of the extraordinary Egyptologists who were willing to share their expertise on short notice to give the important objects of the Thalassic Collection, Ltd. the scholarly attention they deserve. Their enthusiasm and dedication offer clear evidence of the esteem in which they hold the collection and the collectors. Peter Der Manuelian worked tirelessly in Boston to both write entries and produce a handsome catalogue under significant time constraints. Bruce White, a distinguished fine arts photographer, managed to produce the fine photographs included in this volume in the midst of a schedule already crowded with other commitments.

Nancy Roberts, the Carlos Museum's Coordinator of Exhibition Design, created a vision for the exhibition with her usual quiet talent. Her staff produced a first-rate installation as they always do. Kristin West of Emory's General Counsel's Office expertly handled legal details. The Carlos Museum's Registrar, Todd Lamkin, former Registrar, Maureen Morrisette, and Assistant Registrar, Melody Hanlon, skillfully arranged the exhibition logistics.

The Museum's Board of Directors supported this exhibition from the first, recognizing the importance of bringing to Atlanta so distinguished a collection of Egyptian antiquities, one that complements the Museum's own. Thanks are also due to the committee organizing the Carlos Museum's annual gala, Veneralia, for 2001. That committee immediately recognized the value of opening *The Collector's Eye* on the evening of the party, thus celebrating both the Carlos Museum's and the Thalassic Egyptian collections.

The Michael C. Carlos Museum has maintained its own collection of the art of ancient Egypt since the early 1920s. For those who grew up in Atlanta, Emory's museum was colloquially known as "the mummy museum." To its earlier collection, the Museum was able to add in 1999 the Egyptian holdings of the now-defunct Niagara Falls Museum, a highly important group of works assembled in the nineteenth century that is now to be known as the Charlotte Lichirie Collection. That acquisition, which created enormous public excitement, also gave great depth to the Museum's holdings, particularly in Egyptian funerary arts. At the same time, three Egyptologists can now be counted on the staff of Emory University, two of them at the Carlos Museum, and the American headquarters of the American Research Center in Egypt has relocated to the University's campus. It is into this context in Atlanta, with interest in ancient Egypt at a fever pitch, that we introduce the superb works included in *The Collector's Eye: Masterpieces of Egyptian Art from The Thalassic Collection, Ltd.* We are confident both that the exhibition will delight scholars and the general public alike and that this catalogue documenting the collection will quickly become a standard reference work for all those who care about the art and culture of ancient Egypt.

Anthony Hirschel
Director
Michael C. Carlos Museum

Introduction

THE "EYE" OF A COLLECTOR is a rare and special gift. It combines both an innate sense of quality and a keen knowledge of art gleaned from careful study and investigation. This extraordinary collection is the product of the vision of one remarkable individual. Through years of judicious acquisition for The Thalassic Collection, Ltd., Theodore Halkedis has assembled a magnificent microcosm of the art of pharaonic Egypt. The objects in this collection span the ages from the Predynastic Period up to the Roman conquest of Egypt, and range from simple ceramic objects of Nile mud to magnificent royal sculptures carved from the rarest stones. All are linked, however, by their outstanding quality and selected with the greatest sensitivity to the accomplishments of the ancient artisan. These treasures include a group of unassuming pottery molds yielding the most beautiful and finely detailed amulets; exquisite examples of glass and faience, extremely difficult materials to master with the primitive kilns available; alabaster vessels fit, and indeed made for, the greatest of kings, still retaining their jewel-like painted decoration; and sculpture of some of the greatest personages in Egyptian history.

Since every item in this collection is a masterwork, it is difficult to single out any particular piece or set of pieces. All have been lovingly gathered together to form a wonderful narrative of the sublime achievements of Egyptian art, from Djoser's Step Pyramid through the emotionally powerful creations of Middle Kingdom sculpture and the sumptuous style of Amen-hotep III, followed by the revolutionary ideas of his successor Akhenaten. The later periods of Egyptian history are also represented by some of the most important sculptures that survive from that age.

The genesis of The Thalassic Collection, Ltd. in many ways mirrors the growth of Egyptology itself. It all began with the collecting of Egyptomania and objects of the "Grand Tour," assembled by gentlemen of the nineteenth century on their travels to ancient lands. Beginning with this, Ted showed a keen perception of what constituted the highest quality available. Although there were many disparate types of objects that belonged to the Grand Tour genre, the "Holy Grail" of most exotic travelers was Egypt.

Here again, he was able to hunt out the gems of what had been produced, from a gleaming set of alabaster columns to a wonderful Egyptian Revival clock topped by a reproduction of a bust in the Louvre collection, all objects that evoked the twin passions for artistic quality and historical importance. The touchstone for all this was the work of the premiere artist of the period, David Roberts. Roberts' watercolors brought the monuments of Egypt to the attention of the world, thanks to his evocative and skillful renderings. The Thalassic Collection comprises the full range of his works, from the exceedingly scarce field sketches Roberts masterfully created, to his final carefully detailed watercolors and the lithographs produced from them.

Ted then went on to collect the actual antiquities that had been so painstakingly recorded by Roberts and his contemporaries. He quickly developed a deep understanding for the timeless beauty of Egyptian art and unique aptitude for collecting what was both stunning and significant.

Even more importantly, Theodore and Aristea Halkedis, through their great generosity, opened their home to Egyptologists and museum curators, hosting their now famous Salons, to give access to study and appreciate this magnificent collection to those interested.

Ted not only learned from these scholars, but was able to share his own special knowledge and insights. Many of these treasures have been graciously lent to exhibitions and museums the world over.

Ted and Aris have continued their munificence by working with the Carlos Museum to produce this catalogue and exhibition of the entire Thalassic Collection, Ltd., to make these outstanding objects accessible to an even wider audience. We are all eternally grateful for their kindness, graciousness and friendship that has made this dazzling exhibition possible.

Peter Lacovara
Curator of Ancient Art
Michael C. Carlos Museum

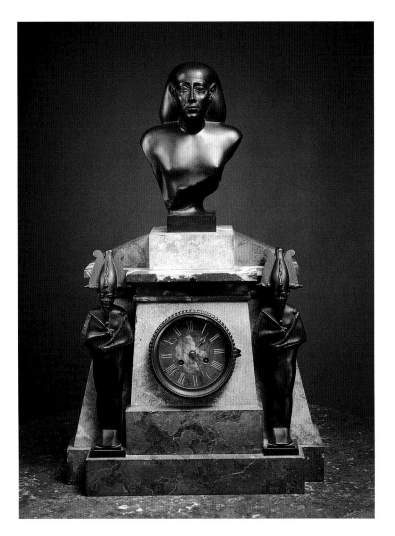

Fig. C. *Clock*
Marble and bronze
About 1890
H. 69 cm; w. 38 cm

During the latter part of the nineteenth century, clocks decorated with Egyptian figures became extremely popular. Most were ordinary mantle clocks surmounted or flanked by sphinxes. The face of the Thalassic clock indicates that it was manufactured by Henry T. Cox of New York, but the internal mechanism was produced in Paris. The clock is more ornate than most, flanked by two figures of Osiris, god of the dead, and the front is adorned with a winged scarab. Another unusual feature is that the clock is topped by a reproduction of a known antiquity—the bust of a man that is in the Louvre (N. 2454). The original is from the Twenty-seventh Dynasty (about 450 BC) and shows a nobleman wearing a bag wig. The inscription on the backpillar breaks off just before the name would have been inscribed, so the identity of the man remains uncertain. BB

Acknowledgments

This superb exhibition is an eloquent testimonial to the affection and regard for Theodore and Arista Halkedis from all who have been involved in this remarkable effort. We are most especially thankful to Bob Brier and Pat Remler, who along with Jack Josephson, served as guiding lights on this project and were always available with sage advice and boundless expertise at every turn.

The catalogue was masterfully conceived and shepherded into final production by Peter Der Manuelian and beautifully realized by Jonathan Sawyer. The touchstones of the catalogue are Bruce White's magnificent photographs. These are all the more remarkable because he was working under a tight deadline, without a studio and in cramped conditions, yet with consummate skill and remarkable good humor he produced these peerless images. This work was greatly facilitated by Harry Halkedis whose charm and patience made even the longest of days a delight. We are also grateful for additional images generously supplied by Max Bernheimer of Christie's, New York, and to Peter Harholdt for his fine photographs of the objects in Atlanta.

To the many catalogue authors, Carol Andrews, Dorothea Arnold, Dieter Arnold, Bob Brier, Richard Fazzini, Rita Freed, Melinda Hartwig, T.G.H. James, W. Raymond Johnson, Jack Josephson, Peter Der Manuelian, Jack Ogden, Elena Pischikova, Pat Remler, Gay Robins, Catharine Roehrig, Eleni Vassilika, we are especially indebted for working so well under a remarkably short deadline. In particular, we would like to thank Yvonne Markowitz and Joyce Haynes for their long hours of research and for sharing their expertise in a wide variety of tasks. Marsha Hill also generously shared her insights and knowledge on many aspects of the catalogue.

It was a delight to work again with Sue D'Auria, whose many years of Egyptological and editorial expertise made the cumbersome task of dealing with so many authors in such a short time relatively painless for the rest of us.

For expert analysis of the objects we are grateful to William Size, Associate Professor in the Department of Environmental Studies at Emory University. We are also thankful to Nadia Lokma, Head of Conservation at the Egyptian Museum, Cairo, Joan Sammons, and Ryan Denzer-King for long hours in cataloguing the amulets for the exhibition.

There is probably no museum, other than the Michael C. Carlos Museum of Emory University, that could accomplish such an exhibition, so well, in such a record time. In particular, we are grateful to Anthony Hirschel, Director, for his vision and unflagging enthusiasm from the outset, and to Catherine Howett Smith, Associate Director and Director of Academic Services, for her diligence, knowledge and organizational ability, which gave structure and clarity to the project.

The registration of the objects for the exhibition and their movement to Atlanta was coordinated with unflappable skill and good humor by Todd Lamkin, Registrar, and their safety at every step was assured under the watchful eyes of Thérèse O'Gorman, Conservator, Renée Stein, Assistant Conservator and Conor McMahon, Conservation intern. Melody Hanlon, Assistant Registrar, not only greatly facilitated the shipping, insurance and registration of the objects, but also organized the photography of the objects here in Atlanta.

Jennifer Gossett, Manager of Budget and Personnel, Joyce Daniels, Assistant to the Director, and Leigh Burns, Assistant in the Office of Budget and Personnel, were always ready with advice and help to coordinate

the numerous transport and budget issues involved with the exhibition.

We are all privileged that Nancy Roberts, Coordinator of Exhibition Design, with remarkable skill and insight designed the exhibition, along with the talents of Stephen Bodnar, Karen Chance, and Michael Gokey, Senior Preparators, and student interns Sean Greathead, Deborah Munroy, Jennifer Padgett, and Ila Hersh.

The exhibition is supplemented by a wonderful range of education programs orchestrated by Elizabeth Hornor, Coordinator of Educational Programs, Julie Green, Manager of School Programs, and Bruce Raper, Manager of Youth and Family Programs.

Very special thanks are also due to Piper Phillips, Curatorial Assistant for the Permanent Collection, Allison Germaneso Dixon, Coordinator of Marketing and Public Relations, Margaret Shufeldt, Assistant Curator of Works on Paper, and Mark Burell, Manager of the Michael C. Carlos Museum Bookstore.

Last, but not least, endless appreciation goes to Betsy Teasley Trope, Assistant Curator, who dexterously managed all aspects of this and many other projects all at once, and without whom this effort would not have been possible.

Peter Lacovara
Curator of Ancient Art
Michael C. Carlos Museum

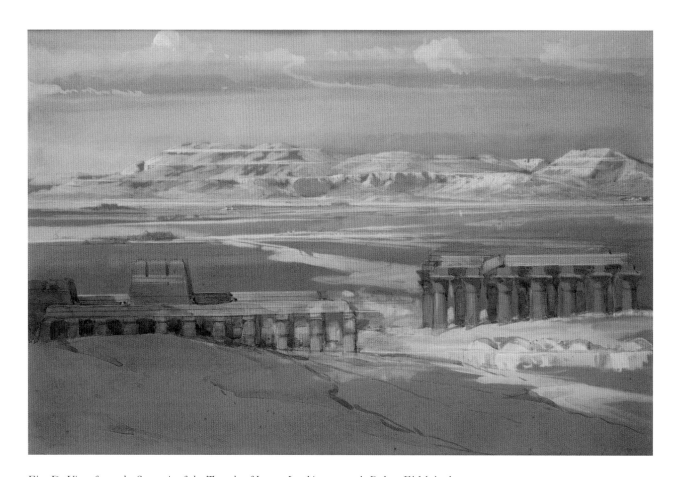

Fig. D. *View from the Summit of the Temple of Luxor Looking towards Baban El Molook*
David Roberts
1838
Watercolor
H. 33 cm; w. 49 cm

List of Contributors

CA	Carol Andrews
DiA	Dieter Arnold
DoA	Dorothea Arnold
BB	Bob Brier
RF	Richard Fazzini
REF	Rita E. Freed
MKH	Melinda K. Hartwig
JLH	Joyce L. Haynes
MH	Marsha Hill
TGHJ	T.G.H. James
WRJ	W. Raymond Johnson
JJ	Jack Josephson
PL	Peter Lacovara
PDM	Peter Der Manuelian
YJM	Yvonne J. Markowitz
JO	Jack Ogden
EP	Elena Pischikova
PR	Pat Remler
GR	Gay Robins
CHR	Catharine H. Roehrig
BTT	Betsy Teasley Trope
EV	Eleni Vasilika

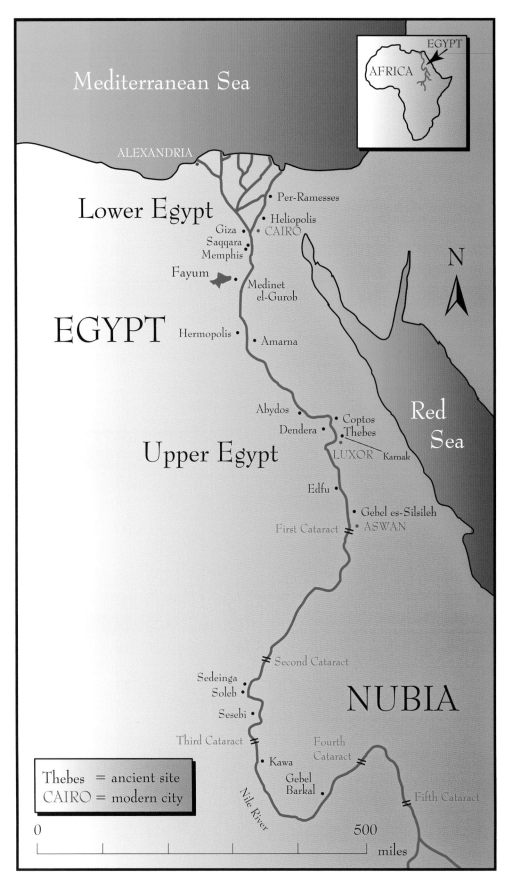

Fig. E. *Overview map of Egypt and Nubia*

List of abbreviations

AAT
Ägypten und Altes Testament

ÄA
Ägyptologische Abhandlungen

ASAE
Annales du Service des Antiquités de l'Egypte

BÄBA
Beiträge zur Ägyptischen Bauforschung und Alter-
tumskunde

BdE
Bibliothèque d'Etude

BIFAO
Bulletin de l'Institut Français d'Archéologie Orientale

BMFA
Bulletin of the Museum of Fine Arts, Boston

BMMA
Bulletin of the Metropolitan Museum of Art, New York

CAA
Corpus Antiquitatum Aegyptiacarum

GM
Göttinger Miszellen

HÄB
Hildesheimer Ägyptologische Beiträge

JARCE
Journal of the American Research Center in Egypt

JSSEA
Journal of the Society for the Study of Egyptian Antiquities

LÄ
Lexikon der Ägyptologie

MÄS
Münchner Ägyptologische Studien

MDAIK
Mitteilungen des Deutschen Archäologischen Instituts, Abteilung Kairo

MMJ
Metropolitan Museum Journal

OLA
Orientalia Lovaniensia Analecta

RdE
Revue d'Egyptologie

SAK
Studien zur altägyptischen Kultur

SAOC
Studies in Ancient Oriental Civilization

ZÄS
Zeitschrift für ägyptische Sprache und Altertumskunde

Chronology of Egyptian history*

DYNASTY "0" (ca. 3100–3000 BC)
An uncertain number of rulers, including Scorpion and Horus King Narmer ("Baleful Catfish")

ARCHAIC PERIOD (ca. 3000–2675)
First Dynasty (ca. 3000–2800)
Seven rulers, including Horus Kings Aha ("Fighter"), Djer ("Stockade"?), Djet ("Snake"?), Den; and Neith Queen Meryet ("Beloved") or Queen Merneith

Second Dynasty (ca. 2800–2675)
Nine rulers, including Hotepsekhemwy, Nynetjer (also read as Netjeren or Neterimu), Seth Peribsen, and Horus-and-Seth Khasekhemwy

OLD KINGDOM (ca. 2675–2130)
Third Dynasty (ca. 2675–2625)
At least five kings, including Djoser, Sekhemkhet, and Huni

Fourth Dynasty (ca. 2625–2500)
Sneferu (ca. 2625–2585)
Khufu or Cheops (ca. 2585–2560)
Redjedef (ca. 2560–2555)
Chephren, or Khafre or Rekhaef (ca. 2555–2532)
Mycerinus, or Menkaure (ca. 2532–2510)
Wehemka? (ca. 2510–2508)
Shepseskaf (ca. 2508–2500)

Fifth Dynasty (ca. 2500–2350)
Userkaf (ca. 2500–2485)
Sahure (ca. 2485–2472)
Neferirkare Kakai (ca. 2472–2462)
Shepsekare (ca. 2462–2455)
Reneferef (ca. 2462–2455)
Nyuserre (ca. 2455–2425)
Menkauhor (ca. 2425–2415)
Djedkare Isesi (ca. 2415–2371)
Unas (ca. 2371–2350)

Sixth Dynasty (ca. 2350–2170)
Teti (ca. 2350–2338)
Meryre Pepy I (ca. 2338–2298)
Merenre, or Nemtyemzaf (ca. 2298–2288)
Neferkare Pepy II (2288–2224/2194)
A few later rulers, including a queen, Nitocris

Seventh–Eighth Dynasties (ca. 2170–2130)
An indeterminate number of monarchs ruling from Memphis

FIRST INTERMEDIATE PERIOD (ca. 2130–1980)
Herakleopolitan Ninth–Tenth Dynasties (ca. 2130–1980)
Eighteen rulers, including Akhtoy (Achthoes) I (fl. ca. 2130–2120), Nubkaure (fl. ca. 2025–2020?), and Merykare (fl. ca. 2015–2000?)

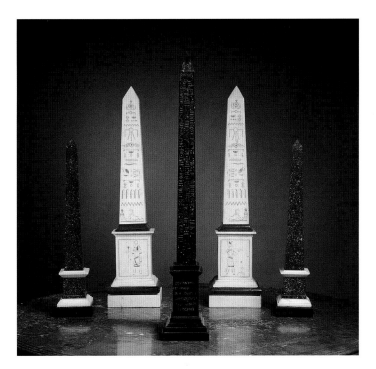

Fig. F. *Obelisks*
19th century
Outer pair: Porphyry; H. 41 cm; w. 9 cm
Inner pair: Composition stone; H. 55 cm; w. 13 cm
Center: Black slate; H. 23 cm; w. 9 cm

The center obelisk is a model of the one standing in the Piazza San Giovanni in Laterno, usually called "the Lateran Obelisk." The largest standing obelisk in the world, it was completed during the reign of the pharaoh Thutmose III (1479–1425 BC) but was not erected until the reign of his grandson, Thutmose IV (1400–1390 BC). The emperor Constantine the Great (AD 274–337) ordered the obelisk removed from Karnak temple where it stood, but died before the task was completed. It was erected by his son and successor Constantius (AD 337–361) who placed a bronze orb covered with gold on the top. When that was struck by lightning, it was replaced by a bronze torch with a flame of gold. The Latin inscription on the base tells of the obelisk's removal and erection. BB

Theban Eleventh Dynasty (ca. 2081–1938)
Mentuhotep, "The Ancestor" (ca. 2081–2075)
Inyotef I (ca. 2075–2065)
Inyotef II (ca. 2065–2016)
Inyotef III (ca. 2016–2008)
Nebhepetre Mentuhotep (ca. 2008–1957)
Sankhkare Mentuhotep (ca. 1957–1945)
Nebtawyre Mentuhotep (ca. 1945–1938)

MIDDLE KINGDOM (ca. 1980–1630)
The Middle Kingdom begins in the Eleventh
Dynasty, with the victory of Nebhepetre Mentuhotep
Twelfth Dynasty, "The House of Itjtawy,"
(ca. 1938–1759)
Amenemhet (or Ammenemes) I (ca. 1938–1909)
Sesostris (or Senwosret) I (ca. 1919–1875)
Amenemhet II (ca. 1876–1842)
Sesostris II (ca. 1844–1837)
Sesostris III (ca. 1836–1818)
Amenemhet III (ca. 1818–1772)
Amenemhet IV (ca. 1773–1763)
Sobeknefru (Regnant Queen, ca. 1763–1759)

Thirteenth Dynasty (ca. 1759–after 1630)
A large number of kings, most of them ephemeral, governing from Itjtawy

Fourteenth Dynasty (dates uncertain, but contemporaneous with later Thirteenth Dynasty)

SECOND INTERMEDIATE PERIOD
(ca. 1630–1539/1523)
"Hyksos" Fifteenth Dynasty (ca. 1630–1523)
 Six rulers, including Apophis (ca. 1575–1535)
"Sixteenth Dynasty" (contemporaneous with Fifteenth Dynasty)

Theban Seventeenth Dynasty (ca. 1630–1539)
About fifteen rulers, ending with Seqenenre Tao II
(?–1543?) and Kamose (ca. 1543?–1539)

NEW KINGDOM (ca. 1539–1075)
Eighteenth Dynasty (ca. 1539–1295/1292)
Ahmose (or Amosis) (ca. 1539–1514)
Amenhotep (or Amenophis) I (ca. 1514–1493)
Thutmose (or Tuthmosis) I (ca. 1493–1479)
Thutmose II (ca. 1493–1479)
Hatshepsut (Regnant Queen, ca. 1478/1472–1458)
Thutmose III (ca. 1479–1425)
Amenhotep II (ca. 1426–1400)
Thutmose IV (ca. 1400–1390)
Amenhotep III (ca. 1390–1353)

Amenhotep IV, later called Akhenaten
(ca. 1353–1336)
Nefernefruaten (ca. 1336–1332)
Smenkhkare (ca. 1336–1332)
Tutankhamen (ca. 1332–1322)
Ay (ca. 1322–1319)
Horemheb (ca. 1319–1292)

Nineteenth Dynasty (ca. 1292–1190)
Ramesses (or Ramses) I (ca. 1292–1290)
Sety (or Sethos) I (ca. 1290–1279)
Ramesses II (ca. 1279–1213)
Merneptah (ca. 1213–1204)
Sety II (ca. 1204–1198)
Amenmesse (ca. 1203–1200)
Siptah (ca. 1198–1193)
Tewosret (Regnant Queen, ca. 1193–1190)

Twentieth Dynasty (ca. 1190–1075)
Sethnakhte (ca. 1190–1187)
Ramesses III (ca. 1187–1156)

Ramesses IV (ca. 1156–1150)
Ramesses V (ca. 1150–1145)
Ramesses VI (ca. 1145–1137)
Ramesses VII (ca. 1137–1129)
Ramesses VIII (ca. 1128–1126)
Ramesses IX (ca. 1126–1108)
Ramesses X (ca. 1108–1104)
Ramesses XI (ca. 1104–1075)
The last ten years of the reign correspond to the
"Repeating Births" (or "Renaissance") under three
high priests of Amen at Thebes ("King" Herihor,
Paiankh, and "King" Pinudjem I), and to the
regency(?) of Smendes at Tanis

THIRD INTERMEDIATE PERIOD (ca. 1075–656)
Tanite Twenty-first Dynasty (ca. 1075–945)
Smendes (ca. 1075–1049)
Amenemnisu (ca. 1049–1045)
Psusennes I (ca. 1045–997)
Amenemope (ca. 999–959)
Osorkon the Elder (or Osochor) (ca. 999–959)

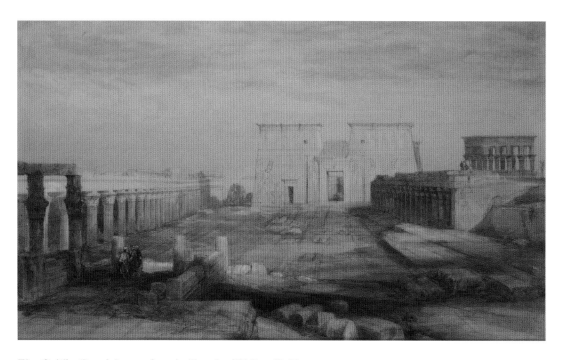

Fig. G. *The Grand Approach to the Temple of Philae, Nubia*
David Roberts
N.D.
Watercolor
H. 31 cm; w. 52 cm

Siamun (ca. 999–959)

Psusennes II (ca. 959–945)

Bubastite Twenty-second Dynasty (ca. 945–712)
About ten rulers, including Shoshenq I (ca. 945–924),
Osorkon II (ca. 874–835/830), and Shoshenq III
(ca. 835/830–783/778)

"Twenty-third Dynasty" (ca. 838–712)
Rival rulers at Thebes and in various northern
principalities

Saite Twenty-fourth Dynasty (ca. 727–712)
Tefnakhte (ca. 727–719)
Bocchoris (or Bakenrenef) (ca. 719–712)

Nubian or Kushite Twenty-fifth Dynasty
(ca. 760–656)
Kashta (ca. 760–747)
Piye or Piankhy (ca. 747–716)
Shabaka (ca. 716–702)
Shebitku (ca. 702–690)
Taharqa (690–664)
Tantamani (664–656)

LATE PERIOD (664–332)
Saite Twenty-sixth Dynasty (664–525)
Psamtik (or Psammetichus) I (664–610)
Necho II (610–595)
Psamtik II (595–589)
Apries (589–570)
Amasis (570–526)
Psamtik III (526–525)

Twenty-seventh Dynasty (first Persian period:
525–404)
Eight rulers, including Cambyses (525–522), Darius I
(521–486), Xerxes (485–465), and Darius II (423–404)

Twenty-eighth Dynasty (404–399)
One ruler, Amyrtaeus of Sais

Twenty-ninth Dynasty from Mendes (399–380)
Nepherites I (399–393)
Hakoris (393–381)
Nepherites II (381)

Thirtieth Dynasty from Sebennytos (381–343)
Nectanebo I (381–362)
Teos (365–362)
Nectanebo II (362–343)

"Thirty-first Dynasty" (second Persian period:
343–332)
Three rulers, including Artaxerxes III Ochus
(343–338) and Darius III Codoman (335–332). A
rebel native ruler, Khababash, may belong here

GRAECO-ROMAN PERIOD (332 BC–AD 642)
Macedonian Dynasty (332–305)
Alexander III, "the Great" (332–323)
Philip III Arrhidaeus (323–305)
Alexander IV (323–305)

Ptolemaic Dynasty (305–30)
Ptolemy I Soter (323–282: as "satrap" 323–305; as
king of Egypt 305–282)
Ptolemy II Philadelphos (285–246)
Ptolemy III Euergetes I (246–222/221)
Ptolemy IV Philopator (222/221–205)
Ptolemy V Epiphanes (209/208–180)
Ptolemy VI Philometor (180–164, 163–145)
Ptolemy VII Neos Philopator (145)
Ptolemy VIII Euergetes II, or Physkon (170–163,
145–116)
Ptolemy IX Soter II, or Lathyros (116–110, 109–107,
88–80)
Ptolemy X Alexander I (110–109, 107–88)
Ptolemy XI Alexander II (80)
Ptolemy XII Neos Dionysos, or Auletes (80–58,
55–51)
Cleopatra VII Philopator (51–30), at first with her
brothers Ptolemy XIII and XIV
Ptolemy XV Caesarion (45–30)
Roman, later Byzantine, Empire (30 BC–642 AD)

* This chronology follows that found in William J. Mur-
nane, "The History of Ancient Egypt," in Jack M. Sasson
et al., eds., *Civilizations of the Ancient Near East* (New York,
1995), pp. 712–14.

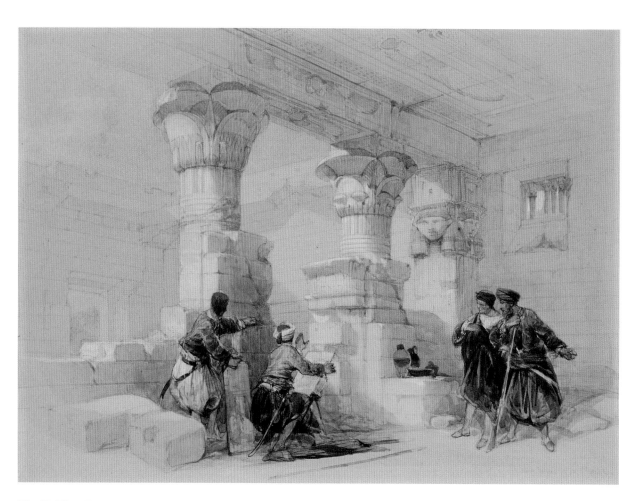

Fig. H. *View From Under the Portico of Dary El Medeeneh, Thebes*
David Roberts
1848
Watercolor over body pencil with body color
H. 21 cm; w. 28 cm

Roberts has painted himself, wearing oriental garb, into the scene. BB

Art and History in Ancient Egypt

Perhaps in no other ancient society were artistic development and historical process so inextricably linked as in pharaonic Egypt. Since, for most periods, monumental commissions in architecture and sculpture were issued by the royal court, the king's image predominated in the decorative program. Moreover, an idealized version of the monarch's face became the standard mode of representation for not only the king and his court, but also for deities and even private persons, making it ubiquitous during the reign and emphasizing the omnipresent power of pharaoh. This somewhat egomaniacal peculiarity of Egyptian art has helped Egyptologists date representations when no context or inscription exists to provide a clue to when they were made. Far from the popular notion of Egyptian art being static and unchanging, it ebbed and flowed with the fortunes of the different dynasties.

Because it is so rich in important pieces, The Thalassic Collection, Ltd., provides a significant historical overview of Egyptian society. Starting with the decorative tiles from the Step Pyramid of Djoser (cat. no. 38), the first large stone royal pyramid in the Nile Valley, most of the major episodes in pharaonic civilization are represented in this exhibition. The end of the "Pyramid Age," or the Old Kingdom (2675–2130 BC), is marked by a fine head rendered in a milky quartz (cat. no. 1). It is an example of a new style that appears at the end of the Old Kingdom. We can see this pattern repeating itself over the ages, as during periods of political breakdown, the "classical" style of the soft, bland countenance typical of the sculpture and relief of the Old Kingdom is abandoned for a more stylized and individualistic approach.

The early Twelfth Dynasty (1938–1837 BC) of the Middle Kingdom saw a return to the serene idealism of the Old Kingdom, as exemplified by a strikingly beautiful statuette in the finest alabaster of a priest (cat. no. 2), which clearly harks back to Fourth and Fifth Dynasty prototypes. The later Twelfth Dynasty saw an experiment with a far more realistic depiction of individual character, captured in the evocative portraits of Sesostris III and Amenemhet III with their haggard faces.

In The Thalassic Collection, Ltd., an extraordinary statue, inscribed for the pharaoh Amenemhet IV (1773–1763 BC, cat. no. 4) represents a transition from the world-weary expressions of the late Twelfth Dynasty to the more stylized sculpture of the following Second Intermediate Period (1630–1539/23 BC). While this remarkable sculpture still depicts the pharaoh as weighted down by age and the burdens of office, there are a number of details, such as the elongated hands and feet, which are hallmarks of the following Intermediate Period.

When Egypt is again reunited under a single ruling dynasty in the New Kingdom (1539–1075 BC), we once more see a conscious evocation of the earlier royal styles in large and impressive sculptures. A monumental bust of a queen in red granite (cat. no. 6) dates to the early Eighteenth Dynasty, and may have

belonged to Hatshepsut (1478/72–1458 BC). In any event, it seems to have suffered the same vicious destruction visited on the portraits of this woman who defied tradition and declared herself pharaoh with all the rights and regalia of a king. An outstanding example of the sculpture of this period is a head of the pharaoh Amenhotep II (1426–1400 BC), the soft features of the king's pleasant face rendered in a highly polished black granite evoking the confident optimism of the time (cat. no. 7).

One of ancient Egypt's greatest builders, Amenhotep III (1390–1353 BC), is represented by a number of important pieces in the collection. Perhaps the most commanding sculpture of all is a magnificent image of the god Ptah-Sokar-Osiris with the features of the king (frontispiece and cat. no. 11). Amenhotep here is shown with a cool distance and yet with a great reserve of strength, appropriate to this powerful deity. One can also see the elegant style of this affluent age echoed in a charming head of a private individual carved in a hard, red quartzite (cat. no. 12).

Amenhotep III's son and successor, the "heretic pharaoh" Akhenaten (1353–1336 BC) is also well attested in the treasures of The Thalassic Collection, Ltd. Akhenaten not only radically changed the traditional religion of Egypt from the worship of many gods to the cult of only one, but also transformed the art style to go along with it. He closed the old temples, built new ones and even founded a new capital city at Amarna. Amarna art was characterized by an almost caricature-like level of abstraction. This is best seen in a wonderful relief of the king as a sphinx (cat. no. 13) with an elongated face and arms, worshipping the sun-disk, the symbol of his god.

Akhenaten's religious revolution failed, and the court returned to the traditional royal centers of Thebes and Memphis. Still, the artistic freedom that flourished at Amarna left a legacy of heightened naturalism in portraiture that carried on into the early years of the following Nineteenth Dynasty (1292–1190 BC).

This artistic hybrid is shown in two of the loveliest sculptures in the collection, a head of the pharaoh Sety I (1290–1279 BC, cat. no. 15), and one of a woman, possibly a royal princess (cat. no. 16). They are carved of a wonderful tan quartzite, which has been given a fleshy softness by a master sculptor. Sety's son, the great Ramesses II (1279–1213 BC) is also represented in the collection (cat. no. 17).

After the long rule of the Ramesside kings, Egypt was again plunged into a period of disunity known as the Third Intermediate Period (1075–656 BC). Order and prosperity were finally restored all along the Nile Valley by the Nubian kings of the Twenty-fifth Dynasty (760–656 BC). There is not only a wonderful portrait head of a Nubian pharaoh in the Thalassic Collection, Ltd., (cat. no. 18), but also a marvelous black granite sphinx inscribed for Psamtik I (664–610 BC). While this superb creation depicts the first ruler of the Twenty-sixth Dynasty (664–525 BC), it still retains the mark of the former official style, undoubtedly from the hand of a master who was trained in the Theban court of the Nubian kings.

The Twenty-sixth Dynasty soon evolved its own style, characterized by a serene classicism that is nowhere better illustrated than in a miraculously well preserved and stunning statue of the god Osiris (cat. no. 20). Carved of graywacke and given a satiny sheen, this divine image is inscribed with the names of a number of kings, but principally that of Psamtik I, who is shown making offerings in a scene carved into the base.

The synergy of Egypt's interaction with the Greek world resulted in a new emphasis on realistic sculpture, which is illustrated in the collection by a masterpiece of the genre, a white quartzite head of an older man (cat. no. 25). Under the rule of the Romans, Egyptian art came even more under the sway of the outside world (cat. no. 26), but experienced the first of the great revivals in outside interest now known as Egyptomania.

PL

Materials and Techniques in Egyptian Art

The skill of the ancient Egyptian artisan shines more brightly in the popular imagination than perhaps that of any other past civilization. This has less to do with artistic innovation or the use of precious materials than with the abilities of the craftsmen and their peerless aesthetic standards, as is so aptly illustrated by the many exquisite examples of art in every medium assembled in The Thalassic Collection, Ltd.

We are fortunate to possess a remarkably detailed picture of the crafts and industries of ancient Egypt, from ceramic and stone vessel manufacture, metalsmithing, jewelry making, faience and glass production, woodworking and textile manufacture to architecture, sculpture and painting. Many of these activities are known from excavated workshops, where the remains of finished goods, waste materials and works in progress were recovered. Additional information in the form of raw materials, tools and equipment has also survived. For ancient Egypt, we are also fortunate in having a large number of artistic representations of manufacture in models, paintings and relief scenes.

A particularly valuable source for details on the organization and activities of Egyptian craftsmen can be seen in the decoration of the Eighteenth Dynasty Theban tomb of the vizier Rekhmire. Here, the crafts represented include leatherwork, carpentry, and metalsmithing (fig. I). Each specialty is treated in detail, recording the complex and myriad activities in which the temple ateliers are engaged.

Many workshops were located within the precincts of palaces, temples, large estates and cemeteries. To judge by craftsmen's titles and material resources afforded the various specialties, there was a clear division between the "fine" and "applied" arts in ancient Egypt. For example, Bak, "Chief Sculptor in the Great and Mighty Monuments of the King in the House of Akhenaten at Akhetaten," who came from a family of illustrious artists, merited a large and beautiful monument. Unsung, however, were the craftsmen who created objects used in daily life. While many items in this category demonstrate extraordinary craftsmanship and aesthetic sensibility, their makers failed to achieve the recognition reserved for artisans who produced large-scale stone sculpture and buildings. The so-called "Satire on the Trades" gives us a picture of the drudgery that was the life of many of these artisans. It recounts: "I have seen the metal-worker at his labor at the mouth of his furnace, his fingers like the stuff of a crocodile, he stinks more than fish roe."

Pottery and Stone Vessels
Ceramic vessels are amongst the most ubiquitous and informative of all the artifacts that have come down to us from ancient Egypt. The majority of these were humble utilitarian pots of household manufacture, but there were also beautifully finished and decorated masterworks produced in royal workshops. Both red-

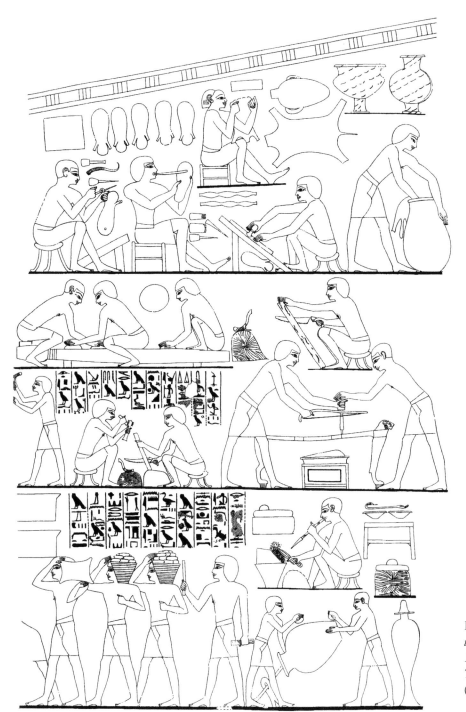

Fig. I. *Craftsmen at work; from the tomb of Rekhmire at Thebes (TT 100),* after N. de G. Davies, *The Tomb of Rekh-mi-Rec at Thebes* II (New York, 1943), pl. 53.

firing Nile mud and light-colored desert clays were used in pottery manufacture. Dynastic Egyptian pottery was rarely decorated. Instead, artisans relied on symmetry of form and surface finish to convey both elegance and beauty. A classic example of the Egyptian aesthetic are the beautifully polished, black-top vases of the Predynastic Period (cat. no. 45). With the advent of an expanded empire in the New Kingdom, however, cosmopolitan tastes ran towards more exotic, decorative products. By then, some vessels were

lavishly embellished with paint and a variety of surface treatments, including appliqué decorations and forms with handles, that suggest foreign influence.

Many of these decorative motifs were also transferred to the manufacture of stone vessels (cat. no. 53). These containers were used for more precious commodities in the Nile Valley. Perfumes, exotic oils, and cosmetics would eventually leach out of porous pottery containers, and before the widespread use of glass, stone was the best way to hold such expensive substances. Many stone vessels were elaborately sculpted in forms that might suggest their use (cat. no. 49), or decorated with images of symbolic importance (cat. no. 74). Egypt was so renowned for the exquisite craftsmanship of these vases that they were imported and copied throughout the ancient world (cat. no. 53).

METALWORK

Metal goods, particularly those fabricated from gold and silver, were prized for their economic, artistic and symbolic value. Gold, the most dazzling of nature's elements, held a unique position, due to its inherent properties of sun-like brilliance, resistance to corrosion and malleability. Mythically regarded as "the flesh of the god," this immutable metal was seen as a means of attaining immortality. Silver, labeled "white gold" by the Egyptians, was viewed as "the bones of the god," and both metals were associated symbolically in images of the deities (cat. nos. 36, 58).

Great quantities of gold were mined in ancient Egypt, particularly in the area of ancient Nubia (cat. no. 54). As a result of the metal's intrinsic value and recyclability, surviving examples of the goldsmith's art

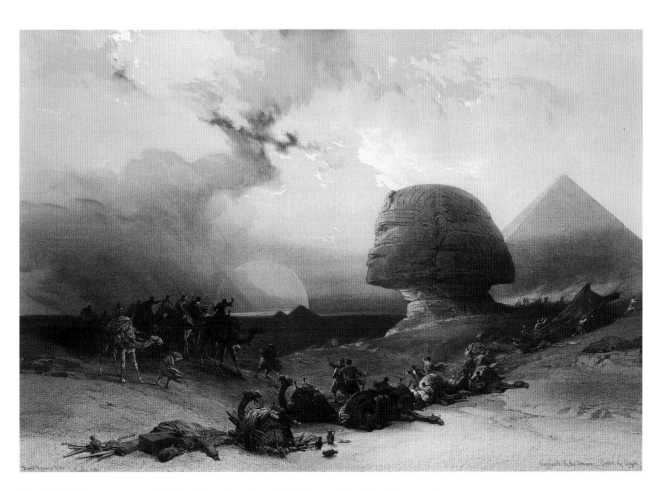

Fig. J. *The Simoon*
David Roberts
1844–46
Lithograph
H. 33 cm; w. 49 cm

Roberts has taken the artistic liberty of showing the sun setting in the east, behind the sphinx. The original painting was owned by Roberts' friend, the author Charles Dickens. BB

are rare. Gold could be cast or hammered into stone or wood molds (cat. no. 55) and chased with decoration, or made into wire to be used for jewelry (cat. no. 57). Sheet gold in the form of thick leaf could be applied to other surfaces, including wood (cat. no. 70), or inlaid into other metals (cat. no. 71). Bronze, an alloy of copper and tin, usually with the addition of lead in ancient Egypt, was also employed for divine images and symbols (cat. nos. 71, 80, 81, 82), as well as for more mundane objects.

FAIENCE AND GLASS

Precious metal jewelry represented an elite, prestige good that few people could afford, but such luxury items were often imitated and mass-produced in less costly materials, such as faience (cat. nos. 46, 47, 60). "Egyptian faience" was named after the famous Italian glazed pottery of the Renaissance. However, Egyptian faience is not made from clay, but is a combination of silica (in the form of quartz readily obtainable from the desert sands), lime, and an alkali, most often natron. The next step in the process entailed the addition of water to the silica–lime–soda mixture. The result is a thick, malleable paste that could be modeled by hand or pressed into a mold.

Colors were formed by the addition of pigments, such as the mineral oxides of copper (blue–green), cobalt (blue, violet), lead antimonate (yellow, light green), iron (red, black, green), manganese (black, purple) and titanium (white). Objects of faience could be formed in several ways. One method involved the immersion of dried faience paste in a glazing powder before firing, most often used to produce small beads. Another technique employed the use of a water-based, silica–lime–alkali slurry over an unfired quartz core, which could also be used on carved steatite, providing the additional benefit of dramatically increasing the hardness of the stone (cat. no. 51). Most commonly, faience was made by the self-glazing (efflorescence) method, in which the faience paste was air-dried, allowing the alkali salts to migrate to the surface, where they "bloomed," or formed a crust, as in the famous Step Pyramid tiles (cat. no. 38). Upon firing in a kiln (800–1000° C), the mixture hardens, creating a porous core surrounded by a dense outer layer containing fused interstitial glass. On the surface was

a thin, glassy coating, which undoubtedly inspired the ancient Egyptian word for faience, *tjehnet,* which means "that which shines or gleams." Another procedure used in faience manufacture involved inlaying faience within faience. This was accomplished by filling incised depressions with faience paste of different colors (cat. nos. 52, 61).

While glass-making/working is closely related to faience manufacture, its basic composition—silica–lime–soda–alumina–magnesia—is more complex and the temperatures required for melting higher, somewhere between 1000 and 1150° C. Unlike faience, which appears in the Nile Valley very early, during the fourth millennium BC, glass was a relative newcomer—a result, perhaps, of extended contact with western Asia during the early Eighteenth Dynasty.

Glass-making in the ancient world was typically a two-step heating process. In the initial phase (sintering), the raw materials were crushed, mixed and heated in clay crucibles. The contents were melted in a brick furnace at temperatures around 800–850° C and solidified into a glass-frit when cooled. Known as "Egyptian blue," this refined vitreous substance could be ground into powder and used by artisans as pigment. The second phase entailed heating the pulverized material at around 1000° C until fusion or the molten state was achieved. As with faience, the glass could be customized through the addition of mineral opacifiers and colorants. Molten glass could be drawn into rods or canes that were fused to the surface of another glass body and manipulated to form decorative festoons and line work. In the Ptolemaic and Roman Periods, these rods could be assembled together to make a mosaic and then fused and sliced to make "mosaic glass," in much the same way that millifiore beads are manufactured.

WOOD

Timber was scarce in Egypt, and the available softwoods, such as acacia (*Acacia nilotica*), tamarisk (*Tamarix nilotica*) and sycamore (*Ficus sycomorus*), were difficult to work and of limited usefulness. This was also the case with wood from the date and dom palm trees. The durable hardwoods—cedar from Lebanon, ash from western Asia, and ebony from central Africa—were imported and therefore used sparingly. Fine

woods were reserved for sculpture (cat. no. 50), or for equipment for high officials (cat. no. 44).

STONE

The Egyptians are most heralded, however, for their stonework. From pyramids to sculpture, the Egyptian artisans excelled in mastering the peculiarities of each type of rock. The Thalassic Collection, Ltd. presents a dazzling array of statues and reliefs carved from a variety of stones. Given that the ancient Egyptians had few effective tools for stoneworking, their accomplishments are even more remarkable. Only hardened copper chisels and saws were utilized through the Middle Kingdom, until bronze came into use in the New Kingdom. Iron was not generally employed for tools until the Late Period. By deftly using stone tools and sand abrasives, the ancient sculptors were able to work even the hardest and most intractable rocks. Limestone was perhaps the easiest to carve, particularly for relief work that would usually be plastered over and painted (cat. no. 13). Stronger granite was used for building or to help secure weaker stones (cat. no. 40). Granite, both red and black, was also used for sculpture, despite how difficult it was to work (cat. nos. 6, 19). Another hard and intractable stone was quartzite, originally a sandstone that was subjected to tremendous heat and pressure. Quartzite was reserved for the finest of royal sculptures (cat. nos. 15, 16), but its gritty hardness also led to its use for smoothing and polishing tools (cat. no. 43).

Graywacke is a type of highly compacted mud, whose ability to take a high, smooth polish made it a favorite for sculpture. Other stones were used less often, including anhydrite, a gray–blue gypsum

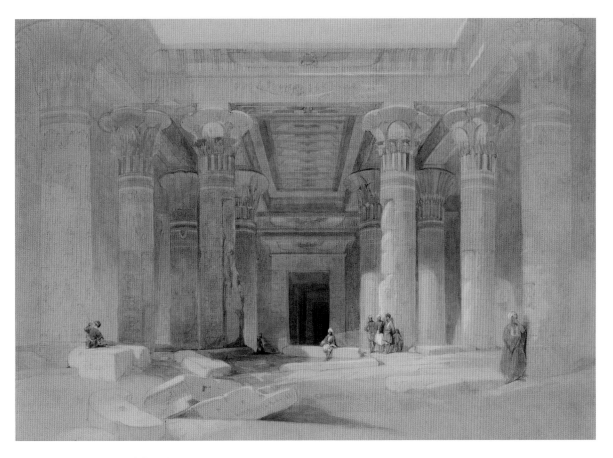

Fig. K. *The Temple of Philae, Egypt*
David Roberts
1846
Watercolor
H. 34 cm; w. 46 cm

used almost exclusively in the late Middle Kingdom. The Thalassic Collection, Ltd. contains one of the only known portraits that survive in this material (cat. no. 5).

In producing their art, the craftsmen who labored under the pharaohs were making monuments to last for eternity. The magnificent pieces in this collection show how well they met their goal.

PL and YJM

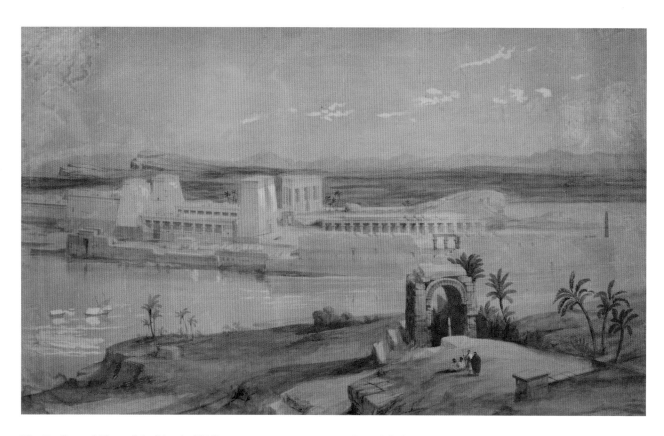

Fig. L. *General View of the Island of Philae*
David Roberts
1838
Watercolor and body color over pencil
H. 96 cm; w. 152 cm

One of the largest known Egyptian works by Roberts, this painting was undoubtedly a field drawing, never intended to be shown as a finished work. It illustrates Roberts' method of working and is different in several details from the completed lithograph. For example, in the final lithograph, a device for raising water from the Nile not present in the field sketch has been added. BB

Egyptomania

Egyptomania—the fascination with Egypt—has existed since ancient times. Perhaps the first to succumb to the mania were the Greeks. Around 450 BC, Herodotus of Halicarnasus, one of the first historians, visited Egypt and never got over it. He eagerly traced much of Greek culture back to Egyptian roots—Greek gods, building in stone, codes of laws—all came from the Egyptians.

Later, Roman emperors delighted in being depicted on Egyptian temple walls in Egyptian garb, with their names written in cartouches. One of the most beautiful examples of Egyptomania was Hadrian's villa in Tivoli, just outside Rome. An entire wing was decorated in the Egyptian style complete with statues of his lover, Antinous.

Frequently, waves of Egyptomania are created by specific events—Napoleon's Egyptian campaign, the opening of the Suez canal, the discovery of Tutankhamen's tomb—but there always seems to be a deep interest in things Egyptological, and collecting Egyptian antiquities is just one manifestation.

David Roberts (1796–1864)

No nineteenth century artist did more to popularize the monuments of ancient Egypt than David Roberts. Born in Edinburgh, Scotland, he began his career painting interior decorations for houses and was soon painting sets for theaters. His career as a serious painter began when he moved to London in 1822 and exhibited his architectural paintings.

In 1838, he traveled to Egypt and continued on to the Holy Land, returning to London in 1840 with hundreds of sketches and paintings that would establish his reputation (figs. D, G, H, J, K, and L). He quickly sold the rights to reproduce his illustrations to the publisher Francis Graham Moon. With the brilliant lithographer Louis Haghe, they produced six folio volumes, three on "Egypt and Nubia" and three on "The Holy Land," which launched Roberts' fame.

Jean-Léon Gérôme (1824–1907)

Nineteenth century Europe seems to have had an insatiable appetite for all things Middle Eastern. Clothes, furniture, houses, all began appearing with an oriental flair. In the art world, the Orientalists produced thousands of paintings to meet the demand, and one of the most successful and prolific was Gérôme.

Gérôme made several trips to the Middle East and his paintings often included Egyptian themes, sometimes harkening back to ancient times. He was a frequent exhibitor at the annual Paris salon and in 1866 exhibited *Cleopatra before Caesar* (see fig. B), which was an instant success. In a highly romantic fashion, Cleopatra is shown emerging from the rug in which she was smuggled into the palace. The drawing in this exhibition was undoubtedly a study for this painting.

The Grand Tour

In the nineteenth century, "The Grand Tour" became almost a requirement for the English upper class. By

1821, Thomas Cook & Son was providing regular steamer service across the English Channel, enabling the British to tour the continent in large numbers. The tour almost always included France and Germany, but the highpoint was the visit to Rome with its ancient monuments. With large numbers of affluent tourists, Rome's craftsmen began producing souvenirs for them to take home. Obelisks were especially popular. The Egyptians had erected them in pairs in front of temples, and during the Roman domination of Egypt no fewer than eleven obelisks were shipped to Rome. Obelisks (fig. F) soon became the symbol of what had been seen in Rome during the Grand Tour and the British returned with miniature obelisks, sphinxes and anything else that indicated antiquity.

BB

BIBLIOGRAPHY

Ackerman, Gerald M. *Jean-Léon Gérôme* (Paris, 1997).

Ballantine, James. *The Life of David Roberts, R.A.* (Edinburgh, 1866).

Guiterman, Helen, and Llewellyn, Briony. *David Roberts* (London, 1986).

Humbert, Jean-Marcel. *Egyptomania* (Ottawa, 1994), pp. 36–113.

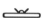

FROM EGYPTOMANIA TO EGYPTOLOGY

Following in the footsteps of artists like David Roberts, Howard Carter (1874–1939) originally went to Egypt to record the monuments with a keen eye and skillful hand. He quickly became interested in archaeology, and became a prolific excavator, eventually discovering the tomb of Tutankhamen in 1922.

Howard Carter would not, I believe, have thought very highly of the concept of Egyptomania in its wildest sense. However, Carter himself, after the tomb's discovery, nurtured the interest of the general public in things Egyptian, by his books on the tomb, and by his lectures. The whole discovery also became invested with an aura of mystery and magic, a development that Carter greatly deplored. He believed that Egyptian objects needed to be appreciated for what they physically were. They did not require stylistic reinterpretation, or exploitation by other means. To see an Egyptian painting, for example, carefully executed in reproduction, could bring a real appreciation of the essence of Egyptian art. He first went to Egypt in 1891 as an artist, to make precise copies of scenes in Egyptian tombs. He was by training a skilled draftsman, and a most accomplished water-colorist. He painted for personal pleasure, but he also developed the practice of making copies of parts of painted tomb scenes, usually including a single very attractive figure, and these paintings he might give to friends or sell to wealthy tourists, mostly British and American. Many of these paintings were made in a somewhat "informal" style, by which he concentrated his detailed treatment on the upper part of his subject, especially the head, painting the rest in a somewhat elusive manner.

The subject of the painting in fig. M is Shepsut (short for Hatshepsut), a "singer of Amen" and the wife of Userhet, the "first prophet of the royal spirit of Thutmose I," whose tomb in the Theban necropolis dates to the reign of Sety I (1290–1279 BC) in Dynasty 19.

TGHJ

Fig. M. *Portrait of Shepsut (Hatshepsut),
from Theban Tomb no. 51*
Howard Carter
1910
Watercolor on paper
H. 60 cm, w. 30 cm, as mounted

Catalogue

Sculpture

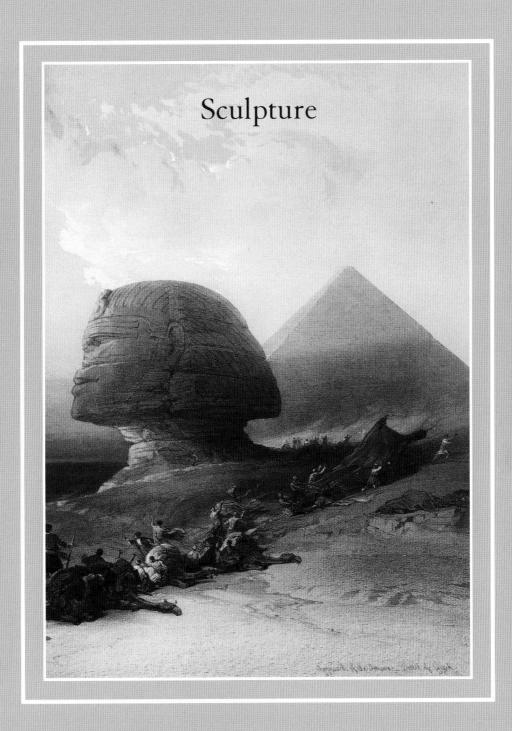

1. Head of a man

Late Old Kingdom, Dynasty 6 (2350–2170 bc)
Milky quartz
H. 10 cm; w. 8.0 cm; d. 7.5 cm

This head, rendered in a hard, milky quartz, is a wonderful example of the so-called "second style" that appears at the end of the Old Kingdom.[1] It is characterized by a departure from the soft, bland countenance of the Old Kingdom and is a foretaste of the more mannerist compositions of the First Intermediate Period. Although fragmentary, this was clearly a particularly fine piece of sculpture in a prized but difficult stone to work. The details of the flowing hairstyle characteristic of the period are carefully rendered, as are the eyes, still retaining their classic Memphite shape, which would soon be replaced by the startled stare of the Intermediate Period. The white translucent stone makes it difficult to see the detailed modeling of the cheeks and ears, which also indicates that this was the work of a master sculptor, as does the choice of material. Milky quartz, while used for beads and vessels, was rarely used for sculpture, being such a hard and difficult stone to work, but examples are known from the Archaic Period and from Kerma in the Middle Kingdom.

PL

Notes

[1] Dorothea Arnold, et al., *Egyptian Art in the Age of the Pyramids* (New York, 1999), pp. 458–60.

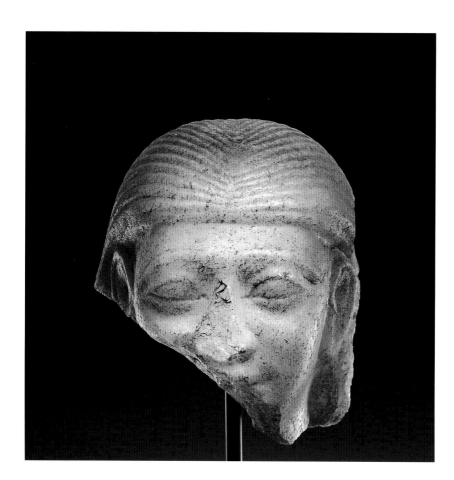

1

2. Statuette with a respectful gesture

LATE DYNASTY 11 OR EARLY DYNASTY 12,
(2008–1842 BC)
CALCITE ("EGYPTIAN ALABASTER")
H. 15.5 CM; W. 4.4 CM; D. 7.7 CM

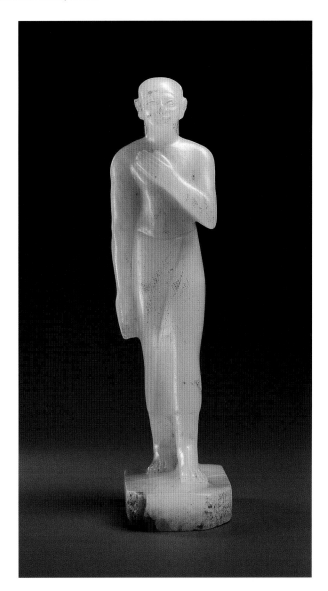

2

A MAN IN SHORT-CROPPED, natural hair wearing a ¾-length wrapped kilt is shown with his left hand resting on his right shoulder. In relation to the body, the head is small, the waist is high, and the shoulders are narrow. This canon of proportion is associated with sculpture of the early Middle Kingdom,[1] a date supported by the broad face, elongated oval eyes and straight mouth.[2] Such a date would suggest that it was orginally placed in a tomb, as statuary of private individuals in temple contexts was rare before late Dynasty 12.

The man's arm position is an unusual one. Most commonly, standing male sculptures are depicted with their hands at their sides. Sons before their fathers[3] or officials attending the tomb owner[4] are occasionally represented in this manner in relief in mastabas from the Old Kingdom on. By the Middle Kingdom, in keeping with the custom of translating two-dimensional representations from Old Kingdom tomb walls into small-scale three-dimensional depictions, it is rendered in the round. It signifies respect. Although neither back pillar nor base is inscribed, such a gesture would indicate that the person represented here is not the tomb owner.

Close examination of the figure reveals the imprint of a coarse textile in several areas. This suggests it was wrapped in linen before it was placed in the tomb.[5]

REF

NOTES

[1] Gay Robins, *Proportion and Style in Ancient Egyptian Art* (Austin, 1994), p. 245.

[2] For example, Mentuhotep III from Armant (Luxor Museum J. 224), illustrated in *The Luxor Museum of Ancient Egyptian Art, Catalogue* (Cairo, 1979), p. 19.

[3] Heidelberg 34, illustrated in Erika Feucht, *Vom Nil zum Neckar* (Berlin, 1986), p. 45.

[4] Prentice Duell, *The Mastaba of Mereruka,* vol. I (Chicago, 1938), pl. 8, lower left.

[5] See, for example, Louvre E 20576, illustrated in Elisabeth Delange, *Catalogue des statues égyptiennes du Moyen Empire* (Paris, 1987), pp. 188–89.

3. A face of the late Middle Kingdom
LATE DYNASTY 12–13, REIGN OF AMENEMHET III
OR LATER (1818–1630 BC)
DIORITE
H. 10 CM; W. 4.0 CM; D. 6.0 CM

KING OR COMMONER, this face of subtly modeled and highly polished diorite was once part of a fine statue. Although now fragmentary, it nevertheless reveals a surprising amount of information. A tiny raised area at the top indicates the figure once wore a wig or crown. The brow overhangs a rimmed eye, and a series of furrows divides the wide expanse of cheek diagonally. One runs from the corner of the eye to the high cheekbone, a second from the nose toward the mouth, and a third, a subtle notch, defines the edge of the lips of a straight, slightly protruding mouth. The chin is broad and square. Considered together, these aspects are hallmarks of sculptures made during the reign of Amenemhet III or slightly later.[1]

The way the face is broken indicates it was deliberately destroyed. Not only did the desecrator's blow to the side of the face detach it from the statue, but additional blows eliminated the nose and damaged the upper and lower eyelid rims, thereby symbolically preventing those features from functioning. Such methods of destruction were common in ancient Egypt.[2]

REF

NOTES

[1] Cyril Aldred, "Some Royal Portraits of the Middle Kingdom in Ancient Egypt," *Metropolitan Museum Journal* 3 (1970), pp. 45ff.

[2] For example, NY, MMA 08.200.2, illustrated in Aldred, *ibid.*, p. 41, figs. 21–2.

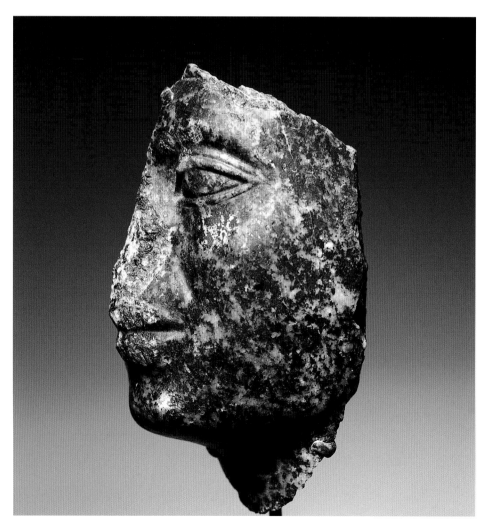

3

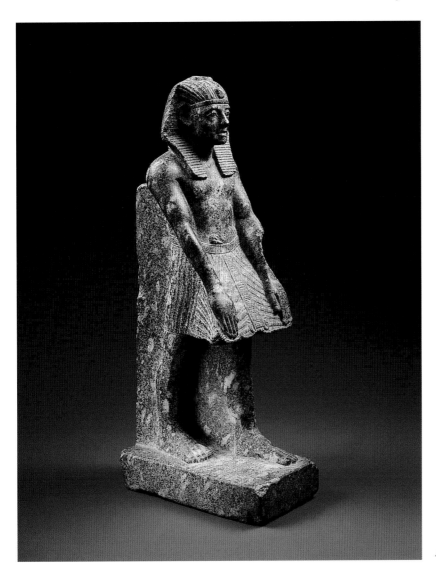

4

4. Amenemhet IV

DYNASTY 12, REIGN OF AMENEMHET IV (1773–1763 BC)
GRANODIORITE
H. 48 CM; W. 14 CM; D. 18 CM

THIS EXTRAORDINARY STATUE, inscribed for the pharaoh Amenemhet IV, represents a transition from the sculpture of the Late Middle Kingdom, as exemplified in the evocative portraits of Sesostris III and Amenemhet III with their careworn expressions, to the "mannerist" creations of the following Second Intermediate Period, characterized by ungainly, elongated proportions. Few monuments of the kings who immediately followed the Middle Kingdom survive, making this piece an important milestone in the evolution of the new style.

Amenemhet IV, who ruled first as co-regent with his father Amenemhet III, and later briefly on his own, is known from only fragmentary depictions, most notably a pedestal with royal visage on rows of uraeii[1] and a sphinx found in Beirut.[2] The sphinx, although partially re-worked in a later period, still contains vestiges of its original physiognomy, and those provide an exact match for this statue. Other unidentified sculptures of the period also bear a close resemblance to this piece, in particular the ex-Havemeyer Collection face now in the Metropolitan Museum of Art.[3] This sculpture, although related stylistically to portraits of Amenemhet III, clearly represents another individual.[4]

While it retains the somewhat haunted hauteur of late Middle Kingdom art, some of the less rigidly defined features characteristic of the following Intermediate Period

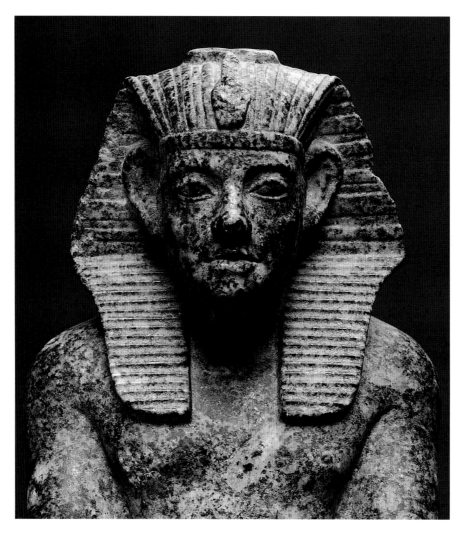

4

can also be seen in this piece. These departures from Twelfth Dynasty tradition have been remarked upon by Cyril Aldred, who noted, "During the long reign of Ammenemes III… a slight but appreciable modification in the realism of the sculpture of Sesostris III is detectable, and the conventions of the Thirteenth Dynasty style are already adumbrated in such features as the summary modeling of the torso with the pectoral muscles joined together, the navel placed at the base of a deep ventral furrow, the disappearance of the sternal notch, and the rise of the corners of the *nemes* headcloth to prominent peaks. Such formulae are a sure indicator of the proliferation of lesser studios with sculptors content to copy in isolation."[5]

Carved of a hard, speckled granodiorite, the sculpture exhibits a variety of surface finishes, from the highly polished face to the roughly finished base. Its remarkable state of preservation may indicate that it had been placed in a *favissa*, or ritual grave for temple sculpture. Even traces of the original ocher pigment have been found within the ears. There are only a few incidental chips that mar its pristine state, found mostly on the back pillar, arm, belt loop and uraeus. However, mineral accretions and microscopic traces of wear attest to its long burial.[6]

The king is depicted striding forward with his arms down and palms held flat against a flaring apron, a pose that first appears in the reigns of Sesostris III and Amenemhet III. He wears the royal *nemes* headcloth with an elaborate triple-stripe pattern and narrow pleated lappets draped over his chest. The top corners of the headdress begin to show the peaks that will become a signature of the following period. At his brow, above the headband of the *nemes*,

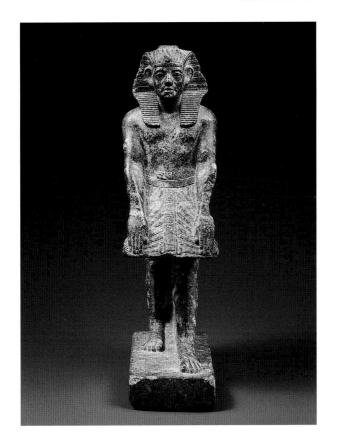

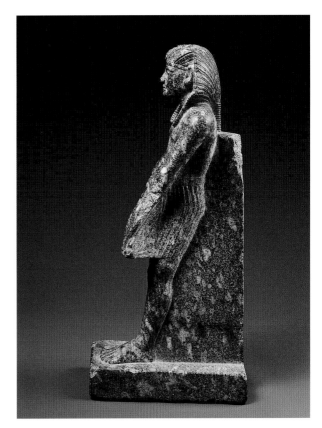

4

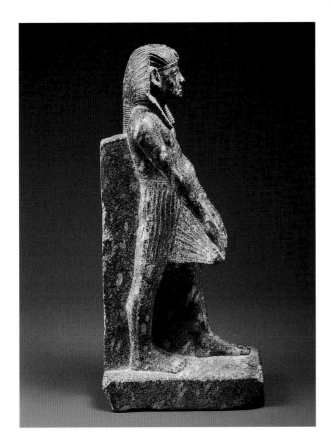

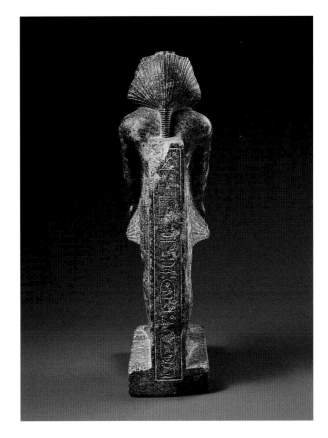

is a uraeus, now missing its head. Behind the hood of the cobra, the body of the serpent lies in a sinuous S-curve that sits high atop his head, as in the statue of his predecessor now in the Hermitage.[7] Amenemhet's large ears are rather simply rendered, which is typical for the period, as is the heavy brow with its subtle indication of eyebrows. His wide-set, large, almond-shaped, hooded eyes are subtly carved with indications of bags, evoking the careworn appearance of royal portraiture of this date. His double-curved lips presage the "cupid's bow" mouth characteristic of the Thirteenth Dynasty. The prominent, round chin and small round nose hint at individual portrait, as in the aforementioned Havemeyer piece.

The king's torso is summarily modeled without an indication of a sternum, but the divisions of the abdomen and navel are clearly defined. He wears no collar on his chest, which is again routine. The heavily muscled arms and legs are subtly and masterfully executed, though the hands are large, as they would become in subsequent sculpture. His belt is of the usual pattern with rectangular blocks separated by groups of four vertical lines. The looped end of his kilt, now slightly damaged, rises above the belt. This pattern continues down the central sash that runs above the symmetrically pleated apron and terminates in two flanking uraeii and four drop beads, only the faintest traces of which are now visible.

The apron flares out quite far and the left leg is advanced in a wide stride, as is evidenced on sculpture of this date. The underside of the kilt is smoothed, but not polished—another standard feature. The negative space between the legs at the rear slopes up, a feature found on an unpublished excavated fragment of a similar sculpture of the same date from Kerma.[8] The feet are long and flat, again a feature of the Second Intermediate Period rather than of the Twelfth Dynasty. The rectangular base is roughed out on the bottom with a pointed chisel as in most statues of this date.

The back pillar begins just below the shoulder, at the end of the long pigtail that descends from the base of the *nemes*, yet again a late Middle Kingdom/Second Intermediate Period indicator. Amenemhet IV's names and titles are incised on the back pillar and read, "The Golden Horus, Kheperkheperu, the good god, lord of the two lands, lord of ceremonies, the king of Upper and Lower Egypt, Maakherure, Son of Re, Amenemhet, [...] forever."

The end of the inscription omits the [given life] epithet, an omission that is hardly unknown and falls within a pattern of abridgments notable in this particular reign.[9] Not only do some of the omissions and odd spellings point to the Second Intermediate Period, but also the peculiarities in the orthography of the hieroglyphic signs. The damage to the name of the god Amen in the cartouche of Amenemhet is probably not an Atenist erasure, but part of the overall damage to the back pillar. It may also be possible that the inscription is a later restoration or has been altered, although it seems less likely than its being contemporaneous.

This important statue makes a pivotal addition to the corpus of late Middle Kingdom sculpture, palpably illustrating the transition between the Twelfth Dynasty and the Second Intermediate Period.

PL

NOTES

[1] Labib Habachi, "New light on objects of unknown provenance I: A strange monument of Amenemhet IV and a similar uninscribed one," *GM* 26 (1977), pp. 27–36; Guy Brunton, "A Monument of Amenemhet IV," *ASAE* 39 (1939), pp. 177–81.

[2] British Museum 58892.

[3] Dorothea Arnold, Alice Cooney Freylinghausen et al., *Splendid Legacy: The Havemeyer Collection* (New York, 1983), p. 113.

[4] Dorothea Arnold has suggested Sobeknofru.

[5] Cyril Aldred, "Some Royal Portraits of the Middle Kingdom in Ancient Egypt," *Metropolitan Museum Journal* 3 (1970), p. 45.

[6] Richard Newman, *Museum of Fine Arts (Boston) Research Laboratory Examination Report: Statue of Amenemhat IV,* T 406.1.1991 (Boston, 1991).

[7] *Egyptian Antiquities in the Hermitage* (Leningrad, 1974), nos. 21–22.

[8] MFA 1920.1185.

[9] William J. Murnane, *Ancient Egyptian Coregencies* (Chicago, 1977), p. 24. For similar Middle Kingdom omissions, cf. Dominique Valbelle and Charles Bonnet, *Le Sanctuarire d'Hathor Maîtresse de la Turquoise* (Paris, 1996) pp. 128–29, figs. 150–51. It was also suggested by Cyril Aldred in a letter dated August 26, 1982, that "This of course could be a scribal error, or carelessness—it was seldom that the statue was placed in a position that the back pillar could be read.... It may be, however, that this would have been incised in a panel on the podium before the right foot (cf. Cairo, CG 42014)." Theodore Halkedis, personal communication.

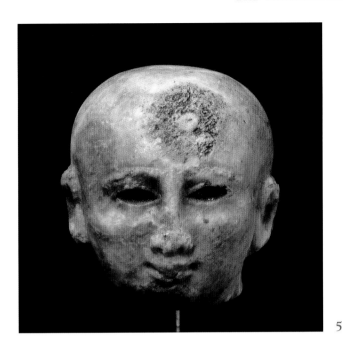

5

5. Anhydrite head

Mid-Dynasty 12–Dynasty 13 (1844–1630 bc)
Anhydrite
H. 4.0 cm; w. 4.0 cm; d. 4.5 cm

Most pieces of Egyptian sculpture are dated by their style, inscription, or provenance. In the case of this small but lovely head, it is the material that provides the first clue. The luminous blue is anhydrite, a stone[1] exploited in the Middle Kingdom but rarely before[2] and seldom thereafter.[3] Most commonly at that time, it was used for the manufacture of vessels, which were often of a fanciful shape.[4] Rarely[5] was statuary carved of this prized material, whose source until now remains unknown.[6] This is the head of one such statue.

The style of the head confirms its Middle Kingdom date. It shows a bald-headed man whose skull exhibits a decided bulge in the rear, a shape frequently found on heads of the Twelfth Dynasty.[7] Baldness is often associated with priests and high government officials.[8] Slightly arched brows in raised relief surmount almond-shaped eyes hollowed out to receive inlays. Similarly shaped hollowed eyes may be found on stone statuary of the Middle Kingdom beginning with the reign of Sesostris II,[9] as seen in the two sculptures of his queen, Nofret.[10] Other noteworthy aspects of the anhydrite head are its round face, high and pronounced cheekbones, broad cheeks, and small pursed mouth. This combination of features suggests that it dates to the middle of Dynasty 12 or later.

REF

Notes

[1] Specifically anhydrous calcium sulphate ($CaSO_4$).

[2] The earliest example is Predynastic in date. See Barbara Aston, James Harrell, and Ian Shaw, "Stone," in Paul Nicholson and Ian Shaw, eds., *Ancient Egyptian Materials and Technology* (London, 2000), p. 23.

[3] For New Kingdom examples, see Edward Terrace, "'Blue Marble' Plastic Vessels and Other Figures," *JARCE* 5 (1966), p. 60.

[4] *Ibid*. For a more recent discussion and analysis, see Biri Fay, "Egyptian Duck Flasks of Blue Anhydrite," *MMJ* 33 (1998), pp. 23–48.

[5] Terrace lists only two fragmentary examples in his catalogue, *op. cit.*, p. 62.

[6] Aston, Harrell, and Shaw, *op. cit.*, p. 23.

[7] For example, Cairo CG 434 and 435, illustrated in Jacques Vandier, *Manuel d'archéologie égyptienne*, vol. III: *Les grandes époques: La statuaire* (Paris, 1958) pl. LXXVI, 3, 4. It also occurs later, particularly in the Late Period.

[8] Vienna 5801, illustrated in Wilfried Seipel, *Gott. Mensch. Pharao. Viertausend Jahre Menschenbild in der Skulptur des Alten Ägypten* (Vienna, 1992), pp. 214–15.

[9] Earlier examples in both stone and wood tend to have pronounced inner and outer canthi, as in Brooklyn 56.85, illustrated in Seipel, *ibid.*, p. 157.

[10] Hans Gerhard Evers, *Staat aus dem Stein* (Munich, 1929), pls. 72–75.

6. Fragmentary statue of a queen

EARLY DYNASTY 18 (1539–1458 BC)
RED GRANITE
H. 64.8 CM; W. 41 CM; D. 29.5 CM

THIS FRAGMENT COMES from the lifesize statue of a queen. Her status is indicated by the vulture crown that has been incised in elaborate detail over her tripartite wig.[1] The body of the bird, covered in a pattern of short feathers, stretches over the top of the queen's head and ends with a series of long tail feathers. The legs have no feather pattern and end in talons holding *shen* hieroglyphs. The bird's damaged head was carved in high relief, its neck rising from the bottom of the narrow frontlet band. Above this frontlet, on either side of the vulture's neck, the upper edges of the wings are decorated with a pattern of short feathers, while the wings themselves are formed of three rows of long feathers that extend down the lappets of the queen's wig. Below this vulture head-dress, vertical incised lines indicate locks of hair. In the back, the wig falls below shoulder blade level where it meets a narrow, uninscribed back pillar. The upper edge of her tight sheath dress ends just below her breasts, which are covered by wide straps, and a beaded collar with five rows of barrel beads and a row of drop beads is visible between the lappets of her wig. The position of the arms, which are close to the body, suggests that the statue presented the queen seated by herself.[2] The style appears to be early Eighteenth Dynasty, with the closest parallel a lifesize seated statue in sandstone dedicated to Queen Mutnofret by her son, Thutmose II.[3] The features of the granite queen have been systematically obliterated, leaving little for comparison, but the shapes of the faces of the two statues and the positioning and form of the ears appear to be similar. Both queens wear tripartite wigs that expose the ears, and both are clothed in dresses with the upper edge ending just below the breast.

Similarities between the Thalassic fragment and the statue of Mutnofret suggest that the granite queen dates to the reign of Thutmose II or shortly thereafter, during the regency or early reign of Hatshepsut. Although the identity of the granite queen must remain in question until such time as the fragment can be joined with an inscribed throne or base, a number of possibilities present themselves. The statue could be another representation of Mutnofret, or it might depict a wife of Thutmose II, either his principal queen Hatshepsut, or perhaps his secondary wife Isis, the mother of Thutmose III. It could also be a representation of Queen Ahmose, the mother of Hatshepsut. Ahmose appears in the birth scene on the second terrace of Hatshepsut's temple at Deir el-Bahri, and her daughter might also have commissioned a statue of her mother to be placed in the temple. The fact that the Thalassic fragment is carved in red granite could indicate that the woman was a principal queen rather than a secondary wife, but too few large statues of individual queens are preserved from the early Eighteenth Dynasty to give particular significance to the material used.[4]

The systematic damage to the face of the Thalassic statue fragment is similar to that found on several of Hatshepsut's granite statues, but this does not necessarily identify it as a representation of her as queen. A lifesize seated image of Sitre, Hatshepsut's nurse, that probably once stood in the temple was also viciously destroyed.[5] If a statue of Hatshepsut's mother was also present in the temple, it might well have suffered the same fate.

CHR

NOTES

[1] Although this is also a divine headdress, it is usually augmented by an additional crown when worn by a goddess.

[2] In pair statues, the woman almost always has one arm around her husband's shoulders. During the New Kingdom, most standing statues of women have the left arm crossing the torso, the hand clutching a *menat* necklace, sistrum, or flail that would certainly be visible in a fragment of this size.

[3] This piece, now in the Egyptian Museum in Cairo (CG 572) was discovered in the temple of Wadjmose in western Thebes. It is published in Ludwig Borchardt's *Statuen und Statuetten von Königen und Privatleuten,* vol. II, Catalogue Général des Antiquités Egyptiennes du Musée du Caire, (Berlin, 1925), p. 121, pl. 97. More views of the statue may be seen in Ingegerd Lindblad's *Royal Sculpture of the Early Eighteenth Dynasty in Egypt*, Medelhavsmuseet, Memoir 5 (Stockholm, 1984), pp. 62–63, pl. 38.

[4] The statue of Queen Mutnofret, a secondary queen, was carved of sandstone notwithstanding her status as mother of Thutmose II. On the other hand, Thutmose III dedicated a

small seated statue made of dark granite to his mother Isis, who was not a principal queen. This statue was probably somewhat later than the Thalassic fragment, during the sole reign of Thutmose III. Stylistically it has far less in common with the Thalassic fragment than does the statue of Mutnofret, which appears to be roughly contemporary with the granite queen.

5 Egyptian Museum, Cairo, Journal d'Entrée 72412, see *BMMA* vol. 27 (1932), Section II, fig. 6, p. 10. This statue depicts Sitre holding the small figure of Hatshepsut, dressed in king's attire, seated on her lap. The presence of Hatshepsut in the statue may account for its destruction, but the image of Sitre has been so shattered that nothing remains of her face, suggesting that she was also a target.

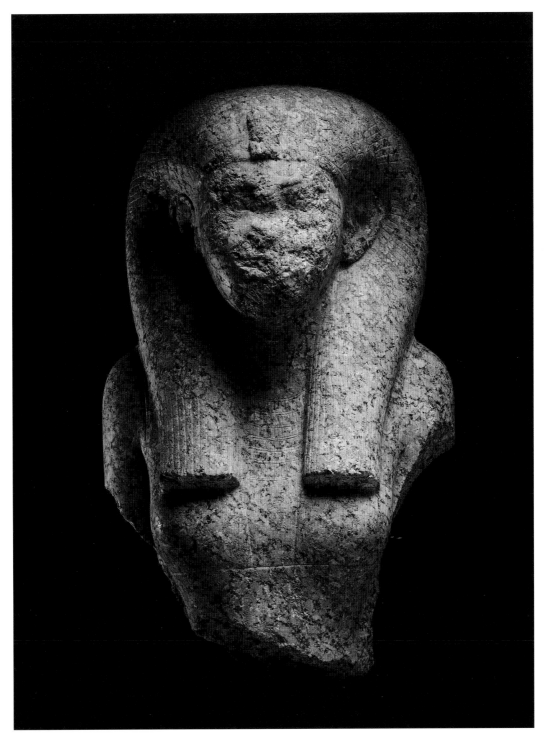

6

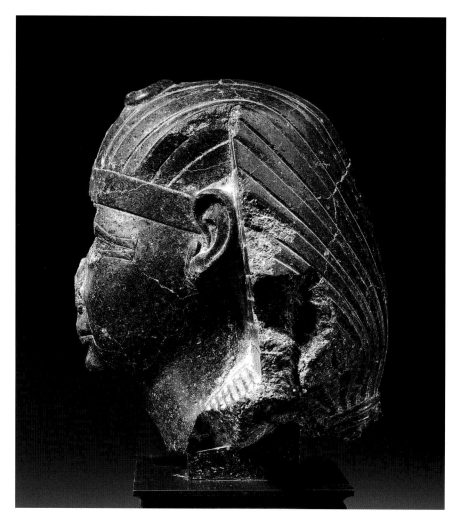

7

7. Head of Amenhotep II

DYNASTY 18, REIGN OF AMENHOTEP II,
(1426–1400 BC)
BLACK GRANITE
H. 23 CM; W. 15 CM; D. 20 CM

ALTHOUGH HARDLY the best known pharaoh of Dynasty 18, Amenhotep II nevertheless proved a worthy successor to his father, Thutmose III, and keeper of the early New Kingdom pharaonic imperialist tradition. Reigning less than thirty years, he concluded several military campaigns in Syria–Palestine to the northeast, and in Nubia to the south. He built ambitiously up and down the Nile, and left us several unique texts extolling his great athletic prowess.[1] Along with Tutankhamen, Amenhotep II was one of the very few pharaohs to be discovered still in royal repose within his own tomb in the Valley of

the Kings.[2] A number of sculptures portray the king, but in such a wide variety of styles that his visage fails to strike the modern eye with the immediate recognizability of a Hatshepsut, an Akhenaten, or a Ramesses II.[3]

The fragmentary nature of this head makes a secure identification with Amenhotep II all the more tentative. The proper left side of the face is the best preserved. The edges of both the plastic eyeline and eyebrow widen as they recede in distinct relief towards the ear.[4] One of the two large coils of the uraeus serpent survives on top of the striped *nemes* headcloth. Three horizontal rings of the gathered pigtail are still visible at the back of the headcloth. The *nemes*'s wide band covers the forehead and extends down to the left ear, which is not overly detailed. Most of Amenhotep II's portraits position the uraeus at the bottom of the band; unfortunately, our head is broken just

where this feature should come into view. Beneath the stripes of the *nemes,* just the beginnings of the thin pleats of the lappets that once graced the king's shoulder are visible below the ear.

The best preserved element of the full, fleshy face is the mouth.[5] The lips are small but well defined, the lower lip particularly emphasized. There is a pronounced depression between the lower lip and the chin area. Above the upper lip, the philtrum is damaged, and only the edge of the proper left nostril is preserved. The king shows a hint of a double chin; the Adam's apple is also clearly pronounced. Despite the heavy losses, the face seems to smile, a rather rare feature in portraits of Amenhotep II.

Some scholars prefer to see two variations to Amenhotep II's portraits, an earlier, youthful style, and a later, idealizing style. Sourouzian has distinguished no less than three basic variations in the portraits of this king.[6] This particular head would fit in best with her first group, as defined by a short face with full cheeks, squarish chin, prolonged, curving cosmetic lines, and mouth corners drawn up in a hint of a smile or slightly hollowed at the corners.[7] Most of the king's images derive from the Theban area, and it is a reasonable assumption that this head likewise might once have graced a seated or standing statue in a temple court or sanctuary, perhaps at Karnak or at Amenhotep's mortuary temple, on the west bank at Thebes.

<div align="right">PDM</div>

NOTES

[1] See Peter Der Manuelian, *Studies in the Reign of Amenophis II* (Hildesheim, 1987), and Wolfgang Decker, *Die physische Leistung Pharaos* (Cologne, 1971), passim.

[2] Victor Loret, "Le tombeau d'Aménophis II et la cachette royale de Biban el-Molouk," *Bulletin de l'Institut d'Egypte* (3 sér.) 9 (1899), pp. 98–112; and Nicholas Reeves and Richard H. Wilkinson, *The Complete Valley of the Kings* (London, 1996), pp. 100–103.

[3] For a useful review of the king's statuary, cf. Hourig Sourouzian, "A Bust of Amenophis II at the Kimbell Art Museum," *JARCE* 28 (1991), pp. 55–74. Additional portraits are discussed in Mohamed Saleh and Hourig Sourouzian, *The Egyptian Museum Cairo. Official Catalogue* (Mainz am Rhein, 1987), cat. no. 139 (JE 36680 = CG 42077), and Arne Eggebrecht, ed., *Ägyptens Aufstieg zur Weltmacht* (Mainz am Rhein, 1987), pp. 238–44, cat. nos. 170–75.

[4] This feature is perhaps best paralleled by the small head in Boston, MFA 99.733, for which see Bernard V. Bothmer, "Membra Dispersa. King Amenhotep II Making an Offering," *BMFA* 52, no. 287 (February, 1954), pp. 11–20, and idem, "Amenhotep II—Restored," *BMFA* 52, no. 288 (June, 1954), p. 41; and by Cairo CG 42074, for which cf. Sourouzian, *JARCE* 28, p. 66, fig. 16.

[5] The rounded fleshiness of Amenhotep II's images is discussed by Edward L.B. Terrace in regard to Cairo JE 36680 = CG 42077, in Terrace and Henry G. Fischer, *Treasures of Egyptian Art from the Cairo Museum* (London, 1970), esp. p. 112.

[6] See her discussion of the earlier literature, *JARCE* 28, esp. p. 64.

[7] *Ibid.,* p. 65.

8

8. Royal nose and lips

DYNASTY 18, PROBABLY REIGN OF THUTMOSE III,
(1479–1425 BC)
BLACK GRANODIORITE
H. 11.0 CM; W. 7.25 CM; D. 8.0 CM

ROYAL PORTRAITURE through most periods of Egyptian history was idealized, and not the true portraiture we are familiar with today. Distinctive facial characteristics such as the shape of the nose, eyes, and even ears were often captured in official Egyptian portraits (both royal and private), but were idealized, made eternally youthful and perfect. The degree of idealism ebbed and flowed from period to period, dynasty to dynasty, even king to king. In late Dynasty 12, for instance, portraits of Sesostris III and his successor Amenemhet III exhibit an astonishing naturalism, as close to true portraiture as was possible for ancient Egypt, but this was very much the exception, and not the norm.

The Eighteenth Dynasty is a rich period for frequency of changes in the style of royal portraiture. This trend culminated in the radical changes of Akhenaten, and gives one the impression that Egyptian art could be very malleable indeed when the occasion demanded. A recent study has shown that Hatshepsut's art style changed several times during her reign, primarily for political reasons, first reflecting the features of her husband Thutmose II and later of her nephew Thutmose III, after he became king and she his regent. When their relationship changed, and she began her coregency with him, her style subtly changed yet again, still within the parameters of the Thutmosid tradition but reflecting her own personal characteristics.[1]

This exquisite fragment of royal portraiture can be dated with a fair degree of certainty to the reign of Thutmose III by the distinctive style of the lips, delineated philtrum, and the noble, arched nose.[2] Our fragment displays a straight dividing line between the wide lips, quite different in style, say, from the smaller, cupid's-bow lips and v-shaped smile of Ramesses II, whose portraits later display an equally proud arch to his own nose.[3] Our fragment's nose with its gentle, Thutmosid arch and soft, rounded tip, contrasts with the noses of Hatshepsut's sculpture, which display a sharper, more pointed tip.[4] That detail combined with the wide mouth, at variance with Hatshepsut's smaller mouth, make an association with Thutmose III most likely.[5]

Laboury has identified four distinct stylistic phases for Thutmose III during his 54-year reign: Type 1, which corresponds to the regency with Hatshepsut (regnal years 1–7) and continued the tradition of his predecessors Thutmose I and II; Type 2, which corresponds to the coregency with Hatshepsut (years 7–21) when her facial characteristics were dominant and his were patterned after hers; Type 3, which corresponds to the beginning of his sole rule after Hatshepsut's death (years 21–42) but which was still influenced by her style; and the last, Type 4, to his final years and the persecution of Hatshepsut (years 42–54), which harkened back to the Type 1 in deliberate rejection of the style associated with Hatshepsut. If Laboury is correct, then our piece would date to Type 3 and the time just after Hatshepsut's death, between Thutmose III's regnal years 21–42.[6]

WRJ

Notes

[1] Dimitri Laboury, *La Statuaire de Thoutmosis III: Essai d'interprétation d'un portrait royal dans son contexte historique*, Aegyptiaca Leodiensia 5 (Liege, 1998).

[2] *Ibid.*, pp. 358–89, figs. 236, 237.

[3] Silvio Curto, *L'antico Egitto nel Museo Egizio de Torino* (Turin, 1984), p. 144 (color plate), p. 146 (figure upper left).

[4] Laboury, *op. cit.*, p. 530, fig. 293.

[5] His son Amenhotep II is less likely as a possibility because his nose, when preserved, is fairly straight: see Hourig Sourouzian, "A Bust of Amenophis II at the Kimbell Art Museum," *JARCE* 28 (1991), pp. 55–74. Although there are far fewer of his sculptures preserved, Thutmose IV is unlikely as well for the prominent "overbite" which causes his upper lip to protrude—not in evidence on our piece; see Betsy M. Bryan, "Portrait Sculpture of Thutmosis IV," *JARCE* 24 (1987), pp. 3–20.

[6] Laboury, *op.cit.*, pp. 640–41.

9

9. Sphinx fragment inscribed for Amenhotep III

Dynasty 18, reign of Amenhotep III (1390–1353 bc)
Golden brown quartzite
H. 30.0 cm; w. 24.0 cm; d. 24.0 cm

In all periods of Egyptian history the lion, whose ferocity and pre-eminence in nature went unchallenged, symbolized the king's supreme power over nature and mankind. The replacement of the lion's head with the human head of the king in the early Old Kingdom made the identification literal. It is a testament to the cleverness of the ancient Egyptian artists that this grafting of human and animal elements was so successful; some of these composite creatures are so life-

like they look like they could get up and pad away at any moment.

Such would have been the case with this fine example inscribed with the prenomen of Amenhotep III, now missing its head, front legs, mid- and hind quarters. The golden brown quartzite must have given the whole statue an eerily naturalistic look of the tawny hide of a real lion, thus lending it additional impact.

The missing head sported a *nemes* headdress, the

each elbow to the corresponding shoulder are rendered very naturalistically. The stylized mane of the lion falls over each shoulder and down the chest, and is rendered with thin, vertical striping. A vertical gap has been left in the center of the chest between the forepaws for the inscription, which reads "Perfect god, Nebmaatre, god […]."

The sphinx originally rested on a raised platform carved from the same stone, part of which can be seen

9

striped lappets of which are preserved on the shoulders, and the *nemes* may have been surmounted by a double crown. The king was bearded, as is indicated by the beard support scar on the chest, and wore a simple, beaded *wesekh* collar around his neck made up of six rows of undifferentiated beads, with an outer terminus row of differentiated, drop-shaped beads. Although the forepaws are broken away, the elbows are preserved, and the stretched tendons connecting

below the elbows. In fact the rounded, worn condition of the under- and backsides suggests that our fragment may have been exposed to the elements upside-down for an extended period of time, which resulted in its extreme wear. It may even have been a surface find. Its broken condition further suggests that it was smashed into pieces for reuse as a building block.

Although sphinxes of Amenhotep III are well-known from many sites, quartzite sphinxes from this

period are rare.[1] Ours is just under lifesize, and may be from a set of quartzite sculptures similar in scale and stone commissioned by Amenhotep III during his last decade, carved in his innovative "deification style" found after the first jubilee in year 30.[2] It is probable that our missing head would have displayed the exaggeratedly youthful style of the Cleveland head with long, narrow eyes that dominate the face, a small turned-up nose, and small outlined mouth.

It is tempting to speculate that this group of sculptures, and a lifesize deity statue in the Vatican made of the same golden quartzite,[3] might perhaps have graced a temple of Amenhotep III at Heliopolis, seat of the sun-god Re, for whom the stone was sacred, and for whom the stone was quarried nearby, at Gebel Ahmar.

WRJ

NOTES

[1] For the colossal quartzite sphinx of Queen Tiye found in Amenhotep III's mortuary temple, see Gerhard Haeny, ed., *Untersuchungen im Totentempel Amenophis' III.* (Wiesbaden, 1981), pl. 11b.

[2] For the best example of this group, Cleveland Museum of Art 61.417, see Arielle P. Kozloff and Betsy M. Bryan with Lawrence Berman, *Egypt's Dazzling Sun* (Cleveland, 1992), pp. 159–61; height 17.3 cm, width 17 cm, depth 25.3 cm.

[3] Museo Gregoriano Egizio #17; *ibid.*, p. 142, fig. V.23.

10. Head with the features of Amenhotep III

DYNASTY 18, REIGN OF AMENHOTEP III (1390–1353 BC)
PERIDOTITE
H. 19.5 CM; W. 5.5 CM; D. 11 CM

No KING IN THE HISTORY of Egypt produced as many and varied sculptures during the course of his reign than did Nebmaatre Amenhotep III during his almost thirty-eight years of rule. Every cult center in the land received sets of sculptures of the king in divine and human form varying in size from small, exquisite votive statuettes, to stupendous colossi worshipped as gods in their own right.

This small head of the king is identifiable as Amenhotep III by the distinctive round face; large, oblique, almond-shaped eyes and arched brows; small, full lips with the hint of a smile; and pert nose. The overall effect is one of almost exaggerated youthfulness, and this was the intent of the ancient artist, to render the king's features in a youthful, idealized manner that reflected his symbolic rebirth and rejuvenation as a result of his jubilee celebrations.

This head is of particular interest because of its unusual material, peridotite, which is a stone not found in Egypt, but was in all probability quarried in Nubia, present-day Sudan. Three other royal statues in this stone are known to date from the time of Amenhotep III: a head of Queen Tiye wearing a heavy wig and horned disc of Hathor, Museum of Fine Arts, Boston 21.2802, procured in Sanam, Sudan and originally part of a group; a striding statuette of Amenhotep III wearing the white crown, face missing, MFA 23.734, excavated at Gebel Barkal; and a statue of a god with the features of Amenhotep III wearing a god's wig and *atef* crown, Brooklyn Museum of Art 67.14, also part of a group.[1]

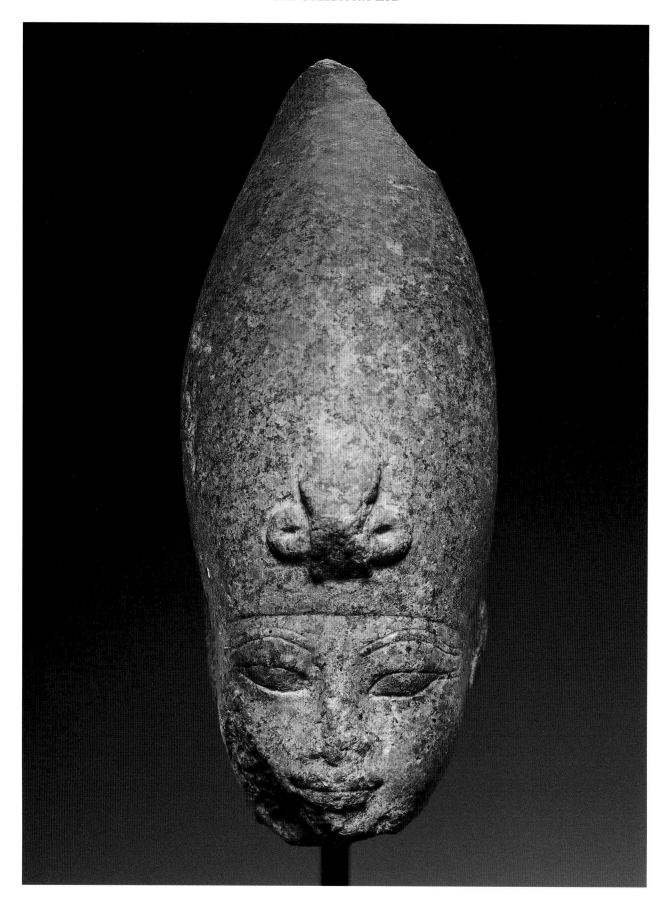

Our head was also part of a dyad or group statuette, as an examination of the back support shows; the right side of the back support preserves a finished edge on line with the middle of the king's head, while the left side is broken away where it continued to the statuette's left, where a companion figure was originally positioned. The left side of the king's head was left unfinished and unsmoothed because it was not visible when the companion figure was present, and now presents a roughened surface.

Pair or group statues of the king and his family, and the king in the company of a deity or deities, are common in this period, from small to colossal, and in a wide range of different stones. It is possible that Brooklyn 67.14 was part of a similar group or pair statue, and may even be the mate to our piece. A seated pair statuette in dark granodiorite of Amenhotep III and

Horus, similar in scale to our head, was excavated in 1989 at Luxor Temple[2] and is now on view in the Luxor Museum of Art. Our sculpture, and the Brooklyn piece, may have derived from a series of sculptures depicting the king in the company of various deities with whom he was identified, and were originally set up in one of his temples in Nubia: Soleb or perhaps Sedeinga. Ongoing excavations at Sedeinga may shed further light on this enigmatic and rare series.

WRJ

Notes

[1] Arielle Kozloff and Betsy Bryan, eds., *Egypt's Dazzling Sun: Amenhotep III and His World* (Cleveland, 1992), pp. 175–77.

[2] Mohamed El-Saghir, *The Discovery of the Statuary Cachette of Luxor Temple*, Deutsches Archäologisches Institut, Abteilung Kairo; Sonderschrift no. 26 (Mainz, 1991), pp. 72–73.

11. Ptah-Sokar-Osiris with the features of Amenhotep III

DYNASTY 18, REIGN OF AMENHOTEP III (1390–1353 BC)
GRANODIORITE

H. 67.3 CM; W. 34.3 CM; D. 28.4 CM

THE ART OF NEBMAATRE Amenhotep III experienced almost constant stylistic change during the course of his almost 38-year reign, but certain identifiable facial characteristics remained consistent from phase to phase: arched brows; elongated, almond-shaped eyes; turned-up nose with bulbous tip; and voluptuous outlined mouth with pronounced "dip" in the center of the upper lip. Even during the last decade of Amenhotep's reign, when his artistic style changed radically after his first jubilee in regnal year 30 to reflect his new "deified" and rejuvenated status, these stylistic hallmarks can still be recognized despite the king's exaggerated youthfulness.[1]

This statue, and a wealth of others like it, date to the period just prior to Amenhotep III's first jubilee and deification in his regnal year 30, in anticipation of which they were commissioned and dedicated. Although the piece is now inscribed on the back support with the names and titulary of Pharaoh Merneptah (1213–1204 BC), who built his own mortuary temple beside Amenhotep III's, the style of the statue dates it firmly to Amenhotep III.[2] Recent excavations of Merneptah's mortuary temple by the Swiss Institute have shown that Merneptah quarried Amenhotep III's much larger complex, which by this time had fallen into ruin, for statuary and building stone. In all probability our piece was one of these appropriated statues; many similar fragments of appropriated Amenhotep III deity statues were found by the Swiss in Merneptah's complex.[3]

Amenhotep III's mortuary temple (modern Kom el-Hetan) in western Thebes was the largest mortuary complex ever built, in its day larger even than Karnak! Sets of deity sculptures, carved with the features of the king, and in a variety of different stones, were commissioned for it; in this way Amenhotep III took on the role of the creator-god as described in the Memphite theology, assembling the images of all the gods and uniting with them as a means of attaining his living deification.[4]

The attributes of this particular deity (plumes, sun disk, horns, *ankh/djed/was* scepter) associate it with the god Ptah in his chthonic aspect as Ptah-Sokar-Osiris, god of the dead, one of the chief manifestations of the deified Amenhotep III in his mortuary complex. Many fragments of these deity sculptures have been found in the ruins of the mortuary temple itself, but many more have been found in sites all over Egypt, where they were transported after Amenhotep III's death, all identifiable by their style and the inscriptions that associate them with the jubilee and the mortuary temple.[5]

WRJ

BIBLIOGRAPHY

Rita E. Freed, Yvonne J. Markowitz, and Sue H. D'Auria, eds., *Pharaohs of the Sun: Akhenaten, Nefertiti, Tutankhamen* (Boston, 1999), p. 202, cat. no. 6.

NOTES

[1] W. Raymond Johnson, "The Setting: History, Religion, and Art," *ibid.,* pp. 38–49.

[2] *Ibid.*, p. 202, cat. no. 6.

[3] Perhaps even the base of this one; time will tell. Hourig Sourouzian is currently preparing the study of the sculpture. For a discussion of the reuse, see Susanne Bickel, *Untersuchungen im Totentempel des Merneptah in Theben, unter der Leitung von Horst Jaritz* III: *Tore und andere wiederverwendete Bauteile Amenophis' III.*, BÄBA 16 (Stuttgart, 1997).

[4] Arielle Kozloff and Betsy Bryan, eds., *Egypt's Dazzling Sun: Amenhotep III and His World* (Cleveland, 1992), pp. 135–36.

[5] Gerhard Haeny, ed., *Untersuchungen im Totentempel Amenophis' III.*, BÄBA 11 (Wiesbaden, 1981).

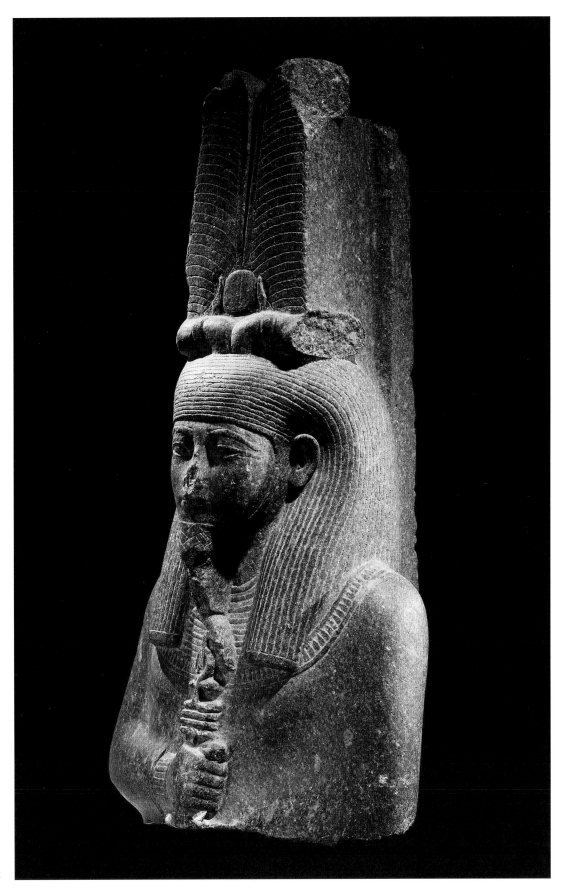

11

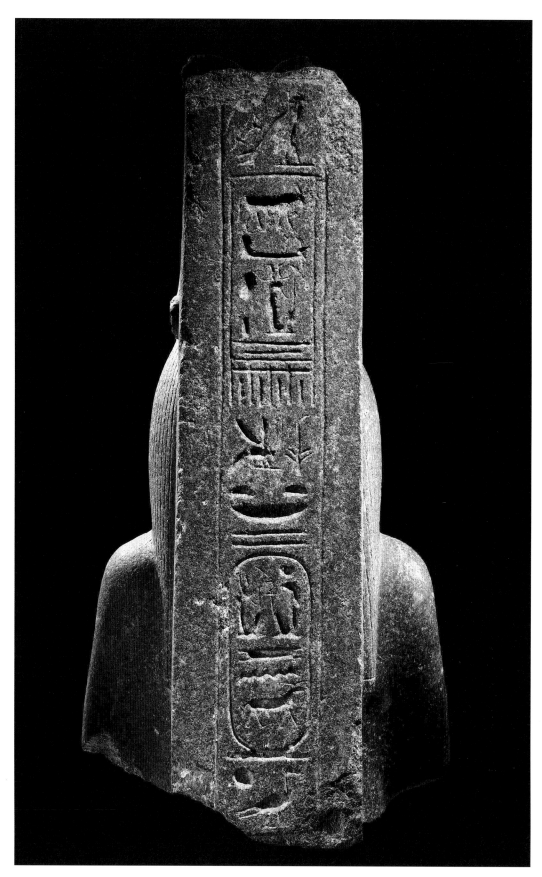

11

12. Head of a block statue

Dynasty 18, reign of Amenhotep III (1390–1353 bc)
Red quartzite
H. 10 cm; w. 7.5 cm; d. 8.0 cm

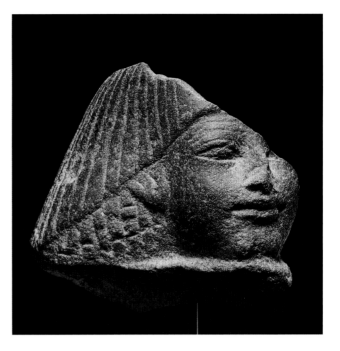

12

This man, probably an official, is wearing a heavy shoulder-length double wig. The upper layers of hair radiate outward from the center of the head, fall straight across his forehead, over the top of his ears, and in graduated lengths over his shoulders. The lower layers of hair are stylized tight curls, depicted by rectangles of different sizes on various levels. The lower part of the ears, visible beneath the wig, have the inner and outer convolutions indicated. The features of the full face look youthful. The large almond-shaped slightly slanted eyes are exaggerated with conventionalized folds above the eye. The pursed mouth is tightly pulled at the corners. The high chin line suggests a beard. The surface of the stone was left unpolished. Such features as a round face, lid lines above the eyes, wealth of detail in the wig, and matte surface illustrate the so-called second style of quartzite statuary in the reign of Amenhotep III.[1] The face recalls strongly that of The Cleveland Museum of Art's brown quarzite head, the Louvre's statue of Neferhotep as a scribe, and to a lesser extent, the brown quartzite head in The Metropolitan Museum of Art.[2] It has been suggested that the group of statues with round, exaggeratedly youthful features should be dated to the last years of Amenhotep's reign, following one of the king's *sed*-festivals.[3] This suggestion is reinforced by the strong iconographic similarity of this group of faces with those of royal family members in the tomb of Kheruef dating to the last years of the reign of Amenhotep III.[4]

The shape and size of the break beneath the wig suggest a block statue, an invention of the Middle Kingdom, and a type often used as votive offerings in New Kingdom temples. It represents private individuals in a squatting position, with the knees drawn up to the chin, and the arms crossed and resting on the knees. In some examples, a long gown envelops the body and reduces it to a schematic block-like shape. Although the provenance of this piece remains unknown, it is not impossible that this statue is the work of sculptors who produced Theban quartzite statuary at the end of Amenhotep III's reign.

EP

Notes

[1] Betsy Bryan, "Royal and Divine Statuary," in Arielle Kozloff and Betsy M. Bryan, eds., *Egypt's Dazzling Sun: Amenhotep III and His World* (Cleveland, 1992), pp. 138–42.

[2] The Cleveland Museum of Art, 1961.417: Lawrence M. Berman, *Catalogue of Egyptian Art* (Cleveland, 1999), pp. 225–26, cat. no. 165; Musée du Louvre, E 14241: Jacques Vandier, *Manuel d'archéologie égyptienne,* vol. III, *Les grandes époques: La statuaire* (Paris, 1958), pl. CXLVIII, 4; The Metropolitan Museum of Art, 56.138: William C. Hayes, *The Scepter of Egypt,* vol. II (Cambridge, MA, 1959), p. 236.

[3] Bryan, *op. cit.*, p. 160.

[4] Epigraphic Survey, Oriental Institute of the University of Chicago, *The Tomb of Kheruef, Theban Tomb 192* (Chicago, 1980), pls. 47, 57.

13. Relief of Akhenaten as a sphinx

DYNASTY 18, REIGN OF AKHENATEN (1353–1336 BC)
LIMESTONE
L. 92.5 CM; H. 58.5 CM; D. 7.0 CM

IN THIS RELIEF, the upraised arms[1] of a sphinx bearing the unmistakable profile of Akhenaten offer a vessel to Aten, the sun disk. In characteristic fashion, the rays end in human hands, one of which offers the sign of life to the king. The cartouches name Aten in its earliest form, in addition to Akhenaten and Nefertiti in their later spellings. According to a recent chronology, this places the relief between years 6 and 8 of Akhenaten's rule.[2] The inscription also provides information about its original provenance, namely a sunshade temple at Akhetaten (Amarna).[3] Although sunshade temples had existed since the reign of Hatshepsut,[4] they are particularly common at Amarna, where examples belonging to Tiye, Nefertiti, Kiye, and a number of Akhenaten's daughters have been identified.[5]

They were located outside the main residential areas of the city and were places of worship.[6]

Despite Akhenaten's repudiation of much of Egypt's traditional religious imagery, the concept of the king as a sphinx was one he retained, undoubtedly because of the identification of the sphinx with Re-Horakhty,[7] a manifestation of the sun god. At Amarna, Akhenaten is shown as a sphinx not only in relief, but also in sculpture in the round.[8]

A number of blocks similar in shape and iconography to this example are known,[9] but since none of comparable size were found precisely in situ,[10] their function and placement is under discussion. Although often identified as lintels from broken-lintel doorways,[11] it has recently been suggested that they functioned as orthostats.[12]

REF

BIBLIOGRAPHY

Dorothea Arnold, *The Royal Women of Amarna: Images of Beauty from Ancient Egypt* (New York, 1996), pp. 22–23, 134.

13

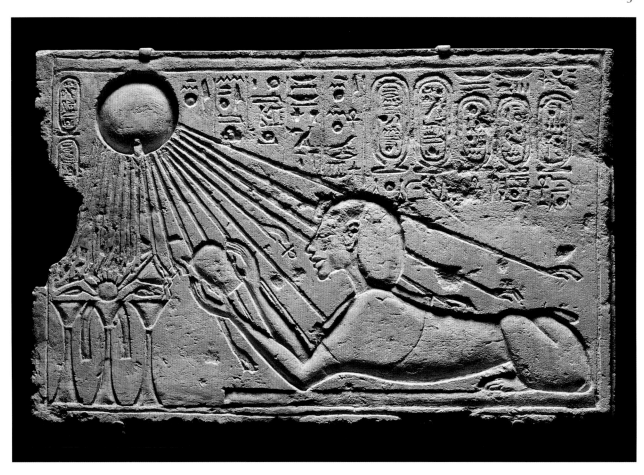

NOTES

[1] Sphinxes with human arms presenting offerings are common in the New Kingdom; see Hourig Sourouzian, "Le roi, le sphinx, et le lion," *Stationen. Beiträge zur Kulturgeschichte Ägyptens* (Mainz, 1998), p. 419.

[2] Dorothea Arnold, *The Royal Women of Amarna: Images of Beauty from Ancient Egypt* (New York, 1996), pp. xviii, 134.

[3] For two possible translations, *ibid.,* p. 134 and Cyril Aldred, *Akhenaten and Nefertiti* (Brooklyn, 1973), p. 99.

[4] Rainer Stadelmann, "Sonnenschatten," *Lexikon der Ägyptologie* 5 (Wiesbaden, 1984), col. 1103.

[5] John Pendlebury, *City of Akhenaten* III (London, 1951), pp. 201–202.

[6] Barry Kemp, "Outlying Temples at Amarna," *Amarna Reports* 6 (1995), p. 461.

[7] For a recent discussion, see Sourouzian, *op. cit.*, p. 419ff.

[8] For example, Pendlebury, *op. cit.*, p. 17, pl. LVIII, 3.

[9] For a list, see Aldred, *op. cit.,* p. 99, to which must be added an additional example now in the Musée d'Art et d'Histoire, Geneva (information provided by Diana Wolfe Larkin, correspondence of November 13, 1996). Diana Wolfe Larkin, *The Broken-Lintel Doorway of Ancient Egypt and its Decoration,* vol. I (Ph.D. dissertation, New York University, 1994), p. 275ff.

[10] Smaller examples, now in the Egyptian Museum, Cairo and the Brooklyn Museum of Art were found in the central hall of the southern section of the Great Palace; see Pendlebury, *op. cit.,* p. 57 and pl. LXVIII 3, 4.

[11] *Ibid.,* p. 57 and most recently, Larkin, *op. cit.,* p. 276ff.

[12] Rita E. Freed, Yvonne J. Markowitz, and Sue H. D'Auria, eds., *Pharaohs of the Sun: Akhenaten, Nefertiti, Tutankhamen* (Boston, 1999), p. 231.

14. Face of Akhenaten

DYNASTY 18, REIGN OF AKHENATEN (1353–1336 BC)
RED GRANITE; TIP OF CHIN PARTLY RESTORED
H. 12 CM; W. 10 CM; D. 7.5 CM

WHILE AKHENATEN SEEMED to have had almost exclusive rights to the worship of the Aten at Amarna, votive sculptures of Akhenaten and his family were in turn venerated by the populace in palace, household, and garden shrines throughout the city. Ranging from a few centimeters in height to upwards of a meter, these statues and statuettes of Akhenaten, Nefertiti, the royal daughters, and even Amenhotep III and Tiye were made of a variety of costly stones, faience, and fine wood. The most popular materials were indurated limestone and fine-grained quartzite, but alabaster was also utilized, some dark granodiorite, and occasionally red and pink granite.

When the city was abandoned and later quarried for building stone (in the Ramesside Period) most of this votive sculpture was smashed into pieces.

Our face exhibits features instantly identifiable as those of Akhenaten: narrow face, high cheekbones, underslung jaw, full wide lips, and long nose, and it was undoubtedly one of the larger votive statues of the king to be found at Amarna. The eyes are not carved in outline, but are rendered as "shadow eyes," raised platforms on which the eye would have been painted, with a ridge that differentiates the eye from the lid. Even without the painted eye, the eye plane, in shadow, gives the impression of the complete eye. Other sculptures of Akhenaten in granite and other stones favor this eye convention, particularly the shabtis from his royal tomb.[1]

The royal diadem, or headband, is indicated on the king's forehead, but there is no trace of a uraeus,

which may indicate that the king was wearing the *khepresh* or blue crown, whose coiled uraeus cobra was located farther up the forehead. Only the proper left ear with heavy lobe is partly preserved; the face appears to have been struck off the head by a sharp blow to the right cheek.

WRJ

NOTES

[1] See Geoffrey Martin, *The Royal Tomb at El-'Amarna* I: *The Objects* (London, 1974), pp. 37–72. For some additional examples of this eye on royal portraiture from Amarna, see Rita E. Freed, Yvonne J. Markowitz, and Sue H. D'Auria, eds., *Pharaohs of the Sun: Akhenaten, Nefertiti, Tutankhamen* (Boston, 1999), cat. nos. 40, 42, 43, and 45.

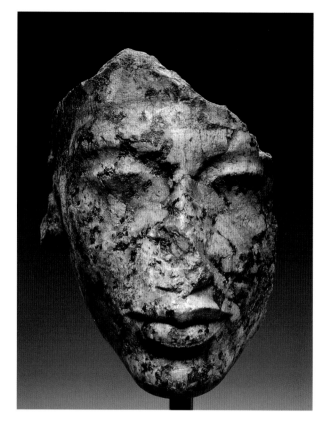

14

15. Head of a king
NEW KINGDOM, PROBABLY EARLY DYNASTY 19,
(1290–1213 BC)
GOLDEN BROWN QUARTZITE
H. 32 CM; W. 17 CM; D. 25 CM

THIS HEAD OF A KING wearing the white crown, fashioned from a light-brown quartzite, most likely represents an early Ramesside ruler, possibly Sety I or Ramesses II.[1] Preserved to the top of the neck, the head has sustained damage to the forehead, nose, lips and chin. The head and hood of the uraeus are missing, though traces of its body extend to the now-broken tip of the crown.

The round face has full cheeks and small, close-set eyes, with cosmetic lines and eyebrows carved in low relief. Of the mouth itself, only the corners remain, defined by deep cavities, with oblique furrows descending toward the jaw.

Early representations of Sety I retain a strong Amarna influence not present in this piece.[2] The broad, unmodeled cheeks and tight, small features more closely resemble the Ramesside style that developed at the end of the reign of Sety I and early in the reign of Ramesses II.

BTT

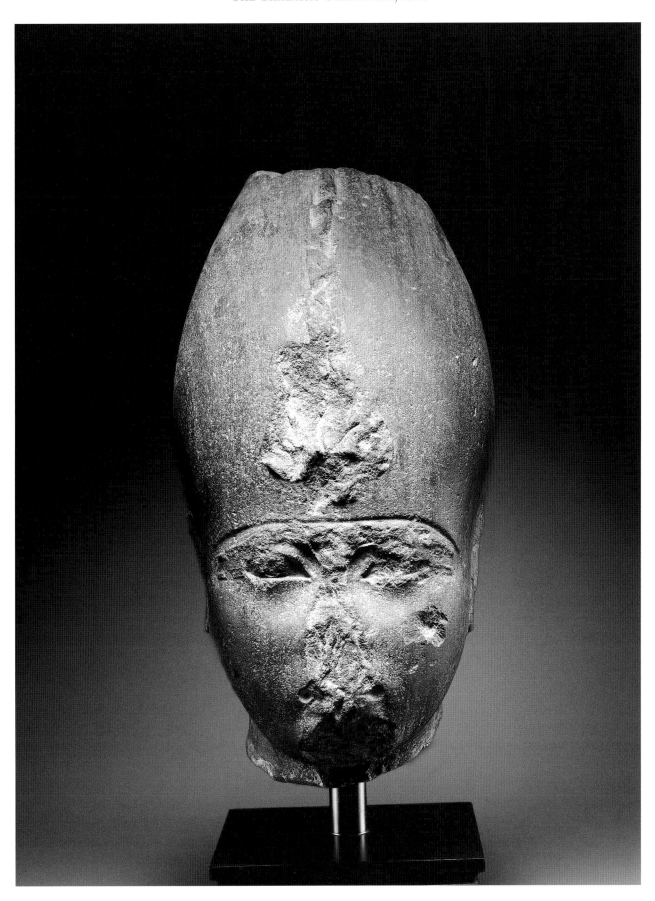

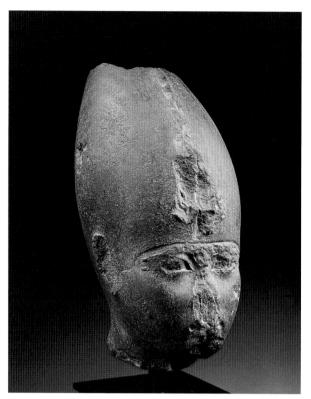

15

Notes

[1] The most distinctive features of Sety I include his aquiline nose, deeply indented chin, and two wrinkles incised below his chin. The preservation of the Thalassic head does not allow evaluation of these features, which are fully outlined in Hourig Sourouzian, "Statues et représentations de statues royales sous Séthi I," *MDAIK* 49 (1993), pp. 239–57, pls. 45–51.

[2] The best example of the residual Amarna style is the colossal calcite statue of Sety in Cairo (CG 42139), with its large, almond-shaped eyes and soft features.

16. Bust from the statue of a goddess

DYNASTY 19, REIGN OF SETY I OR EARLY YEARS OF
RAMESSES II (1290–1270 BC)
GOLDEN BROWN QUARTZITE
H. 35 CM; W. 20 CM; D. 15 CM

THIS ENDEARING FEMALE image has a delicately rounded youthful face, long neck and small breasts with prominently displayed nipples that suggest a tightly clinging garment of the finest linen. Around the neck hangs an elaborate broad collar composed of six strings separated by blank spaces, on which the joining jewelry elements may have been painted with now-vanished pigments. Pendants in the shape of flower petals dangle from the lowest string. The narrow parallel strands of the simple tripartite wig are arranged horizontally above the forehead, curve downward behind the ears, and fall vertically over the shoulders, reaching almost to the breasts in front, and to about the middle of the shoulder blades in the back. A number of strands in elongated horseshoe shape mark the line in the middle of the back section, where the two vertical parts of the wig meet. The artificial hair is fullest above the shoulders, then narrows down in the two front sections, causing the wig's front-view outline to undulate in a graceful protracted curve. Beside the cheeks and neck, the carving of the wig stops before the strands actually touch the figure's head and neck. The remaining blank space may again have been filled with paint, or was intentionally left undefined to set off the face in an effective manner. The usual narrow horizontal band at the bottom of the wig is preserved in the back. It consists of a blank area below a single incised line, about half an inch above the wig's lower edge. In front of each ear, the natural hair of the female protrudes in the form of a small, plain tab.

Photographs show that at an earlier point in time, the beautiful honey-colored stone material was in places more pitted than is seen now. To even out the surface, small amounts of modern fill were applied, especially on the left brow and both lids of the left eye, the left cheek below the eye, and the left side of the chin. Both arms are broken off, including the shoulders. The outlines of the breaks at the sides indicate that the arms were hanging down, and that below the

height of the breasts, flat areas of stone (the so-called "negative space") separated each arm from the body. A slender rectangular back pillar was once attached to the back of the statue, obscuring the lower center of the wig. Only the outline of this pillar against the statue is still clearly defined; the rest is broken away so that the depth can no longer be determined.

Stylistically the sculpture possesses all the hallmarks of early Nineteenth Dynasty art. Like many other works created during the end of the Eighteenth and the beginning of the Nineteenth Dynasties, it was decisively influenced by the sensitively realistic art of the reign of King Akhenaten (the Amarna period: ca. 1353–1336 BC). Amarna influences are unmistakably present in the fine modeling with which the artist has rendered the sleek strands of the wig, the smooth skin and soft flesh of the face, and the subtly rounded breasts below the inertly flat jewelry. Amarna influence can also be detected in the carving of the quartzite sculpture's striking eyes below softly rounded brow ridges. The eyes' natural shape, without any of the usual rims, bands or cosmetic lines, is well known from such post-Amarna works as the head of King Tutankhamen in the Metropolitan Museum,[1] but the sculptor of the present work has rounded the eyeballs even more realistically and has brought to life with special delicacy the thin tissue of the eyelids.

Among all post-Amarna royal images, representations of King Sety I (1290–1279 BC) are closest to the female sculpture.[2] Like the quartzite figure, Sety was depicted with a round face, full cheeks and a smiling mouth whose upturned corners disappear into the flesh of the cheeks. The king's chin is broad and rectangular and juts forward, as the chin of the sculpture presented here; and as in that work his rather small ears are positioned high in the head, and the bridge of the nose is broad and flanked by deep shadows over the corners of the eyes. The similarities are, indeed, close enough to suggest a date for the carving of the female sculpture during the reign of Sety I. The possibility exists, however, of a slightly later date for the sculpture during the earlier years of Sety's son and successor Ramesses II (1279–1213 BC). A certain proportional idiosyncracy in the facial features is noticeable in a number of Sety's images, and appears in an extreme configuration in a bust in Dallas that has

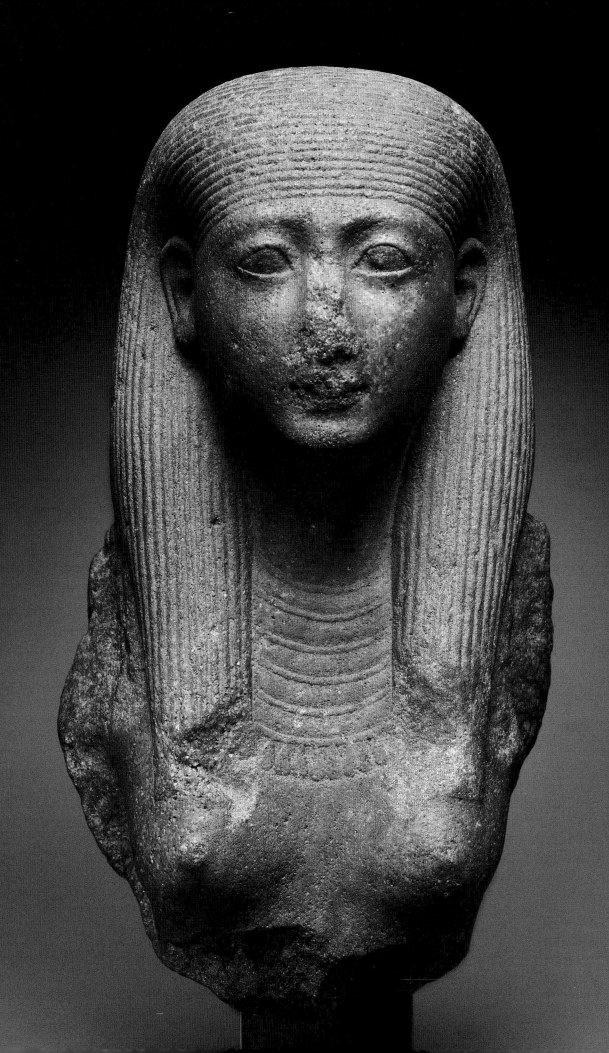

rightly been identified as a work created during the last years of the reign.[3] Similarly irregular proportions occur in some early images of Ramesses II, such as the famous bust from Tanis and related works.[4] The same odd proportions are seen in the female image. In this whole group of sculptures—the female image, the late Sety bust and the representations of the young Ramesses—the highly positioned eyes occupy only the front plane of the face, and the mouth is preternaturally small above the broad chin. The result is a disproportionate prominence of cheeks and temples in the faces, and a somewhat prim expression around the mouth. In the quartzite work, these traits appear as reminiscences of infant faces, and thus contribute to the female's air of youthful innocence, while in the royal images, the odd proportions are combined with heavy rimmed eyes, creating a general impression of artificiality that underlines the pharaoh's semi-divine qualities.

An identification of the quartzite sculpture as the representation of a member of the Ramesside royal family appears to be unlikely. A number of queens related to Sety I and Ramesses II are indeed depicted with the tripartite wig, but this is always combined with uraeus cobras and either a vulture headdress or a crown.[5] Ramesside princesses, on the other hand, are usually not adorned with uraei on their foreheads, but their headgear is definitely more elaborate than the one of the quartzite female. The various statues of princesses at Abu Simbel, for instance, show young women wearing short round wigs with a substantial hairpiece ("lock of youth") falling over one side.[6] Mortal ladies of high status, on the other hand, were usually depicted in an enveloping wig or—less commonly—in a tripartite headgear ornamented by bands and flowers and sometimes an additional waved hairpiece around the face; some more simple wigs are at least distinguished by a center parting[7] or—in reliefs—a modius on the head.[8]

Of all Ramesside artistic representations, divine images are most similar to the quartzite sculpture in the simplicity of the head ornament, with its distinctively archaistic character.[9] Following rather closely some important works created a hundred years earlier, in the time of King Amenhotep III,[10] Ramesside male and female deities predominantly wear the simple tripartite wig without central parting of the strands as it is seen in the present sculpture.[11] Since the female gender of this work's subject seems guaranteed, she must be a goddess. As a single figure,[12] this goddess was most probably represented standing, her left hand holding a long staffed scepter close to the front of her body.[13] Since she does not wear a crown and uraeus cobra, she was probably not one of the great goddesses closely related to kingship, such as Hathor or Mut.[14] In the time of Amenhotep III, the goddesses Nephthys and Neith were depicted, however, with the simple tripartite wig without any additional crown.[15] In Ramesside times a great number of—what seems to us—more minor deities also appeared in such guise.[16] The deity represented in the present sculpture must remain without a name until a lucky find provides other parts of the piece that carry an inscription.

The question of the location of the workshop in which this quartzite masterpiece was carved can only

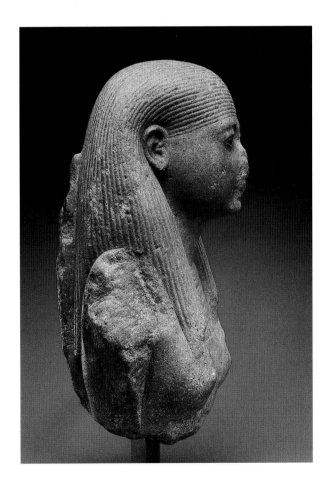

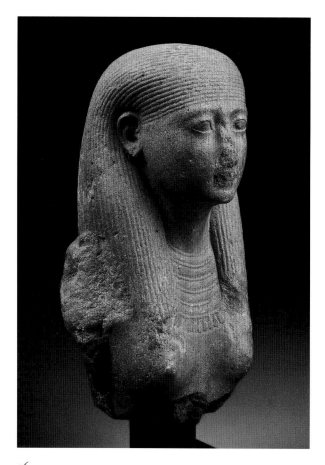

16

the sculpture here under discussion. Known works from Asyut[21] in Middle Egypt combine full flesh with prominent bones and rather flat features. The Middle Egyptian sculptures are especially richly adorned with elaborate dresses and very detailed wigs. Neither their facial structure nor their richness in accoutrements fits the quartzite sculpture here under discussion. The question then arises whether the goddess was carved in a Lower Egyptian workshop. Indeed, a number of pieces from Delta sites seem to share important stylistic characteristics with the deity, although no examples from the reign of Sety I are available. The bust of the young Ramesses II from Tanis (originally without doubt from the Ramesside capital in the eastern Delta, Pi-Ramesses) has been mentioned already.[22] Beside the unusual facial proportions, the manner in which the nipples of the breasts are pressing through the garment in this piece is also found in the quartzite goddess. Other statues of Ramesses II from Tanis and Bubastis—also in the eastern Delta—share the quartzite deity's relative facial flatness, full cheeks and the way the globular eyeballs press against the thin lids.[23] Only in these Delta works does one find, moreover, something of the sensitivity for soft surface qualities combined with relatively simple facial modeling that are such important characteristics of the quartzite goddess. Based on these stylistic similarities, the present author would like to suggest that the quartzite goddess was created in a Delta workshop.

DoA

NOTES

[1] Dorothea Arnold, *The Royal Women of Amarna: Images of Beauty from Ancient Egypt* (New York, 1996), p. 123, fig. 120. This type of eye continues to be carved well into the reign of Ramesses II as Bernard V. Bothmer, "Eyes and Iconography in the Splendid Century: King Amenhotep III and His Aftermath," in Lawrence M. Berman, ed., *The Art of Amenhotep III: Art Historical Analysis* (Cleveland, 1990), p. 90 already remarked. In Ramesside times, however, such eyes are predominantly seen in non-royal sculptures.

[2] Hourig Sourouzian, "Statues et représentations de statues royales sous Séthi I," *MDAIK* 49 (1993), pp. 239–57 with pls. 45–51, the late date is mentioned on p. 251; Victoria Solia, "A Group of Royal Sculptures from Abydos," *JARCE* 29 (1992), pp. 107–22.

[3] Dallas Museum of Art 1984.50: Sourouzian, *op. cit.*, pl. 49a, b; Solia, *op. cit.*, pp. 108–109, figs. 1–6.

be answered tentatively, due to the fact that knowledge about Ramesside art, although greatly advanced in recent years,[17] is still in need of more study. A brief sampling of art works with known provenance shows that the creation of the female sculpture at Thebes or Memphis can be excluded with fair certainty. Memphite sculptures from the late Eighteenth and earlier Nineteenth Dynasties have angular faces with a prominent bone structure, broad and mostly straight mouths, and narrow eyes: all features distinctly different from what is seen in the quartzite goddess.[18] The Theban Ramesside style is even more removed from the style of the quartzite piece. Theban faces of this period are fleshy and deeply modeled, and the features are well defined, and large in relation to forehead, cheeks and chin.[19] Moving further north in Upper Egypt, the few preserved sculptures from Abydos[20] present a style that is closely related to Theban art, although the modeling is softer and the features are less deeply carved. Again none of the pieces from Abydos comes close to

[4] Mohamed Saleh and Hourig Sourouzian, *The Egyptian Museum, Cairo: Official Catalogue* (Mainz, 1987), cat. no. 202; for the base see now: Hourig Sourouzian, "Raccords Ramessides," *MDAIK* 54 (1998), pp. 284–87, pl. 44. Among the related works is above all the bust in the British Museum (now also with a base) from Elephantine: Sourouzian, *ibid.*, pp. 281–84, pl. 42, although its expression is softer and less artificial. The famous statue in Turin (Kurt Lange and Max Hirmer, *Egypt, Architecture, Sculpture, Painting in Three Thousand Years* [Greenwich, 1956], pls. 230, 231) is a Theban version of a similar facial configuration. On the female side the bust of Queen Isisnofret in Brussels certainly belongs into the same group: Christian Leblanc, "Isis-Nofret, Grande Epouse de Ramsès II, la reine, sa famille, et Nofretari," *BIFAO* 93 (1993), pp. 313–33, pl. I A. The head and torso in Cairo, Hourig Sourouzian, "Raccords Ramessides," *op. cit.*, pp. 290–92, pls. 46, 47 (see also Edna R. Russmann, *Egyptian Sculpture* [Austin, 1989], pp. 148–150, no. 68) presents a significantly different concept of the young Ramesses II and is actually more closely related to the Sety I in the Metropolitan Museum (acc. no. 22.2.21, according to the inscriptions possibly from Abydos) than the Dallas bust that Victoria Solia, *op. cit.*, pp. 107–22 has linked with it.

[5] Most notable: Queen Merit-Amen from Thebes: Saleh and Sourouzian, *op. cit.*, cat. no. 208, and from Akhmim: Mohamed El-Saghir, *Das Statuenversteck im Luxortempel* (Mainz, 1992), p. 61, fig. 130. Others: Jacques Vandier, *Manuel d'Archéologie Egyptienne*, vol. III: *Les Grandes Epoques, La Statuaire* (Paris, 1958), pp. 426–29; Christiane Desroches-Noblecourt, "Abou Simbel, Ramsès, et les Dames de la Couronne," in Edward Bleiberg and Rita Freed, eds, *Fragments of a Shattered Visage, The Proceedings of the International Symposium on Ramesses the Great* (Memphis, 1991), pp. 127–66; and Hourig Sourouzian, *Les Monuments du roi Merenptah* (Mainz, 1989), pp. 2–7, especially pl. 3b. For Isisnofret, queen of Ramesses II, see also: Christian Leblanc, *op. cit.*, pp. 313–33. Queen Tuj wears an enveloping wig in her statue in the Vatican: Giuseppe Botti and Pietro Romanelli, *Le Sculture des Museo Gregoriano* (Vatican, 1951), pp. 18–21, no.–28, pls. 19, 20, 22.

[6] Christiane Desroches-Noblecourt and Charles Kuentz, *Le Petit Temple d'Abou Simbel* (Cairo, 1968), vol. II, especially pls. 13, 15, 18, 19. For relief representations of Princess Tia, daughter of Sety I and sister of Ramesses II, see Labib Habachi, "La reine Touy, Femme de Séthi I, et ses Proches Parents Inconnus," *RdE* 21 (1969), pp. 27–47; and Geoffrey T. Martin, *The Hidden Tombs of Memphis: New Discoveries from the Time of Tutankhamun and Ramesses the Great* (London, 1991), especially pp. 110–11, figs. 73–74 where the elaborate wig of the princess on the right contrasts impressively with the simple ones of the deities on the left.

[7] Vandier, *op. cit.*, pp. 489–92.

[8] Herbert E. Winlock, *The Temple of Ramesses I at Abydos*, MMA Papers no. 5 (New York, 1937), pp. 16–17, pl. III.

[9] See for the wig the Middle Kingdom *ka* statue of King Hor in the Cairo Museum: Saleh and Sourouzian, *op. cit.*, cat. no. 117.

[10] Arielle P. Kozloff and Betsy M. Bryan, eds., *Egypt's Dazzling Sun, Amenhotep III and His World* (Cleveland, 1992), pp. 126–53, 178–84 with nos. 17–19; and Betsy Bryan, "The statue program for the mortuary temple of Amenhotep III," in Stephen Quirke, ed., *The Temple in Ancient Egypt: New discoveries and recent research* (London, 1997), pp. 57–81.

[11] Some prominent examples of single deity statues: Eva Rogge, *Statuen des Neuen Reiches und der Dritten Zwischenzeit, CAA Kunsthistorisches Museum, Wien, Ägyptisch-Orientalische Sammlung,* Lieferung 6 (Mainz, 1990), pp. 76–83: the god Imikhentwer; T.G.H. James, "A Ramesside Divine Sculpture at Kingston Lacy," in Christopher Eyre, Anthony Leahy and Lisa Montagno Leahy, eds., *The Unbroken Reed: Studies in the Culture and Heritage of Ancient Egypt* (London, 1994), pp. 139–47; Laura Donatelli, *La Raccolta Egizia di Giovanni Acerbi* (Mantua, 1983), pp. 39–41, no. 8, color plate on p. 28 (I owe the knowledge of this quartzite piece to

16

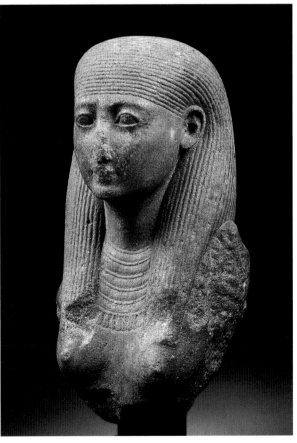

Marsha Hill). Examples of groups of deities: Ludwig Borchardt, *Statuen und Statuetten von Königen und Privatleuten im Museum von Kairo*, vol. 2 (Berlin, 1925), pp. 101–103, pl. 93, nos. 554–555; William C. Hayes, *The Scepter of Egypt,* Part II: *The Hyksos Period and the New Kingdom (1675–1080 B.C.)*, revised edition (New York, 1990), p. 348, fig. 218; Madeleine Page-Gasser and André Wiese, *Ägypten, Augenblicke der Ewigkeit: Unbekannte Schätze aus Schweizer Privatbesitz* (Mainz, 1997), pp. 176–78.

[12] That it was a single figure is, of course, evident from the back pillar, see above.

[13] Compare the goddess of the group: Hayes, *op. cit.,* p. 348, fig. 218.

[14] Compare the Hathor in the Metropolitan Museum group: *ibid.,* and the Mut in the newly reconstructed group: Hourig Sourouzian, "Raccords Ramessides," *op. cit.,* pp. 279–81, pl. 41.

[15] Kozloff and Bryan, *op. cit.,* pp. 183–84, nos. 19, 19a. See also the goddess Nut on the underside of the sarcophagus lid of Merneptah from Tanis: Hourig Sourouzian, *Les Monuments du roi Merenptah*, pp. 182–83, pl. 38c.

[16] T.G.H. James, *op. cit.,* pp. 139–47.

[17] Thanks mainly to the work of Hourig Sourouzian, see the book and articles quoted in the notes.

[18] See the goddesses' heads: Hourig Sourouzian, "Statues et représentations de statues royales sous Séthi I," *op. cit.,* pls. 46b, 47a, b. The royal heads from this pair of statues (*ibid.*, pl. 46c, d) are significantly different, possibly attempting—in their way—a likeness of the king. Other attested Memphite pieces: Rogge, *op. cit.,* p. 83 in the tradition of Geoffrey T. Martin, *op. cit.,* p. 86, fig. 57; Rita E. Freed, Yvonne J. Markowitz and Sue H. D'Auria, eds., *Pharaohs of the Sun* (Boston, 1999), p. 195, fig. 153. Into this style fits well: Dorothea Arnold, "Head of a Goddess," in *The Metropolitan Museum of Art Bulletin* 58, no. 2 (Fall 2000): *Recent Acquisitions, A Selection 1999–2000,* p. 9 (I want to thank Adela Oppenheim for contributing research to this piece).

[19] Among the images of the time of Sety I see, for instance, the Amen face in the Louvre newly joined to a Theban group by Hourig Sourouzian, "Raccords Ramessides," *op. cit.,* pp. 279–81, pls. 40d, 41; for a statue dating to the early years of Ramesses II see the Turin statue: Kurt Lange and Max Hirmer, *op. cit.,* pls. 230, 231; for a queen of Ramesses II the famous bust of Merit-Amen in Cairo: Saleh and Sourouzian, *op. cit.,* cat. no. 208.

[20] Beside the Metropolitan Sety I : William C. Hayes, *op. cit.,* pp. 330–31, fig. 210 on p. 335, and Victoria Solia, *op. cit.,* pp. 110–11, figs. 7–12, are three heads still in the temple of Sety I; one only is illustrated: Hourig Sourouzian, "A Bust of Amenophis II at the Kimbell Art Museum," *JARCE* 28 (1991), p. 58, fig. 5; the two others are illustrated in a Lehnert and Landrock K Lambelet & Co. slide (no. E 1462).

[21] The statue of Yuni, and the group of Yuni and Renenutet: Hayes, *op. cit.,* pp. 349–52, figs. 219, 220 on pp. 351 and 353; Yuni alone: Peter F. Dorman, Prudence Oliver Harper and Holly Pittman, *The Metropolitan Museum of Art: Egypt and the Ancient Near East* (New York, 1987), pp. 68–69, fig. 47; and the group: Anne K. Capel and Glenn E. Markoe, eds. *Mistress of the House—Mistress of Heaven. Women in Ancient Egypt* (Cincinnati, 1996), pp. 172–74, cat. no. 93. A female bust in the Cincinnati Art Museum has rightly been added to this stylistic complex: Anne K. Capel, *ibid.*, pp. 169–72, cat. no. 92. The Hathor and Wepwawet group in the Metropolitan Museum: William C. Hayes, *op. cit.,* pp. 348–49, fig. 218, is somewhat different in style.

[22] See note 4.

[23] Tanis: William Flinders Petrie, *Tanis* Part I (London, 1885), pl. 14, 2; Cairo, Egyptian Museum CG 575, Borchardt, *op. cit.,* pp. 123–25, pl. 98. Bubastis: London, British Museum 585 [1066], Edouard Naville, *Bubastis* (1887–1889) (London, 1891), pl. 21A; Boston 89.558, Vandier, *op. cit.,* pl. 127, 2; Cairo, Egyptian Museum CG 636, Borchardt, *op. cit.,* p. 185, pl. 117. The style, which Vandier, *op. cit.,* pp. 395–96, understood as influenced by the Middle Kingdom Delta style, evidently continues into the reign of Ramesses' successor: Sourouzian, *Les Monuments du roi Merenptah,* pp. 79–85, pls. 15, 16, and also very close is a statue from the Fayum: *ibid.,* pp. 107–109, pl. 19.

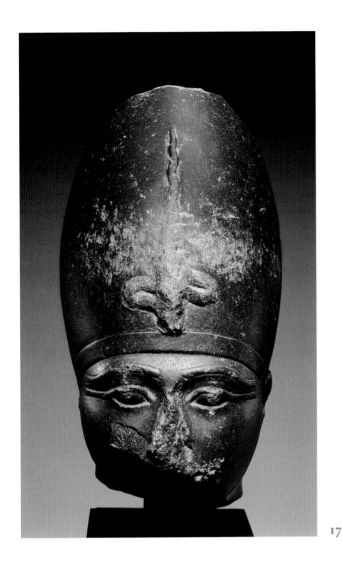

ing down the cheeks from the center of the ear tabs, indicate that he wore a false beard. The area around the eyes, though somewhat abraded, is in good condition. The slightly arched eyebrows, carved in low relief, follow the sharply modeled upper edge of the eye sockets. The inner ends of the brows are rounded; the outer ends, which nearly touch the frontlet at the sides of the head, are squared. Below the brow, the eyes are slightly inset and the crease of the upper lids has been delicately modeled. The eyes are rimmed along the top by thick cosmetic lines that extend back to the end of the eyebrows and are squared in a similar fashion. The eyeballs are rounded and cut back at the bottom so that the lower lids form a thick ledge.

Although the nose has been hacked off, the edge of the proper right nose wing and the outline of the left are visible. At the edge of the diagonal break along

17

17. Head of a king

DYNASTY 19, PROBABLY REIGN OF SETY I OR EARLY
RAMESSES II (1290–1213 BC)
BASALT
H. 26.7 CM.; W. 14 CM.; D. 16 CM.

THIS FRAGMENT IS FROM a statue of a king wearing the white crown of Upper Egypt.[1] The crown is fitted with a wide frontlet made in one piece with the ear tabs. A uraeus, its neck rising from the top of the frontlet, also decorates the front of the crown. The cobra's hood and head have been destroyed, and a wide band of pitting mars the smooth surface on either side of the snake's body. Similar damage has been inflicted on the king's neck below the proper left ear. Most of the lower third of the king's face is missing, but chin straps, carved in low relief and extend-

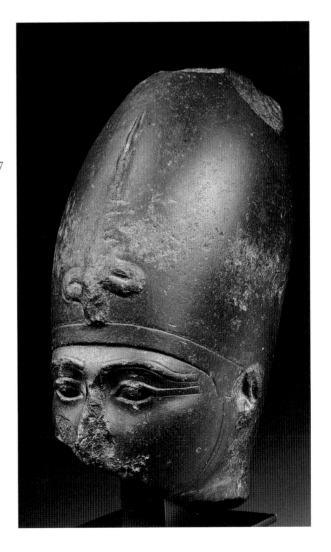

the lower portion of the face, a drill hole probably indicates the proper left corner of the mouth. Although the proper right ear is missing, the outline of the left ear is still clearly visible. There is no indication of the lower edge of the crown behind the ear, and the neck broadens markedly in this area. At the back, the large broken area along the head, neck, and crown indicates that the statue was supported by a back pillar or back slab.

During the New Kingdom, kings are most often shown wearing the *nemes* headcloth or the blue crown, and statues of pharaohs wearing the white crown are rare.[2] One interesting example carved in granite depicts a striding king in a coronation scene flanked by Horus and another deity.[3] Although the figures in this group are carved as separate, almost freestanding images, the king has a wide pillar behind his head that supports the forearms and hands of the two gods who touch his crown, as though they have just placed it on his head. The Thalassic fragment is roughly the same scale as this coronation statue, and it might have belonged to a similar group.[4]

The Thalassic head probably dates to the early Ramesside period. A number of features, including the shape of the ear, the treatment of the frontlet and chin strap, the closeness of the outer ends of the eyebrows to the frontlet, and the drill hole at the corner of the mouth, are similar to a fragmentary statue of Sety I in the Metropolitan Museum of Art.[5] However, these features are also found on a number of statues belonging to Ramesses II, and the head could represent either king.

CHR

BIBLIOGRAPHY

Sotheby's Antiquities, 9 July 1984 (London, 1984), p. 70, lot 186. *Sotheby's Antiquities, 11 December 1989* (London, 1989), p. 21, lot 51.

NOTES

[1] My thanks to Marsha Hill, who examined the head with me, making a number of very useful observations and comments.

[2] The best preserved examples are a colossal standing statue of granite in the British Museum (BM 61), identified as an image of Amenhotep II that was usurped by Ramesses II, see T.G.H. James, *Ancient Egypt: The Land and its Legacy* (Austin, 1988), fig. 95, p. 138; and a lifesize standing statue of basalt in Cairo (CG 42053) representing Thutmose III. There are also numerous representations of kings as Osiris, such as those decorating Hatshepsut's temple, but these are colossal representations intended to be integrated into temple architecture (whether engaged or freestanding), and are made of sandstone or limestone, not the hard dark stone of the Thalassic example. The Thalassic fragment probably does not represent Osiris himself, since the god seems not to have a uraeus on his white crown until later.

[3] This granite group is in Cairo (CG 629). It is inscribed with the name of Ramesses III, but may be usurped from an earlier king, see Matthias Seidel, *Die königlichen Statuengruppen* vol. I (Hildesheim, 1996), pp. 180–82, pl. 40.

[4] If the Thalassic fragment were part of a coronation statue, the hands of the gods would have to touch the crown somewhat farther back than in the Cairo statue, and it is certainly possible that the head belongs to a statue of a solitary king with a back pillar rising high enough to support the white crown.

[5] MMA 22.2.21, published in William C. Hayes, *The Scepter of Egypt*, Part II (Cambridge, 1959), fig. 210, p. 335. In this photograph, the head has been heavily restored. Clearer photographs may be seen in Victoria Solia, "A Group of Royal Sculptures from Abydos," *JARCE* 29 (1992), pp. 110–11, figs. 7–11.

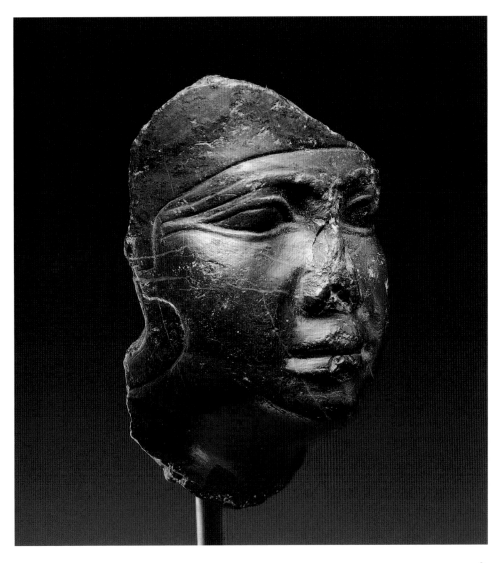

18. Royal head

LATE DYNASTY 25 (690–664 BC)
BROWN JASPER
H. 6.2 CM; W. 4.5 CM; D. 3.4 CM

DESPITE THE SMALL SCALE and fragmentary condition of this well-carved, expressive portrait, it is clearly the likeness of a Kushite king. The unusually large tab encircling a now-missing ear, securing the white crown, confirms the royal status of its subject. Only a small portion of the king's headdress survives on the right side of the head. The broad, fleshy face, largely intact, bears heavy features, including deeply-carved "Kushite folds" along the sides of the damaged nose. Long cosmetic lines extend from the outer corners of the prominent almond-shaped eyes, the eyebrows arching above them. Faint traces of the orbicularis oris muscle encircle the unsmiling, full-lipped mouth.

This portrait can be reasonably attributed to Taharqa, the penultimate king of Dynasty 25 (690–664 BC). The idiosyncratic features of the Thalassic head parallel distinctive images of that king in New York[1] and Cairo.[2]

JJ

NOTES

[1] On a fine faience *menat* weight in the Metropolitan Museum of Art 41.160.104, bequest of W. Gedney Beatty, l. 9.5 cm, see Richard Fazzini, *Egypt Dynasty XXII–XXV,* Iconography of Religions XVI, 10 (Leiden, 1988), pl. VI, 3; and a shabti figure, Metropolitan Museum of Art 18.2.10,

granite, h. 20 cm, see Karol Myśliwiec, "Das Königsporträt des Taharka in Napata," *MDAIK* 39 (1983), p. 152.

[2] The Egyptian Museum CG 560, granite, h. 36.5 cm; Mohamed Saleh and Hourig Sourouzian, *The Egyptian Museum Cairo: Official Catalogue* (Mainz, 1987), cat. no. 245.

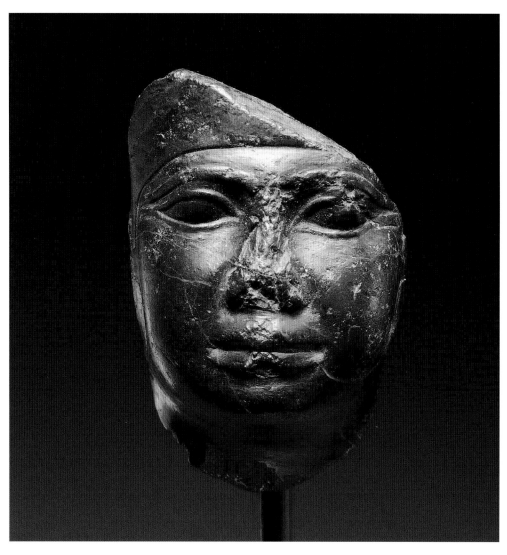

18

19. Recumbent sphinx

Dynasty 25 or 26 (760–525 BC)

BLACK GRANITE

H. 17.8 CM; W. OF BASE 10.7 CM; L. 37.2 CM

ONE IMAGE CAN SOMETIMES express as much as a good many words. This was certainly true of one icon of ancient Egyptian art, the sphinx, whose leonine body signifies power and whose combination of animal body and human head identifies its subject as other than human. Its general significance—not to mention its nuances of meaning of which we are now unaware—made the sphinx an appropriate means of depiction for some deities, as well as for a royal personage considered to be divine, to hold a divine office, or to play divine roles. The royal person in question was normally a king, but was not infrequently a queen or princess.[1] Large-scale sphinxes stood in pairs or greater numbers before temples and temple doorways,[2] and a smaller sphinx such as this may have been placed protectively by a doorway further back in a temple.

The Thalassic sphinx is an image of a king wearing the royal headcloth called *nemes*. The six notches above its tail give it an unusual articulated lower spine. The inscription on the chest between the forelegs includes two common royal titles. One is *netjer nefer*, normally translated "good god" or "perfect god" and which may characterize the king as "junior" to a greater god/gods.[3] The other title is "Lord of the Two Lands," namely Upper or southern Egypt, and Lower or northern Egypt. These titles are accompanied by a cartouche containing the name Psamtik. This claims the image for Psamtik I, II, or III of Dynasty 26 (664–525 BC) whose reigns were, respectively, 664–610 BC, 595–589 BC,

19

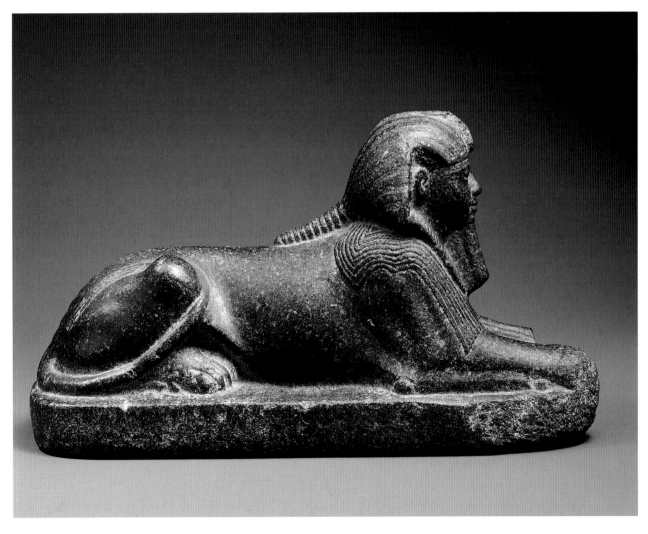

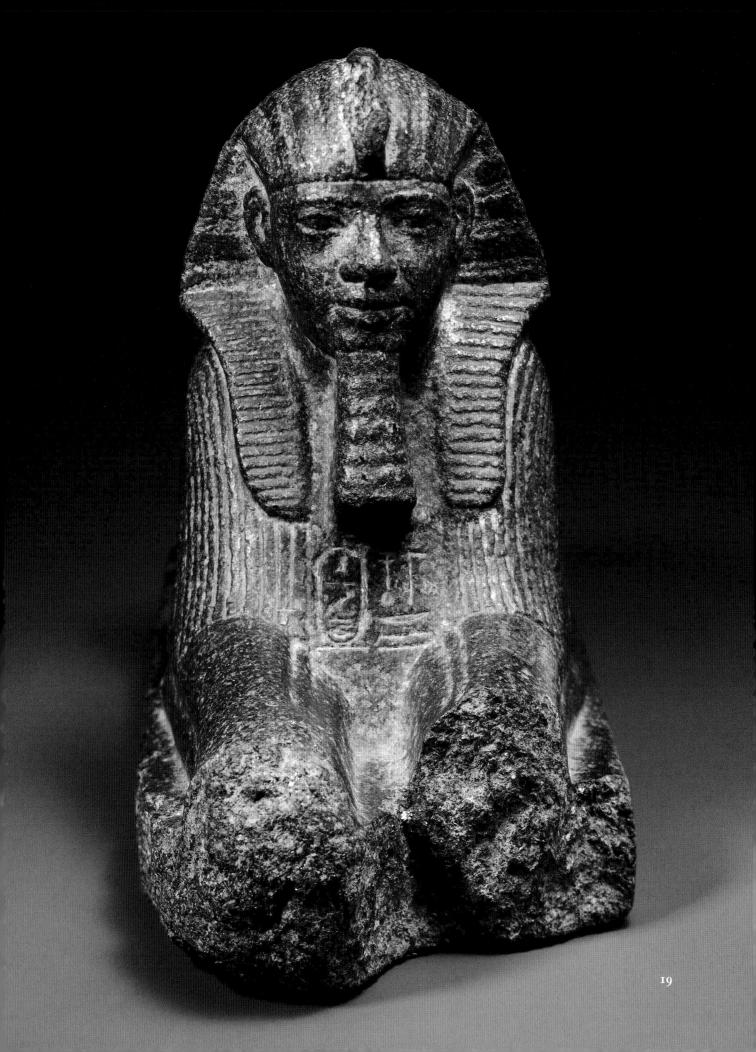

and 526–525 BC. However, even though there is no evidence to suggest that these texts replaced earlier inscriptions, the cartouche does not prove that the sculpture was originally made for any of those kings because it could simply have been added to a sculpture made earlier.

The style of the face and head of the Thalassic sphinx makes it safe to eliminate the reigns of Psamtik II and III from consideration as the time of its creation. By their reigns, the royal sculpture of Dynasty 25 had evolved in the direction of the elegant and idealizing, with horizontal brows, high-set eyes that are often narrow and slightly slanted, faces that can be long, and a curved lower lip that conveys the appearance of a slight smile.[4] Such features differ considerably from the physiognomy of the Thalassic sphinx, which has more in common with royal statuary of Dynasty 25. It is these differences in style, and some marks around the hood and body of the *uraeus,* that led to its interpretation as a work of Dynasty 25 made between about 716–660 BC, from the reign of King Shabaka to that of Tantamani, while the sphinx was on loan to the Museum of Fine Arts, Boston. There the curatorial staff's study of the piece led to the conclusion that, as with most images of the Kushite (Sudanese) kings of Egypt of Dynasty 25, it originally had two cobras on its *nemes* and that they were re-carved into the traditional single cobra for Psamtik I.[5] Unfortunately, although such a re-carving may have taken place, the evidence for it does not appear to be conclusive. More unfortunate is the fact that the corpus of closely dated Dynasty 25 three-dimensional images of kings that retain their heads is very small. And even the total number of sculptures with heads, or of which only heads are preserved, that are dated or attributable to Dynasty 25 is small, although the number has grown somewhat since the one overall study of such statuary.[6] All of this makes it difficult to attribute uninscribed heads to a specific reign, let alone to argue for such an attribution within the confines of an entry such as this. Here it will only be said that the Thalassic sphinx shares a sufficient number of stylistic traits—e.g., the broad and short face, broad nose and heavy mouth—with some works that are definitely of Dynasty 25 to make its attribution to that period possible. And these parallels would

be valid even if the sphinx had never had two cobras, because not every sculpture of Dynasty 25 kings had more than one uraeus.[7]

On the other hand, as the Thalassic sphinx may never have had a double uraeus, one must also consider another possible solution to the question of its dating. It could be a work of the reign of Psamtik I. To be sure, the very few three-dimensional royal faces that can be related to that king, including a statuette of Osiris in the Thalassic Collection (cat. 20), and the only other sphinx inscribed for the king which retains a head (Cairo, Egyptian Museum JE 36915 = CG 48630), resemble far more what is known from later in Dynasty 26 than they do the face of the

19

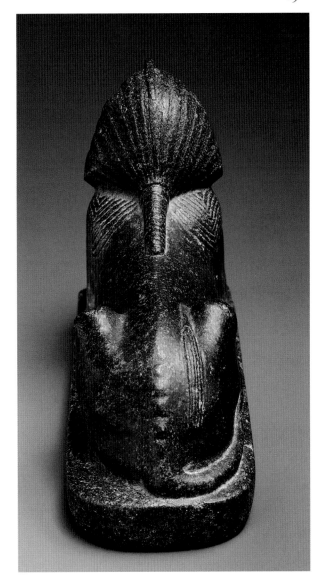

Thalassic sphinx.[8] On the other hand, at least at Thebes, it is difficult to differentiate between the facial features made during late Dynasty 25 and those made early in the long reign of Psamtik I,[9] and the same may have been true elsewhere.

Whether the Thalassic sphinx is a work of Dynasty 25 or early Dynasty 26,[10] it is one of a relatively few complete sphinxes of either era preserved, and a work of considerable art historical significance.

RF

NOTES

[1] For Egyptian sphinxes in general see Christiane M. Zivie-Coche, "Sphinx," in Wolfgang Helck and Wolfhart Westendorf, eds., *Lexikon der Ägyptologie* 5 (Wiesbaden, 1984), cols. 1139–47.

[2] For the placement of sphinxes see, e.g., Maya Müller, *Die Kunst Amenophis III. und Echnatons* (Basel, 1988), pp. III, 4–10.

[3] See, e.g., Stephen Quirke, *Ancient Egyptian Religion* (London, 1992), p. 38.

[4] See, e.g. Edna Russmann, [Statuary] "Kushite and Saite dynasties (c. 750–525 BC)," in J. Turner, ed., *The Dictionary of Art* 9 (London and New York, 1996), p. 889; and Jack Josephson, "Royal Sculpture of the Late XXVIth Dynasty," *MDAIK* 48 (1992), pp. 93–97.

[5] As indicated on the gallery label for the piece. Non-Dynasty 25 images of Egyptian kings are crowned with only one cobra, even though a pair of cobras is otherwise common in ancient Egyptian iconography and symbolic of a number of dualities, including that of Upper and Lower Egypt. Egyptologists still debate whether or not the double uraeus had come also to signify the Kushite homeland and Egypt.

[6] Edna Russmann, *The Representation of the King in the XXVth Dynasty* (Brussels, 1974). To the heads in stone listed there, add at least the following: (1) A statue of

a king before a ram: Richard Fazzini, "A Sculpture of Taharqa(?) in the Precinct of the Goddess Mut at South Karnak," *Mélanges Gamal Eddin Mokhtar* I, BdE XCVII, 1 (Cairo, 1985), pp. 293–306. (2) A head with the accession no. 1991.156 published in the *Cincinnati Art Museum. Annual Report, 1991–1992,* p. 27 (illus.). (3) British Museum EA 63833 previously dated to Dynasty 22–23 but with recognition of its Dynasty 25 stylistic features by Wilfried Seipel, *Gott. Mensch. Pharao. Viertausend Jahre Menschenbild in der Skulptur des Alten Ägypten* (Vienna, 1992), pp. 368–69, cat. 147. Independently attributed to Dynasty 25 by Patrick Cardon, Richard Fazzini, and Edna Russmann, the latter in Edna Russmann et al., *Eternal Egypt. Masterworks of Ancient Art from The British Museum* (New York, 2001), cat. 220 on pp. 223–25. (4) A head in the Thalassic Collection attributed to Dynasty 25 by Jack Josephson in the present publication (cat. 18). (5) A head from a sphinx in another private collection (to be published by Richard Fazzini). For a Kushite statue of a god recently discovered in the Southampton City Council Museum and attributed to the reign of Taharqa, see K. Wardley and V. Davies, "A New Statue of the Kushite Period," *Sudan & Nubia* No. 3 (1999), pp. 28–29, pls. XIV–XVII, and Renate Krauspe, *Das Ägyptische Museum der Universität Leipzig* (Mainz am Rhein, 1997), pp. 106–108.

[7] See, e.g., Russmann, *The Representation of the King*, p. 35.

[8] Jack Josephson, "A Portrait Head of Psamtik I?," in Peter Der Manuelian, ed., *Studies in Honor of William Kelly Simpson*, vol. 2 (Boston, 1996), pp. 429–38. The Thalassic sphinx also differs from the Karnak sphinx in lacking pleating on its *nemes*, being flatter in profile from side to side having a *uraeus*-cobra with undulating body.

[9] Jack Josephson and Mandouh Mohamed Eldamaty, *Statues of the XXVth and XXVIth Dynasties,* Catalogue Général of Egyptian Antiquities in the Cairo Museum, Nrs. 48601–48649 (Cairo, 1999), pp. iv–v.

[10] The present author will return to this question in *Aspects of Ancient Egyptian Art, Architecture, and Religious Iconography: Late Dynasty XX–Dynasty XXVI* (in progress).

20. Statuette of Osiris

EARLY DYNASTY 26 (650–640 BC)
DARK GREEN GRAYWACKE
H. 35.9 CM; W. 9.0 CM; D. 18 CM

OSIRIS IS SEATED on a low-backed throne enveloped in a long cloak covering his feet, a mummiform representation usually associated with that god. His left hand grasps a crook scepter, his right, a flail, or fly-whisk. An *atef* crown, composed of a white crown with a uraeus, flanked by feathers, covers his head.

A decorated back pillar rises from the top of the throne to the middle of the crown. The idealized face is short and round. Narrow, almond-shaped eyes, extended by cosmetic lines carved in plastic relief, are surmounted by curvilinear eyebrows reaching to the outer extremities of the cosmetic stripes. A plaited beard is attached by chin straps below the knobby chin. The figure is integral to a thick, rounded-front base engraved with inscriptions, including an offering scene and cartouches enclosing the prenomen of the first king of Dynasty 26, Waibre and his nomen,

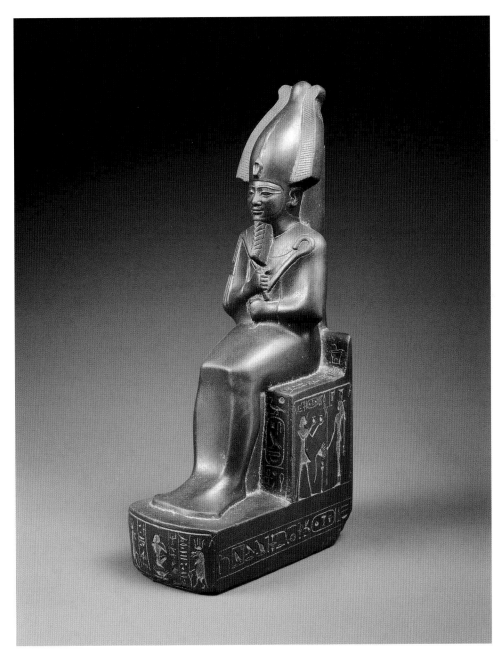

20

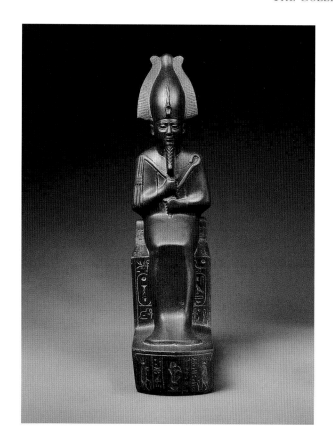

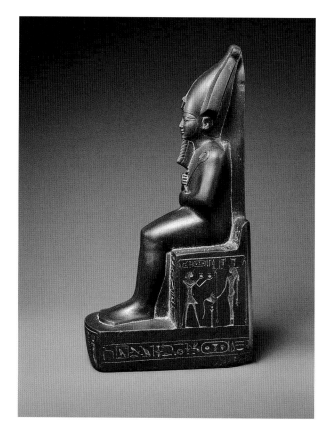

20

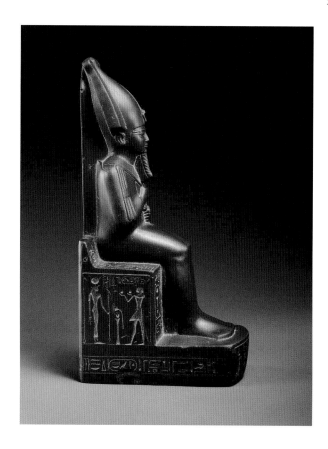

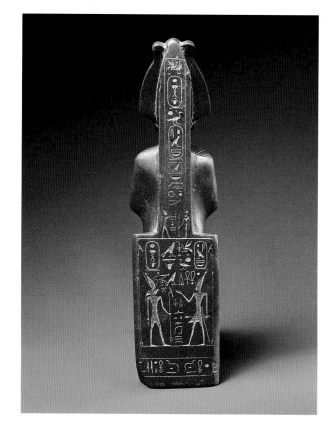

Psamtik. The throne bears additional offering scenes and the royal names. The inscription also refers to the city of Shendenu (Pharbaithos) in the eastern Delta, where the statuette probably was placed in a temple.

Rarely has an artifact from ancient Egypt survived in the near pristine condition of this beautifully carved statuette, its blemishes only a few small chips on the base. In a phenomenon described as "archaism," the Saite period, often referred to as a time of a "renaissance" of the arts, witnessed a return to the elegant style of statuary of Dynasty 18. This votive object can be accepted as a portrait of the reigning king, Psamtik I, and is certainly the product of a workshop of the highest caliber.[1]

The stick-like figures of the king and the gods in the offering scenes and misspellings in the text on the throne make it likely that they were added to the finished statuette in that provincial town. The text on the base, of higher quality, was probably inscribed in the workshop that produced the statuette. It is doubtful that this sculpture originated in the eastern Delta, but rather was carved in a royal workshop in a major center in Egypt. Its material suggests a Theban origin since graywacke, a favored stone in Dynasty 26, is found only in the Wadi Hammamat, a quarry located in the eastern desert, close to that city. Numerous high-quality graywacke Osiris figures are known to have originated in Thebes, but notwithstanding the material, the Thalassic statuette displays stylistic characteristics making a northern origin more likely. A study of Theban Osiris statues by Herman De Meulenaere and Bernard V. Bothmer details the iconography of Osiris figures from the Twenty-fifth and Twenty-sixth Dynasties.[2] They suggest that the position of the beard is a dating criterion, noting that the chin is partially or fully covered until the reign of Necho II.[3] The chin of the Thalassic statuette, surely earlier than Necho, is completely exposed. The straps securing the beard on the Thalassic figure are separate pieces, unlike the chin straps on early Dynasty 26 Osiris figures from Thebes on which only one side is delineated, imparting a cowl-like appearance to the crown. Furthermore, the face is considerably rounder and shorter than Theban examples. These characteristics suggest a non-Theban origin, and because the other major center of royal sculpture workshops during that time

was Memphis, it can be inferred that this ancient capital, closest to the Delta, was the probable location of the atelier in which the Thalassic statuette was carved. Due to the near total obliteration of monuments from the Saite Period in Memphis, examples of statuary from that city made in the Twenty-sixth Dynasty are virtually unknown, rendering comparisons to the New York figure very difficult. The discovery in the Karnak Cachette in 1903–04 of a large number of Theban sculptures revealed numerous examples of the southern style, but the scarcity of any from the north make the Thalassic statuette especially significant. Kushite influence evinced by this figure indicates a date early in the reign of Psamtik I, circa 650–640 BC.

The modern provenance of this statuette is particularly interesting. It was purchased from a thrift shop in 1926 where it had been anonymously donated. Taken to the Metropolitan Museum of Art for examination, it was recognized as authentic and placed temporarily on view, as a loan.[4] It subsequently disappeared from sight in a private collection until put up for auction at Sotheby's in 1992.

JJ

BIBLIOGRAPHY

Jack Josephson, "A Fragmentary Egyptian Head from Heliopolis," *Metropolitan Museum Journal* 30 (1995), pp. 7–8, fig. 3.

Idem, "A Portrait Head of Psamtik I?" in Peter Der Manuelian, ed., *Studies in Honor of William Kelly Simpson* Vol. 2 (Boston, 1996), pp. 436–37, fig. 7.

Jaromír Málek, *Topographical Bibliography of Ancient Egyptian Hieroglyphic Texts, Statues Reliefs and Painting* VIII, part 2, (Oxford, 1999), p. 1060, no. 802-038-380.

Sotheby's Sale Catalogue June 25, 1992, no. 31.

NOTES

[1] A common practice in Dynasty 18; see Arielle Kozloff and Betsy Bryan, eds., *Egypt's Dazzling Sun* (Cleveland, 1992), p. 178.

[2] "Une tête d'Osiris au Musée du Louvre," *Kêmi* 19 (1969), pp. 9–16.

[3] *Ibid*, p. 14.

[4] From departmental records at the Metropolitan Museum of Art. Dr. Marsha Hill kindly located a letter written Aug. 24, 1926 to L.S. Bull, then departmental curator, from the A.I.C.P. Opportunity Shop explaining the circumstances of the sale to Mr. Greener.

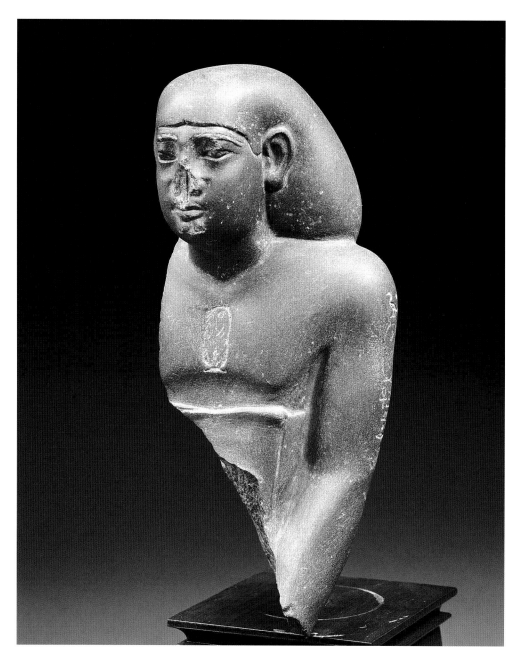

21

21. Priest or official

DYNASTY 26, REIGN OF NECHO II (610–595 BC)
GRAYWACKE
H. 22.2 CM; W. 9.0 CM; D. 9.0 CM

THIS OBJECT, its lower half missing, is the remainder of a standing statue originally holding a shrine, a pose common in Dynasty 26. On the chest is a partially erased cartouche, below which the top of a high skirt is visible. The left forearm is bent forward, but its hand, which would have grasped one side of the

shrine, is lost. The right side is sheared off below the shoulder. At the rear, a small part of a finely engraved back pillar unfortunately does not include the name of the subject. The well-modeled face, realistic for its time, and bag wig are intact except for the nose and right lower portion of the headdress. The latter has a cusp at its centerline, an unusual detail seen only in mid-Dynasty 26. Sculpted more than a half-century after the end of Dynasty 25, this fine statuette still retains some stylistic characteristics of that era, including a rather

fleshy face, "Kushite folds" along the nose, and a short, full-lipped mouth.

Unquestionably this object dates to the reign of Necho II, despite an attempt at erasure, presumably ordered by Necho's son, Psamtik II.[1] Enough remains of both the king's names to be quite secure in their reading. The chest bears the name Wehemibre, the arm, Necho.

JJ

NOTES

[1] See Nicolas Grimal, *A History of Ancient Egypt*, trans. by Ian Shaw (Oxford, 1992), p. 362.

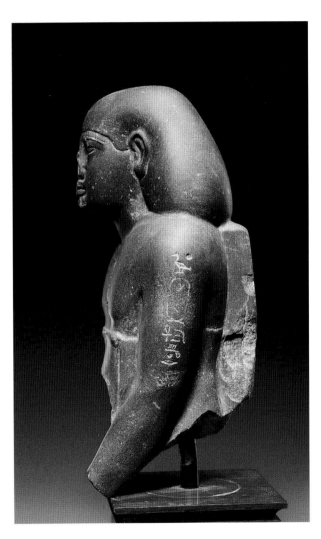

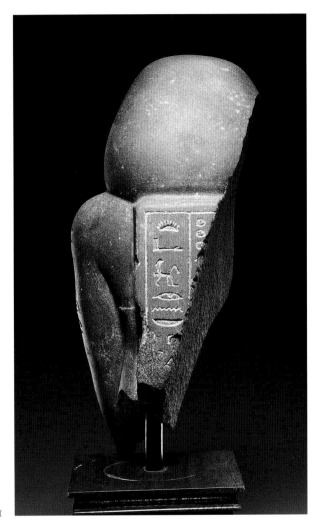

21

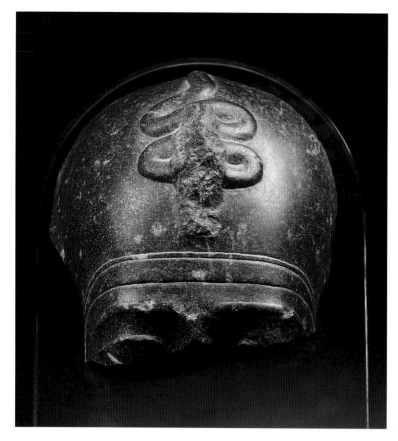

22

22. Fragmentary royal head

MID-DYNASTY 26 (610–570 BC)
GRANODIORITE
H. 23.5 CM; W. 20 CM; D. 14 CM

THE SURVIVING PORTION of this royal representation, consisting of the front of a blue crown, the forehead, and one nearly complete eye, demonstrates the outstanding craftsmanship achieved by artisans of the Saite Dynasty. The size indicates a statue somewhat larger than life, making it a relic of one of the largest royal sculptures known from Dynasty 26. The front of the partial blue crown bears a damaged and conspicuous double-loop uraeus, a form of this symbol common at this time. The head and hood of the cobra are missing. The almond-shaped right eye, with a short pointed cosmetic line, a plastically rounded upper lid, its lower lid mostly missing, and the forehead with slightly arched eyebrows are all that remain of the face.

A small number of comparative three-dimensional royal statues from this time are extant, the closest parallels to this object being a fragment in New York,[1] and two heads, in Paris and Bologna.[2] The three have been assigned dates ranging from the reign of Necho II to that of Apries. The Thalassic fragment is certainly of one of the three kings, including Psamtik II, who ruled between 610–570 BC.

JJ

NOTES

[1] The Metropolitan Museum of Art 1994.198, Lila Acheson Wallace gift, diorite, h. 30.2 cm: Bernard V. Bothmer, *Egyptian Sculpture of the Late Period, 700 B.C. to A.D. 100* (Brooklyn, 1960), cat. no. 51, p. 58, pl. 47, figs. 114–15.

[2] Louvre E 3433; graywacke, h. 36 cm: Lawrence Berman and Bernadette Letellier, *Pharaohs: Treasures of Egyptian Art from the Louvre* (Cleveland, 1996), pp. 78–79, illus.; Museo Civico 1801, graywacke, h. 40 cm: Jack Josephson, "Royal Sculpture of the Later XXVIth Dynasty," *MDAIK* 48 (1992), p. 94, pl. 16b.

23. Fragmentary head

MID-DYNASTY 26 (610–570 BC)
GRAYWACKE
H. 12.7 CM; W. 8.0 CM; D. 8.0 CM

THIS FRAGMENT OF A HEAD demonstrates the warm, satiny finish and fine detailing obtained by working graywacke that made this stone so popular with Saite sculptors. Only the right side of the face, bag wig, and the shoulder have survived. The features on this beautifully carved object are meticulously rendered, in particular the anatomically correct ear. The exaggeratedly slanted, almond-shaped eye is striking, and along with an accentuated high cheek bone, imparts an oriental cast to the face. A short, pointed cosmetic line extends from its corner, and a delicately arched, plastically rounded eyebrow surmounts it. A rather thin-lipped, organically rendered mouth, a hint of muscle above it, is mostly undamaged.

This object can be assigned to the reign of one of the three pharaohs who ruled Egypt between 610–570 BC, Necho II, Psamtik II, or Apries. Since this image was so thoroughly destroyed, it is tempting to opt for Necho II, whose son, Psamtik II, for reasons unknown, ordered the mutilation of his father's name and images wherever it might appear, including private statuary bearing his cartouche.[1]

JJ

NOTES

[1] See Nicholas Grimal, *A History of Ancient Egypt*, trans. by Ian Shaw (Oxford, 1992), p. 362.

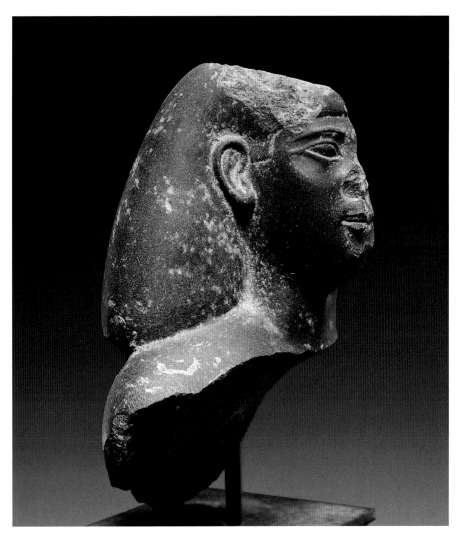

23

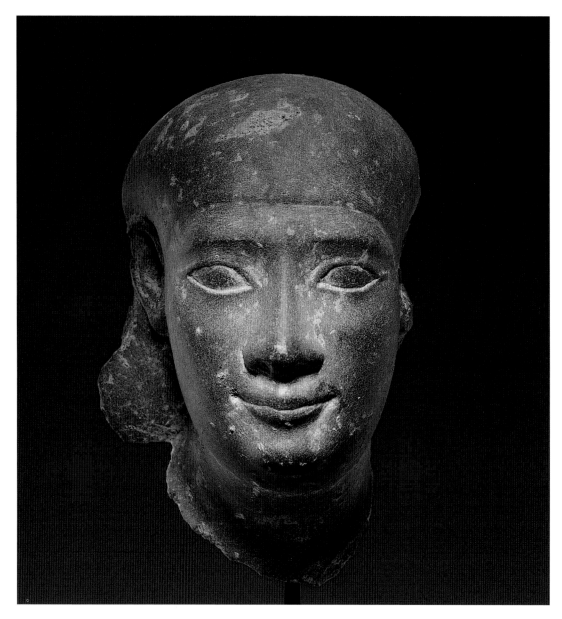

24

24. Head of a private person

MID-PTOLEMAIC PERIOD (LATE THIRD CENTURY BC)
GREYWACKE
H. 10 CM; W. 6.5 CM; D. 4.5 CM

PROBABLY THE REMAINDER of a standing statue, this well-preserved, idealized head, wearing a smooth, high-crowned bag wig, survives from the Ptolemaic Period (332–30 BC). It is carved in a stone used from the very beginning of the Egyptian Empire, but rarely employed in the Ptolemaic era. Numerous styles were in vogue during that era, including classical

Hellenistic, idealizing and realistic Egyptian, and various combinations drawn from both cultures. This head is sculpted in a pure Egyptian style. Its characteristics are found in the first half of the Greek domination, including the youthful idealized face, exaggeratedly large almond-shaped eyes with level natural eyebrows, a fine straight nose, and a sickle-shaped smiling mouth. The intact face displays little modeling. The top of the back pillar is missing, depriving the art historian of a potentially valuable dating criterion. A straight or trapezoidal apex would be expected on this

statue, the pointed, or semi-circular shape usually being associated with statues from the first century BC or AD.

This head is comparable to that of a standing statue of Pekher-khonsu, whose face and wig are similarly fashioned, and which Bothmer dates to the second half of the third century, an attribution also applicable to this head from the Thalassic Collection.[1]

JJ

NOTES

[1] Rosicrucian Egyptian, Oriental Museum no. 1583; diorite, H. 48.4 cm; Bernard V. Bothmer, *Egyptian Sculpture of the Late Period, 700 B.C. to A.D. 100* (Brooklyn, 1960), pp. 130–31, cat. no. 102, pl. 95, figs. 255–56.

25. Portrait of a priest

FOURTH CENTURY BC

WHITE QUARTZITE

H. 17.9; W. 10 CM; D. 17 CM

THE MAN IS PORTRAYED partially bald, a fringe of hair ringing the sides of his head in a fashion often associated with musicians of the goddess Hathor.[1] The lack of an inscription renders this identification uncertain, but he is assuredly a priest, the subject of most private statuary. The subject of this portrait was no ordinary priest. The size, material, and extraordinary workmanship of this sculpture testify to his wealth and importance. Pronounced modeling of the skull and the face indicate signs of age associated with the middle years. The eyes are small, deep-set under an overhanging brow, with long incised folds creasing their corners, and under them, conspicuous baggy pouches of flesh. The forehead is furrowed by bony or fleshy growths, highlighting its individuality. The small, down-turned mouth, with grooves indenting its corners, is slightly damaged, the nose mostly missing. The back of the head, where the dorsal pillar would have terminated, is sheared away.

The face is not only realistic and individual, but expressive as well. The impression imparted by this distinctive portrait is that of a dour, serious individual. At first glance, it could be a Hellenistic philosopher portrait. The white quartzite, with numerous black spots on its surface, employed in the making of the New York head, apparently is from a quarry in the vicinity of Memphis.[2] The quartzite, rarely used at that time, resembles the marble used in sculpture by the Greeks, and may have been a deliberate choice. Hellenistic influence was widespread in the Mediterranean region and there is little question that the Egyptians were aware of, and assimilated some of the features of this culture.

This realistically carved head has been attributed to dates ranging from the Middle Kingdom to the Ptolemaic Period, the last being generally accepted. A recent study by Jack Josephson, Richard Fazzini, and Paul O'Rourke has concluded that the sculpture dates from the fourth century BC, and is of Memphite origin.[3] Its style is influenced by Greek artistic conventions introduced by Hellenistic settlers who lived in Memphis during the reign of Nectanebo I (381–362 BC) and his successors. It is particularly unfortunate that the back pillar is missing, since one criterion for the attribution of these expressive heads to Dynasty 30 is a truncated triangle at its terminus in the occipital region of the skull.[4]

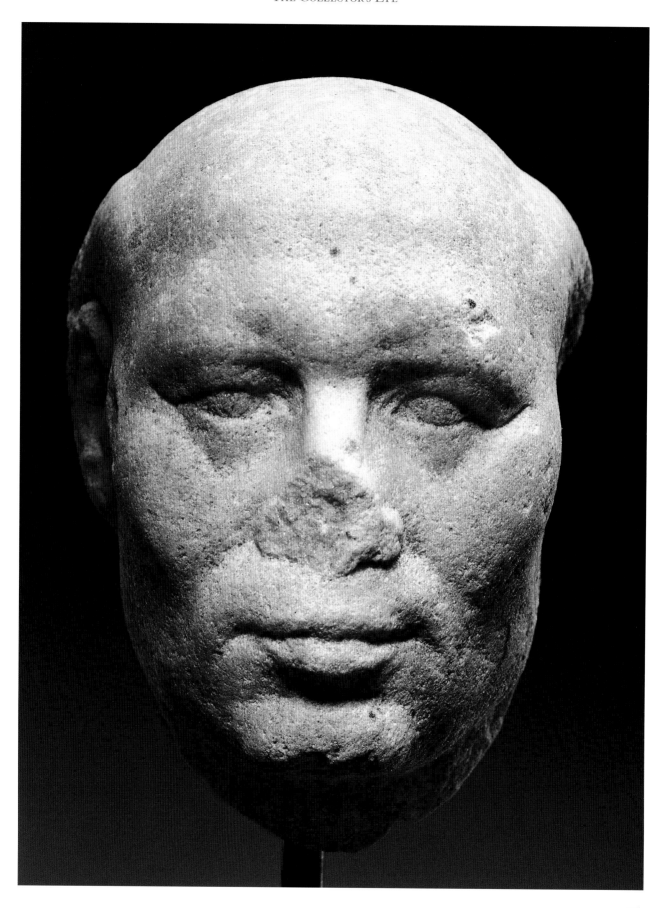

The Thalassic head belongs to a set of expressive, realistic portraits combining Greek and Egyptian idioms made during the final years of native rule, one of a group of the finest sculptural portraits from ancient Egypt, exemplified by the Berlin and Boston "Green Heads," and undoubtedly sharing a common date and site of origin.[5] It is the Berlin head, in particular, whose close resemblance to the New York sculpture is so persuasive of that mutuality. The strong visual correspondence and highly individualistic, undercut lower lips of both statues lead to the conclusion that they are from the same hand, a sculptor of extraordinary ability who has created a splendid, powerful portrait of this unknown priest from the Fourth Century.

JJ

NOTES

[1] See J.J. Clère, *Les chauves d'Hathor*, OLA 63 (Leuven, 1995), p. 3, figs. 1–3.

[2] Identified by George Wheeler, objects conservator at the Metropolitan Museum of Art, as a medium-grained quartzite, not well-metamorphosed, and close in appearance to material from Gebel Ahmar; see Rosemarie and Dietrich Klemm, *Steine und Steinbrüche* (Berlin, 1993), p. 288, fig. 333. Wheeler believed the black spots are the results of manganese inclusions affected by bacterial contamination.

[3] The study will be a forthcoming article in *JARCE*.

[4] *Supra*.

[5] Berlin, Ägyptisches Museum 12500, graywacke, h. 21.5 cm: Robert Bianchi et al., *Cleopatra's Egypt* (Brooklyn, 1988), p. 141, cat. no. 46; Museum of Fine Arts, Boston 04.1749, graywacke, h. 10.8 cm: Bianchi et al., *op. cit.,* p. 140, cat. no. 45.

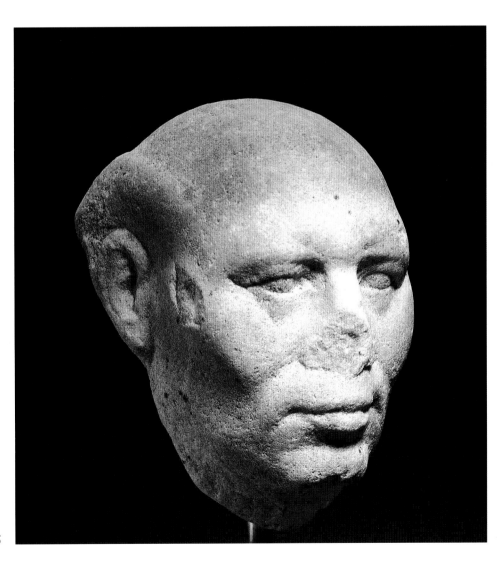

25

26

26. Head of a male votary

PTOLEMAIC PERIOD (SECOND–FIRST CENTURY BC)
GRANITE
H. 9.5 CM; W. 7.0 CM; D. 9.0 CM

As we expect Egyptian sculpture to be modeled in ideal terms and according to an eternal vision of youth, we are surprised by the occasional signs of age in Egyptian portraiture. Indeed, scholars often attributed such realism to the influence of Hellenism in Egypt. However, a stark realism was introduced in Egyptian private male sculptures, though not on female sculptures, from the seventh century BC onwards. The word "portrait" itself perhaps may be misleading, as many of the non-idealizing features are actually composed of a repertory of formulae, so that the heads can be organized sequentially in time by art

historians. These sculptures, like their idealizing predecessors, conformed to the proportions of the period, were frontal, and were usually provided with a back pillar.

The present hard stone head shows a mature balding man with curly hair and with strong furrowed forehead. His eyes are round and closely set together in deep orbitals under a pronounced rounded ridge of a brow. Gone are the plastically applied eyebrows, upper and lower lids and cosmetic stripes of the earlier pharaonic period. The nose is somewhat battered, the mouth is small and thin-lipped with slight nasolabial furrows. The cheeks lack bulk, and at the same time are missing a strong underlying bony structure. Although in some way naturalistic, with the strong slope of the brow to the outer corner of the eyes, there is a lack of pronounced detailing of the upper lids, and

further signs of age such as crow's feet at the corners or more pronounced naso-labial furrows. This may be due to the hardness of the stone, and its small scale, as the furrows of the forehead have the benefit of a greater expanse due to the receding hairline. The lack of these age details may also be due to a purposeful omission of formulae. The remnant of a trapezoid back pillar is evident at the back of the head, and this confirms the frontality and the absolute Egyptian nature of the figure. Such back pillars were introduced in Dynasty 27 in connection with shaven and not bewigged heads.[1] The figure could have been shown kneeling or standing, possibly presenting an offering or image of a deity, but it was not likely to have been represented sitting.

As was generally the case in pharaonic Egyptian art, private images mirrored the style of the reigning king. This was less so in the Late Period, when private portrait sculpture developed along a number of lines, independent of the monarch. Thus for example, private images could be highly polished idealized images sometimes with unreal egg-shaped pate, or they could range towards the highly veristic. The sculptural scope was possibly because these sculptures were votive ones, set up in temples, and in a sense almost competing to be noticed. The present head is a product of the Ptolemaic Period and actually reflects the Ptolemaic royal imagery on coinage, particularly in the closeness of the round wide eyes under the strong sloping brow.[2] The proportions of the features suggest a date within the second half of the Ptolemaic Period, but it would be unwise to hazard a more precise date within the period.

EV

BIBLIOGRAPHY

Christie's New York, May 30, 1997. Lot no. 49, p. 28.

NOTES

[1] Bernard V. Bothmer, *Egyptian Sculpture of the Late Period, 700 B.C. to A.D. 100* (Brooklyn, 1960), cat. nos. 65, 78, 83, 108.

[2] Robert S. Bianchi et al., *Cleopatra's Egypt: Age of the Ptolemies* (Brooklyn, 1988), cat. no. 61.

Composite elements

27. Fragments from composite statuary

A.

ROYAL BEARD
LATE DYNASTY 18 (1353–1292 BC)
EGYPTIAN BLUE
H. 6.0 CM; W. 6.5 CM; D. 1.8 CM

B.

FRAGMENT OF A LAPPET
LATE DYNASTY 18 (1353–1292 BC)
EGYPTIAN BLUE
H. 8.5 CM; W. 3.7 CM; D. 2.0 CM

LATE EIGHTEENTH DYNASTY sculptors sometimes fabricated statuary in pieces of contrasting materials.[1] This technique was especially popular during the reign of Akhenaten, the pharaoh who built an entire city in Middle Egypt within a brief period of time. Hundreds of statues of the royal family were needed to furnish the temple and palace complexes located in the city's center, as well as the numerous small shrines attached to private residences. Carving statues in sections reduced the time needed to meet the intense demand as skilled artists directed their energies toward the most challenging tasks. This was the case in the Amarna studio of the master sculptor Thutmose that was excavated by the Germans early in this century. In one section of the atelier, a group of extraordinary royal heads carved in hard stone was recovered,[2] while other areas of the workshop yielded small stone and faience fragments. Apparently, there was a division of labor in the studio, with the most talented sculpting royal heads and artisans providing embellishments such as inlays, crowns, and jewelry.

These fragments, made of a faience-like material known as Egyptian blue, were once part of composite statues[3] nearly lifesize in scale. The blue beard—an accoutrement of royal male figures—has two borings at the top, indicating that it was pegged in place. The lappet fragment, possibly from a male divinity,[4] would have been secured to the stone by an adhesive. The blue color may have been intended to imitate lapis lazuli, a stone associated with the gods.

YJM

NOTES

[1] For a discussion of composite statuary during this period, see Jacke Phillips, "The Composite Sculpture of Akhenaten," *Amarna Letters* 3 (1994), pp. 58–71.

2 For a description of the workings of the studio, see Dorothea Arnold, *The Royal Women of Amarna: Images of Beauty from Ancient Egypt* (New York, 1996), p. 41ff.

3 Although lifesize statues of faience are believed to have existed, the more common situation was the use of faience for wigs, crowns, etc. See Elizabeth Hastings, *The Sculpture from the Sacred Animal Necropolis at North Saqqara, 1964–76* (London, 1997), section A, pp. 3–4.

[4] Personal communication from W. Raymond Johnson to Peter Lacovara, 2000.

27

28A

28. Elements from composite royal figures

A.
BLUE CROWN
DYNASTY 18, REIGN OF AKHENATEN (1353–1336 BC)
FAIENCE
H. 9.6 CM; W. 10.9 CM; D. 9.6 CM.

B.
BLUE CROWN FRAGMENT
DYNASTY 18, REIGN OF AKHENATEN (1353–1336 BC)
FAIENCE
H. 8.5 CM; W. 8.4 CM; D. 5.8 CM.

C. THE JOSEPHSON WIG
QUEEN'S WIG WITH FILLET
DYNASTY 18, REIGN OF AKHENATEN (1353–1336 BC)
FAIENCE
H. 12.7 CM; W. 14 CM; D. 5.8 CM.

ARTISTS OF THE AMARNA PERIOD often created statues of the royal family in sections. This method was especially suited for statuary destined for the temples, palaces, and private shrines of Akhetaten (also called Amarna), the capital city built by the heretic pharaoh Akhenaten.

Located on an undeveloped site in Middle Egypt, Akhetaten was built in record time and the demand for royal representations was undoubtedly great. Master sculptors, such as the Overseer of Works, Thutmose, applied their considerable skills in producing life-like images of the royal family. Heads and limbs, recovered from Thutmose's studio by German excavators in 1912, were made of various stones, including limestone, quartzite, and granodiorite.[1] Several heads, such as the famous yellow quartzite head of Nefertiti, have tangs at the top that served as supports for crowns, presumably of different materials.[2]

The *khepresh*, or blue crown, has its origins in the Second Intermediate Period and was the favored crown of Akhenaten during his years at Akhetaten.[3] A limestone statuette of Akhenaten, discovered in one of the city's private residences, has a separate limestone crown with a frontal slot for a uraeus.[4] This crown, as well as the crown fragment, are made of blue faience and bear the typical circle decoration. They would have adorned similar sculptures.

The blue faience wig was made to decorate an image of the queen in high relief.[5] The depression encircling the head was most likely fitted with a fillet made of gold sheet. Similarly, the rectangular hole at the top was made to accommodate a crown of precious materials.

YJM

BIBLIOGRAPHY

Rita E. Freed, Yvonne J. Markowitz, and Sue H. D'Auria, eds., *Pharaohs of the Sun: Akhenaten, Nefertiti, Tutankhamen* (Boston, 1999), cat. nos. 63–64.

NOTES

[1] Dorothea Arnold, *The Royal Women of Amarna: Images of Beauty from Ancient Egypt* (New York, 1996), pp. 41–46.

[2] Rita E. Freed, Yvonne J. Markowitz, and Sue H. D'Auria, eds., *Pharaohs of the Sun: Akhenaten, Nefertiti, Tutankhamen* (Boston, 1999), cat. no. 42.

[3] *Ibid.*, cat. no. 63.

[4] Cairo JE 43580. See Mohamed Saleh and Hourig Sourouzian, *The Egyptian Museum, Cairo: Official Catalogue* (Mainz, 1987), cat. no. 160.

[5] Freed, Markowitz, and D'Auria, eds., *op. cit.*, cat. no. 64. See also Florence Friedman, ed. *Gifts of the Nile: Ancient Egyptian Faience* (Providence, 1998), cat. no. 26.

28C

28B

29. Skullcap as inlay

New Kingdom, possibly Ramesside Period,
(1292–1075 bc)
Faience
H. 19.8 cm; w. 21.1 cm; d. 4.0 cm

This unusually large bright blue faience skullcap, with a glossy surface and a sunk loop at the back for attachment, was clearly intended as an inlay into a lifesize composite relief figure of the god Ptah. Of all the Egyptian deities, only the patron god of craftsmen, who was always depicted in human form enveloped in a closely fitting garment, wore such a head covering, which was ideally colored blue.[1] The size of the inlay suggests it was for insertion into a sunk relief on a temple wall, perhaps in the god's chief cult place at Memphis. Certainly nothing of this type on a similar scale for inlaying is otherwise known.[2] The date is suggested by the technical achievements in the manufacturing of faience at the time and the adherence of the Ramesside pharaohs to the god.[3]

CA

Notes

[1] Compare for appearance the blue faience skullcap worn by the gilded wooden figure of Ptah from the tomb of Tutankhamen, illustrated in I.E.S. Edwards, *Treasures of Tutankhamun* (New York, 1976), pl. 22.

[2] Compare the Egyptian blue female wig for inlaying in Florence Friedman, ed., *Gifts of the Nile: Ancient Egyptian Faience* (Providence, 1998), p. 184, cat. no. 26.

[3] Five of the Ramesside kings bore the epithet "beloved of Ptah."

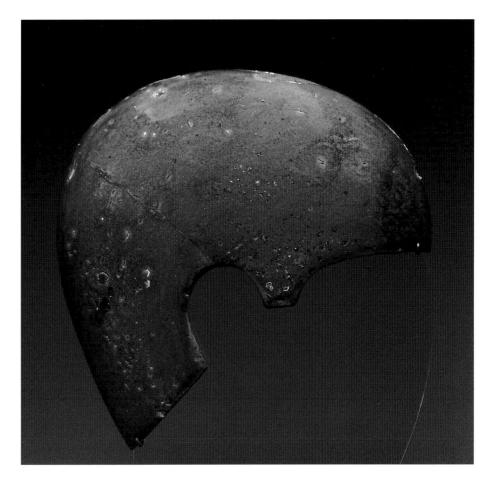

29

30. Uraei

A. COBRA HEAD
DYNASTY 18 (1539–1295/92 BC)
GLASS
H. 0.5 CM; L. 1.0 CM

B. COBRA HEAD
DYNASTY 18 (1539–1295/92 BC)
GLASS
H. 0.9 CM; L. 2.4 CM; W. 1.9 CM

C. URAEUS
LATE PERIOD (664–332 BC)
BRONZE, GOLD
H. 3.2 CM; W. 2.2 CM; D. 1.1 CM

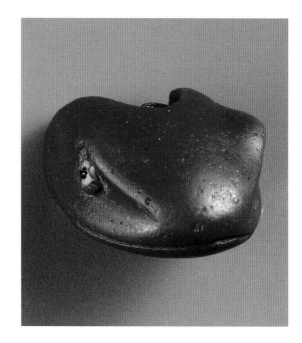

30A

IN ITS DISTINCTIVE, upright posture, the cobra (*Naja haje*) embodied aggression and inspired fear. As such, it became the symbol most readily associated with the king, protecting him and representing his protective capabilities. Diminutive uraei such as the glass heads probably adorned temple furnishings or votive offerings,[1] while the metal example may have decorated a headdress.[2]

The two cobra heads (A, B) with widely flaring eye sockets are formed of dark blue glass. The eyes, now missing, were inlaid in another material. The heads are U-shaped in back, with deep indentations that would correspond to tangs on hoods of a different material.

The small, solid-cast bronze uraeus (C) shows traces of gilding on the tail, head, and the raised outlines of the hood. The sections of the hood were inlaid with another material, possibly glass or semi-precious stones, now lost. Remnants of a tenon on the back indicate that the uraeus was inserted into another object, perhaps a headdress.

BTT

NOTES

[1] Compare to the much larger example in cat. 31, probably used in an architectural context.

[2] Günther Roeder, *Ägyptische Bronzefiguren* (Berlin, 1956), pp. 388–89, fig. 569. Peter Pamminger, *Ägyptische Kleinkunst aus der Sammlung Gustav Memminger* (Wiesbaden, 1990), cat. no. 41, p. 69.

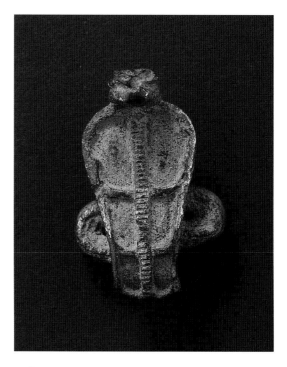

30C

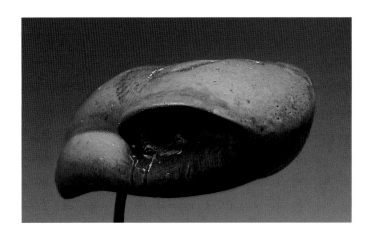

31. Cobra head inlay

New Kingdom (1539–1075 bc)
Glassy faience
H. 4.6 cm; w. 7.5 cm; l. 12 cm

The cobra (*Naja haje*), associated with royalty as early as the Predynastic Period, frequently occurred as an architectural element.[1] In later periods, cobras wearing solar disks appeared atop divine or royal shrines, often arranged in friezes. Tutankhamen's canopic shrine was adorned with a frieze of composite snakes, their faience heads attached to gilded wood bodies.[2]

This magnificent head, its eyes inlaid in another material, is significantly larger than those surmounting Tutankhamen's shrine, though it was likely employed in a similar manner. Since the back of the cobra is finished, it was probably mounted on top of, rather than inserted into, a frieze such as an example discovered at Amarna.[3] A solar disk, perhaps gilt or glass, would have crowned the serpent, attached by a metal tang inserted into a rectangular hole in the center of the head.[4]

BTT

Bibliography

Christie's South Kensington, April 21, 1999. Lot no. 39, p. 21.

Notes

[1] The earliest extant example of a stone frieze of cobras occurs in the Third Dynasty pyramid complex of Djoser at Saqqara; see Jean-Philippe Lauer, *Saqqara: The Royal Cemetery of Memphis: Excavations and Discoveries since 1850* (London, 1976), pl. 95.

[2] Dorothea Arnold, *An Egyptian Bestiary* (New York, 1995), cat. no. 48, p. 42.

[3] Rita E. Freed, Yvonne J. Markowitz, and Sue H. D'Auria, eds., *Pharaohs of the Sun: Akhenaten, Nefertiti, Tutankhamen* (Boston, 1999), cat. no. 73, p. 226.

[4] There is copper staining from the headdress and its mount on the top of the head, immediately behind the hole.

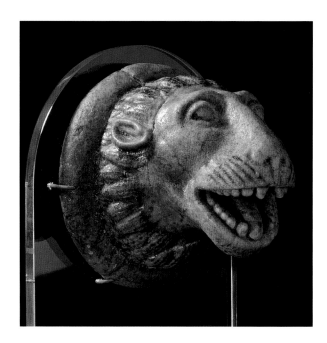

32

32. Lion protome
ROMAN PERIOD, CA. FIRST–SECOND CENTURY AD
FAIENCE
D. 9.5 CM; L. 9.4 CM

DURING THE GRAECO–ROMAN Period, luxury items such as vessels and decorative elements were frequently fashioned of faience. This bright turquoise lion head was probably intended to embellish a piece of furniture. The lion's head protrudes from a flat, solid disk, suggesting that it was set into, rather than mounted onto, another object. The whiskers, eyes, and mane are detailed in dark blue. Small, well-formed ears are flattened against the striated tufts of the mane. The lion is snarling, his parted jaws revealing carefully modeled fangs and tongue.

Lions (*Panthera leo*) frequently decorated Egyptian furniture, but were rarely depicted with open mouths. It has been suggested that the pose results from Persian influence, though open-mouthed lions were already attested during the Saite period.[1]

BTT

NOTES

[1] Lawrence M. Berman, *Catalogue of Egyptian Art* (Cleveland, 1999), cat. no. 340, pp. 439–40; Bernard V. Bothmer, *Antiquities from the Collection of Christos G. Bastis* (New York, 1987), cat. no. 18, p. 52; John Cooney, *Catalogue of Egyptian Antiquities in the British Museum*, vol. 4 (London, 1976), no. 335, pp. 37–38.

33. Inlay in the form of a human head
DYNASTY 30–31 (381–332 BC)
GLASS
H. 2.2 CM; W. 2.6 CM; D. 1.0 CM

THE USE OF GLASS inlays in the ornamentation of coffins, wooden shrines, and furniture begins in Dynasty 18. An exceptional example comes from the tomb of the chariotry-officer Yuya (KV 46), father of Queen Tiye, the principal wife of Amenhotep III. The inlays, which decorate the lid of Yuya's fourth coffin, are in the form of hieroglyphs made of turquoise, dark blue, and red glass. Other inlays of similar date are figural in nature, such as the intimate scene of Tutankhaten and Ankhesenpaaten featured on the back of the king's throne.[1]

The use of glass as an inlay material continues throughout the first millennium BC, even during those periods when core-formed glass vessel production declines.[2] Surviving examples of inlaid polychrome glass include a panel from a wooden shrine inscribed for King Amasis (570–526 BC),[3] a panel from a wooden shrine of Darius I (521–486 BC),[4] and the central panel from a shrine inscribed for Nectanebo II (362–343 BC).[5]

The second half of the fourth century BC experienced a revival of glass inlaying in sarcophagi following the tradition of Dynasty 18. It differs in that mosaic glass, a later development, is combined with monochromatic elements. The glass inlays from the mummiform coffin of the high priest Petosiris[6] and the Gliddon sarcophagus fragment in the Smithsonian[7] exemplify this combined technique.

This blue glass inlay in the shape of a frontally-presented human head was cast in an open mold and most likely represents the hieroglyph *her*, the ideogram in the word "face" or the preposition meaning "upon."[8] The complete sign includes a neck, missing from this small glyph. The face is highlighted, however, by white glass set into the eyes.

YJM

NOTES

[1] Mohamed Saleh and Hourig Sourouzian, *The Egyptian Museum, Cairo: Official Catalogue* (Mainz, 1987), cat. no. 179.

[2] David Frederick Grose, *The Toledo Museum of Art. Early Ancient Glass: Core-formed, Rod-formed, and Cast Vessels and*

Objects from the Late Bronze Age to the Early Roman Empire, 1600 B.C. to A.D. 50 (Toledo, 1989), pp. 83–84.

3 Royal Ontario Museum 969.137.2. See Robert Bianchi, "Those Ubiquitous Glass Inlays from Pharaonic Egypt: Suggestions about Their Function and Dates," *Journal of Glass Studies* 25 (1983), pp. 29–35.

4 British Museum 37496; *ibid.*, pp. 31–32.

5 Brooklyn Museum 37.258E. See Elizabeth Riefstahl, *Ancient Egyptian Glass and Glazes in the Brooklyn Museum*

(Brooklyn, 1968), no. 69, p. 109.

6 Saleh and Sourouzian, *op. cit.*, cat. no. 260.

7 Bianchi, *op. cit.*, p. 34.

8 An alternate explanation is that the inlay served as the face of a shabti figure, although the standard color for glass shabti faces (and hands) is red. See John Cooney, "Glass Sculpture in Ancient Egypt," *Journal of Glass Studies* 2 (1960), p. 27.

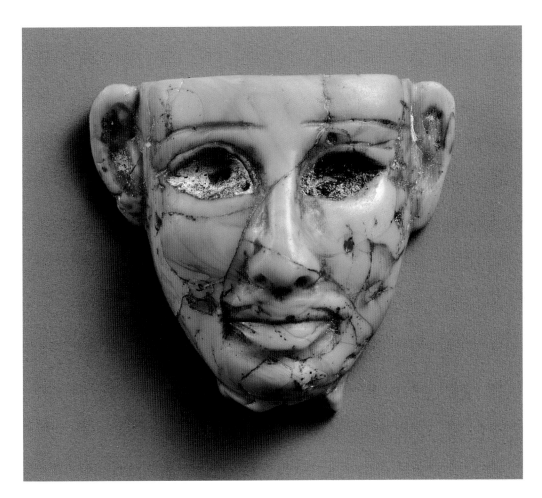

33

34. Royal inlay

DYNASTY 30–EARLY(?) PTOLEMAIC PERIOD (381–222 BC)
FAIENCE
H. 4.6 CM; W. 3.3 CM; D. 1.0 CM

THIS HEAD OF A KING in a dense turquoise-glazed faience is broken at the neck. The king wears a *khepresh* crown with a double-coil uraeus. A cobalt blue glaze has been applied to the crown with the complex decoration left in reserve: at the rear of the crown a falcon wearing the sun disk holds a *maat* feather in its spread wing and the *shen* sign in its talon, and small disks cover the entire surface. The king has a natural brow, almond-shaped eye, and prominent lower face with turned-up nose, sharply slanted smile, and round, slightly receding chin.

Traces of gilding may be seen on the upper surface of the inlay, some distance behind the head of the uraeus. A few apparently random grooves, perhaps setting marks or for adhesion, may be seen in the pale blue faience body exposed on the back of the piece.

Inlay of architecture and temple furniture with faience elements has a long history in Egypt. From the Late and Ptolemaic Periods, there are preserved examples of inlay elements for composite depictions as well as complete inlay figures.[1] Judging from the preserved spring of a shoulder, this royal inlay showed at least the entire upper part of a king's body, like a figure of a king very similar in size and general style said to be from Memphis,[2] and could have shown the entire figure of the king. He would have been kneeling or striding, and presumably making a gesture of offering or worship. The thick flat edges of the inlay suggest it fitted into a cell in a fairly thick matrix, possibly a wooden baldachin, a screen, or a shrine, which was then gilded.

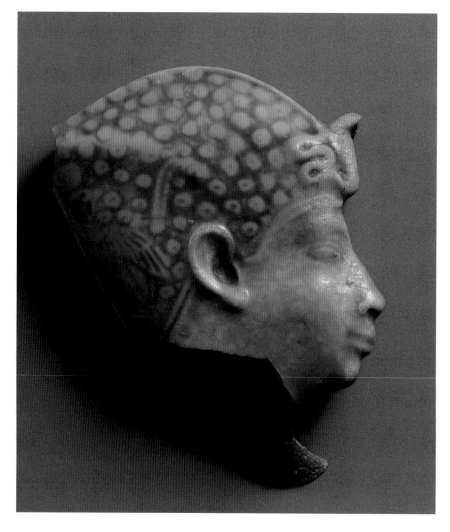

34

A date in the fourth century or Ptolemaic Period, based on the shape of the blue crown, its narrow frontlet, and facial features that have general parallels throughout the period, is clear.[3] Iconographic features offer little assistance for a narrower date. Chronological implications of the uraeus with two loops on the blue crown, a form once suggested to be associated in relief only with Nectanebo II, need further study. Identification of all clearly late images wearing a falcon on the back of the crown as Nectanebo II, famously constituting himself "the falcon," or as posthumous representations associated with his cult, is hardly valid, since the device has a long history and every king was identified with Horus.

Still, it may well be that this inlay and most of the known large inlays of this type—all of rather close style—are to be dated to the relatively restricted period of Dynasty 30 through the reign of Ptolemy III. One large group of these inlays referenced above contains elements that must be from the names of Dynasty 30 kings, and is said to be from Hermopolis Magna, a site where the Dynasty 30 kings undertook important building programs and which received significant attention still under Ptolemy III.[4]

MH

NOTES

[1] For a very large wig, a composite element, see Christine Insley Green, *The Temple Furniture from the Sacred Animal Necropolis at North Saqqara 1964–1976* (London, 1987), p. 24. Cairo JE 67980 and a large group of elements in the Metropolitan Museum of Art, acc. nos. 18.2.8–.9 and 26.7.991–.1010, are examples of complete or mostly complete figures; all these except MMA 26.7.1005–.1010 are said to be from Ashmunein/Hermopolis Magna.

[2] The Metropolitan Museum of Art, acc. no. 26.7.1006.

[3] See Robert S. Bianchi *et al.*, *Cleopatra's Egypt* (Brooklyn, 1988), p. 96 and note 3 for discussion of many of the issues of attribution and dating related to the iconography and style. Add Emma Brunner-Traut and Helmut Brunner, *Die Ägyptische Sammlung der Universität Tübingen* (Mainz, 1981), p. 44, for more on Tübingen 359, the three-dimensional king's head with a relief falcon on the back; photographs suggest the falcon may have held feathers, but this is nowhere mentioned. Relief plaque Leiden no. 241 (W.A. van Leer, *Egyptische Oudheden* [Ex Oriente Lux 3, Leiden, 1936], no. 3 and pl. 2) shows a falcon clearly holding feathers as here; the Leiden falcon emblem is even further elaborated and the crown has other significant emblems.

[4] Dieter Arnold, *Temples of the Last Pharaohs* (New York, 1999), *passim,* regarding Hermopolis Magna, and Tuna el-Gebel; and Dieter Kessler, regarding the same, *LÄ* 2 (1977), cols. 1137–1147 and *LÄ* 6 (1986), cols. 797–804, respectively.

35

35. Fist holding a cylindrical object

POSSIBLY OLD KINGDOM, DYNASTIES 5–6,
(2500–2170 BC)
LIMESTONE
L. 6.5 CM; W. (AT KNUCKLES) 3.6 CM; D. 2.2 CM

THIS FINELY CRAFTED FIST once belonged to a small statue of a standing man. The break, the lack of finishing on the inside of the palm, the size of the hand, and the care with which the fingers are executed indicate that it was originally part of the pendant right arm of a statuette. Carved out of limestone, the detailed and delicate execution of the nails, fingers and flesh folds suggest that this fragment may be of Old Kingdom date.[1]

Clasped within the fist is a cylindrical object that has been identified on standing statues as either a handkerchief,[2] a *Steinkern* or an emblematic staff.[3] Although it is often painted white, its identification with the handkerchief is no longer widely accepted.[4] A recent examination of this elusive shape has determined that it is to be understood as an object with its own separate use and development.[5] Although its exact nature remains undetermined, this cylindrical object is commonly found on male statues in the Old Kingdom, and as such, can be understood as a masculine attribute.[6]

MKH

NOTES

[1] Louvre AF 12409: Christiane Ziegler, *Les statues égyptiennes de l'ancien empire* (Paris, 1997), p. 235, cat. no. 74; MMA, New York 64.66.2: Henry G. Fischer, "An Elusive Shape within the Fisted Hands of Egyptian Statues," *MMJ* 10 (1975), p. 10, figs. 2–3; Egyptian Museum, Cairo, CG 77 and CG 145: Ludwig Borchardt, *Statuen und Statuetten von Königen und Privatleuten im Museum von Kairo* I (Berlin, 1911), p. 63, pl. 17; p. 106, pl. 32.

[2] Georges Perrot and Charles Chipiez, *Geschichte der Kunst im Alterthum: Aegypten*, translated by R. Pietschmann (Leipzig, 1884), p. 855, as a loop of cloth; and Fischer, *op. cit.*, pp. 14–15, as a handkerchief; Ziegler, *op. cit.*, p. 51, cat. no. 6, as a roll or handkerchief.

[3] Wilhelm Spiegelberg, "Der 'Steinkern' in der Hand von Statuen," *Rec. Trav.* 28 (1906), pp. 174–76; Bernard V. Bothmer, "A Wooden Statue of Dynasty VI," *BMFA* 46 (1948), p. 34; idem, "Notes on the Mycerinus Triad," *BMFA* 48 (1950), p. 15; Jacques Vandier, *Manuel d'archéologie égyptienne*, vol. III (Paris, 1972), p. 19; Krzysztof Grzymski, "Royal Statuary," in Dorothea Arnold et al., *Egyptian Art in the Age of the Pyramids* (New York, 1999), p. 53, who also notes it may be a handkerchief. However, as Fischer, *op. cit.*, p. 12, argues persuasively, the presence of an emblematic staff argues for the practice of symbolic abstraction, which is not supported in ancient Egyptian art.

[4] See for example recent catalogue entries in Dorothea Arnold et al., *op. cit.*, cat. no. 67, pp. 269–71; no. 68, p. 273.

[5] Albrecht Fehlig, "Das sogenannte Taschentuch in den ägyptischen Darstellungen des Alten Reiches," *SAK* 13 (1986), pp. 77–79.

[6] Christiane Ziegler, *op. cit.*, p. 235, cat. no. 74.

36. Crown of sun-disk and horns
Late Period (664–332 bc)
Gilt bronze
H. 4.0 cm; w. 3.5 cm

This delicate and detailed three-dimensional crown once adorned the head of a small bronze, or less likely, wooden figure of a female deity. A modius of rearing uraei forms the base of the crown from which the bronze horns extend, enclosing the hollow solar disk. Each uraeus has a raised vertical ridge that runs up the center of its body. Both the uraei and the sun-disk are gilt. A small tang extending from the bottom center of the crown demonstrates how it was originally affixed to a statuette.

While the crown of sun-disk and horns is commonly associated with the goddess Hathor, many female deities wear it, such as the hippo goddesses

Taweret[1] and Ipet,[2] and others. By far the greatest number of bronze statuettes that wear the crown, however, belong to Isis.[3] Accordingly, one suspects that this crown was most likely affixed to a figure of this goddess.

JLH

Notes

[1] See the amulet of Taweret in Carol Andrews, *Amulets of Ancient Egypt* (London, 1994), fig. 39; for a bronze statuette, see Günther Roeder, *Ägyptische Bronzefiguren* (Berlin, 1956), p. 407, pl. 58d.

[2] For an image of Ipet see Stephen Quirke and Jeffrey Spencer, *The British Museum Book of Ancient Egypt* (New York, 1992), fig. 61.

[3] For Isis suckling Horus in bronze and wood, *ibid.,* fig. 48; for standing and seated bronze Isis figures, see Roeder, *op. cit.,* pls. 33–36; for a drawing of the crown itself see figs. 290–91.

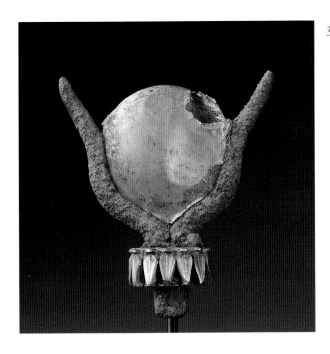

36

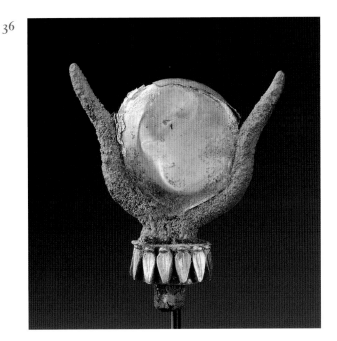

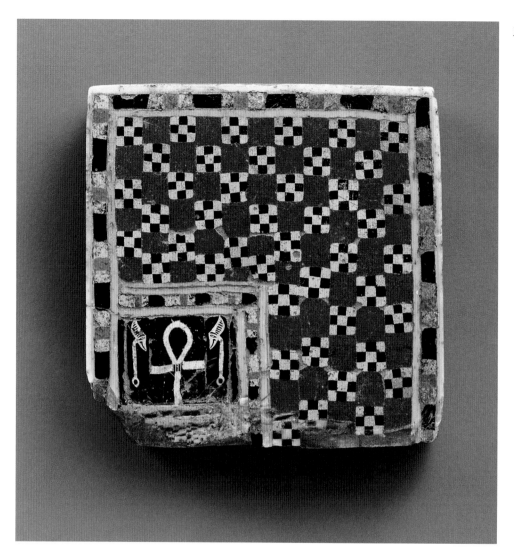

37

37. Inlay in the form of a throne[1]

FIRST CENTURY BC TO FIRST CENTURY AD
MOSAIC GLASS
H. 4.0 CM; W. 4.1 CM; D. 0.9 CM

Mosaic glass was a specialty of Ptolemaic and early Roman glassmakers. The first step in its fabrication entailed the manufacture of numerous glass canes of various colors. The canes were then arranged according to a specific pattern and cast in an open, one-piece mold.[2] The final step involved grinding and polishing with abrasives to create a jewel-like effect. Many of the inlays produced by this bundling and fusing method were delicate, complex constructions that were incorporated into larger compositions. For example, an image of a king inlaid into a wooden

shrine would be made in several parts—some monochrome, others polychrome mosaic glass.[3]

This colorful mosaic inlay fragment, backed with red glass, represents the profile of a royal or divine throne. The checkerboard pattern, composed of alternating squares of red with squares made up of nine small units of opaque white and dark blue glass, was a popular design motif during this period.[4] In the left lower corner is a central *ankh* hieroglyph flanked by *was* sceptres. The signs, composed of opaque white with yellow details, are embedded in a matrix of dark blue glass. Both this section and the outer frame are bordered by a decorative band outlined in opaque yellow glass.

Inlays of mosaic glass were often used to decorate wooden shrines, such as the Ptolemaic shrine from

Tebtynis that features a queen with an elaborate costume of mosaic glass.[5] They could also, on occasion, be set into walls.[6]

YJM

BIBLIOGRAPHY

Hermann A. Schlögl, *Le don du Nil: Art égyptien dans les collections Suisses* (Basel, 1978), p. 99, cat. no. 385.

NOTES

[1] Ex-collection of the Comptesse de Béhague (Paris); Kofler-Truniger Collection (Lucerne).

[2] For several examples of complex patterns formed by this method, see David Frederick Grose, *The Toledo Museum of Art: Early Ancient Glass: Core-formed, Rod-formed, and Cast Vessels and Objects from the Late Bronze Age to the Early Roman Empire, 1600 B.C. to A.D. 50* (Toledo, 1989), cat. nos. 621–23, pp. 360–61.

[3] For an example in the Brooklyn Museum, see Elizabeth Riefstahl, *Ancient Egyptian Glass and Glazes in the Brooklyn Museum* (Brooklyn, 1968), cat. no. 76, p. 110.

[4] For several "checkerboard" examples, including a *neb* basket, see Sidney Goldstein, *Pre-Roman and Early Roman Glass in the Corning Museum* (Ithaca, 1979), cat. nos. 608, 610, 651, and 751.

[5] Enrico Leospo, *La Vie del Vetro. Egitto e Sudan*, exhibition catalog (Pisa, 1988), cat. no. 8, fig. 8, p. 93.

[6] For an extraordinary mosaic glass fish used to decorate a wall, see Donald B. Harden, *Glass of the Caesars* (Milan, 1987), p. 31.

Architecture

38. Tiles

DYNASTY 3, REIGN OF DJOSER (CA. 2650 BC)
FAIENCE
AVG. L. 5.0 CM; W. 3.0 CM; D. 1.2 CM
SAQQARA, PYRAMID OF DJOSER

0 back 5 cm side

Individual tile drawing

THE STEP PYRAMID OF DJOSER at Saqqara is not only one of the most magnificent monuments to be found in Egypt, but represents the first use of stone masonry in building on a grand scale. Details found in perishable materials in earlier buildings were rendered in stone by the pharaoh's architects, under the direction of the legendary Imhotep.

A number of tombs of the first dynasties had substructures lined with reed mats, possibly to symbolize the fields of reeds in the next world.[1] The subterranean galleries of the Step Pyramid complex were decorated with over 35,000 tiles of pale blue-green color, to imitate grass hangings. The rectangular, convex tiles were set between horizontal bands carved into the limestone bedrock, imitating the ties that would have held the reed bundles together. At the back of each tile is a pierced projection. Presumably, the tiles would have been strung together, tied in place, and set with a fine gypsum mortar, traces of which can be seen on the edges of some of the tiles. Number strokes, possibly indicating placement, have been cut into the backs of some tiles, including several in this group. One of these tiles has an *ankh* carved into the back, perhaps an added wish for the king's eternal life. When in place below ground, the tiles must have sparkled in the torchlight, evoking the magical realm of the next world and the promise of rebirth. Similar tiles have been found in other sites of this period, but none approached the abundance of those found in the Step Pyramid.

PL

NOTES

[1] Florence Friedman, ed., *Gifts of the Nile: Ancient Egyptian Faience* (Providence, 1998), pp. 180–81.

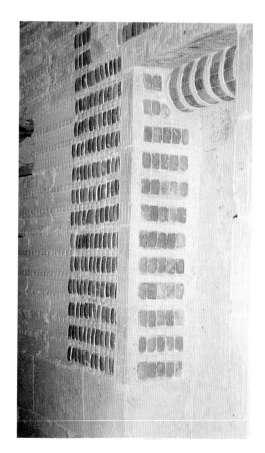

Tiles in situ in the South Tomb of the Step Pyramid complex at Saqqara

39

39. Grape cluster

LATE DYNASTY 18 (1390–1295/92 BC)
EGYPTIAN BLUE
H. 12.7 CM; DIAM. 6.3 CM

B UNCHES OF GRAPES are depicted in Egyptian art as hanging from kiosks shading the royal throne and in palace decoration as friezes along ceilings. Rather than actual fruit, imitations in faience and glass may well have served as more permanent architectural embellishments. Examples have been found with a number of different means of attachment, probably for specific uses. This particularly fine, three-dimensional example was meant to be free-hanging. The individual grapes appear to have been hand-formed separately and then pressed together before firing. A means of attachment would have been fitted through the hole in the top.

Such free-hanging elements may have been suspended from the beaks of duck heads, as found in the palace of Amenhotep III at Malqata.[1] These magnificent ornaments not only would have been beautiful decorations, but would have served to underscore the abundance at Pharaoh's command.

PL

BIBLIOGRAPHY

Rita E. Freed, Yvonne J. Markowitz, and Sue H. D'Auria, eds., *Pharaohs of the Sun: Akhenaten, Nefertiti, Tutankhamen* (Boston, 1999), cat. no. 75, p. 227.

NOTES

[1] Robb de P. Tytus, *A Preliminary Report on the Re-excavation of the Palace of Amenhotep III* (New York, 1903), p. 14, fig. 4.

40. Dovetail cramp of Sety I

Dynasty 19, reign of Sety I (1290–1279 bc)
Gray granite
L. 37.9 cm; w. 19 cm; d. 11.5 cm

From the Old Kingdom on, Egyptian builders connected wall blocks of temples, pyramids, and—more rarely—private stone buildings with dovetail cramps. The cramps were intended to prevent the movement of the blocks. The king's cartouche was often written on the surface, perhaps in order to magically increase the cramp's cohesive power.

Whereas wood was normally used for cramps, stone and metal are extremely rare. Inscribed stone cramps such as this example are only known from the so-called Osireion, west of the temple of Sety I at Abydos, a huge underground structure recalling the monumentality of Old Kingdom architecture and believed to be a symbolic tomb of the god Osiris. The cramps connecting the wall blocks and architraves of this building were made of granite and either inscribed with black ink, or beautifully sculptured with the name of Sety I. The cramps were cemented into corresponding sockets of the wall blocks, with the cartouche downwards, and their tops flush with the upper surfaces of the blocks thus linked together. The royal cartouches Menmaatre and Sety Meryenptah are preceded by the royal epithets *sa-Re* "son of Re," *netjer-nefer* "the young god" or by *neb-tawy* "the lord of the two lands."

Since the excavation of the monument in 1913/14, at least seven cramps of the Osireion have surfaced, in Abydos,[1] Berlin,[2] the British Museum,[3] the Egyptian Museum Cairo,[4] and on the international art market.[5] An unusually large specimen is in the British Museum, which is 53.3 cm (or about one Egyptian cubit) long. The other examples are smaller.

DiA

Notes

[1] Henri Frankfort, *The Cenotaph of Seti I at Abydos* (London, 1933), pp. 4, 17, 24, pl. 8 [1].

[2] Alfred Grimm, Sylvia Schoske and Dietrich Wildung, *Pharao: Kunst und Herrschaft im alten Ägypten*, exhibition catalogue Kaufbeuren (Munich, 1997), cat. no. 104.

[3] E.A. Wallis Budge, *British Museum: A Guide to the Egyptian Galleries (Sculpture)* (London, 1909), p. 159 [572].

[4] Seen by Di.A., unpublished.

[5] *Christie's Antiquities, 8 April 1998* (London, 1998), pp. 70–71, nos. 150–51.

40

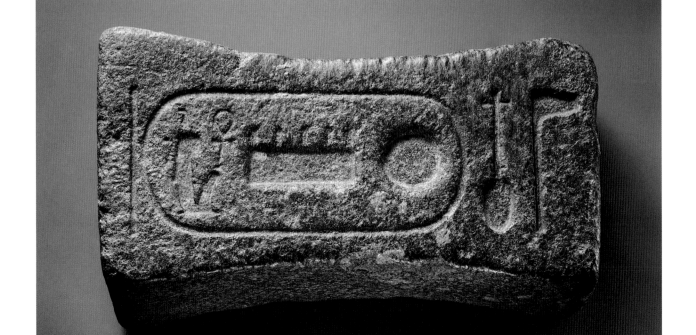

41. Foundation deposit elements

DYNASTY 19 (1292–1190 BC)

FAIENCE

A. PINTAIL DUCK: H. 2.2 CM; W. 2.8 CM; D. 0.4 CM

B. PINTAIL DUCK: H. 2.4 CM; W. 2.8 CM

C. HAUNCH OF BEEF: L. 3.6 CM; W. 1.5 CM; D. 0.9 CM

Groups of small faience birds, ox heads, legs of beef and plaques with the royal name were manufactured in great numbers and included as foundation deposits in royal building projects.[1] They symbolize actual food found as offerings in earlier monuments. Many of these items are associated with the names of Ramesses II, hardly surprising considering the vast amount of construction that was undertaken during his lengthy reign.

PL

NOTES

[1] Carol Andrews, *Amulets of Ancient Egypt* (London, 1994), p. 92.

41A, B, C

42

42. Model column

PTOLEMAIC PERIOD (332–30 BC)
FAIENCE
H. 14 CM; DIAM. 5.0 CM

MODEL BUILDINGS and architectural elements appear to have been given by the Pharaoh as presentation pieces at temple ceremonies.[1] The type of complex column capital represented on this piece was a development of the Persian and Ptolemaic Periods. With its more squat appearance and elaborate, articulated parts, it is an ungainly descendant of the elegant floral pillars of earlier dynasties. Examples of these supports can be found in sacred architecture of the Ptolemaic and Roman Periods, as for example in the temples of Philae, Kom Ombo and Edfu. While a wide variety of capitals have been classified, the details of this example are too summary to provide an exact identification.[2] The rather mottled appearance of the thick glaze layer indicates its late date of production, when the art of making faience in Egypt was in decline.

PL

NOTES

[1] Alexander Badawy, *A Monumental Gateway of Seti I* (Brooklyn, 1975).

[2] Maureen Haneborg-Lühr, "Les chapiteaux composites: études typologique, stylistique, et statistique," in *Amosiadés: Mélanges offerts au Professor Claude Vandersleyen par ses anciens étudiants* (Louvain, 1992), pp. 125–52.

Daily Life

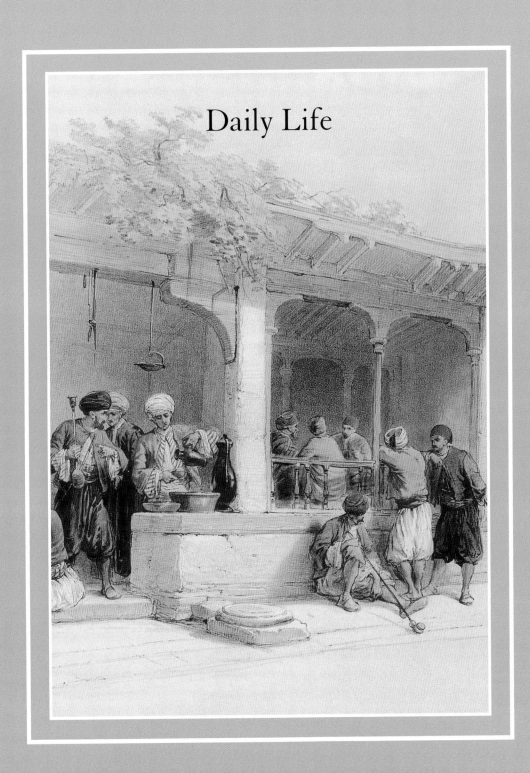

43. Papyrus burnisher inscribed for the Aten

Dynasty 18, reign of Akhenaten (1353–1336 bc)
Red quartzite
H. 1.8 cm; w. 5.0 cm; l. 6.1 cm

In addition to ancient Egyptian texts found on tomb and temple walls, numerous inscriptions survive on sheets of papyrus, the ancient world's premium writing material until the inventions of parchment (second century bc) and paper (first century ad). Several tools assisted the Egyptians in transforming papyrus from a marsh plant into a trusted writing medium.[1] The manufacturing process involved cutting the long papyrus stalks into strips and placing them in two layers, at right angles to each other. The Egyptians then pressed or pounded the two layers into a single sheet, the cell tissues or sap within the stalks serving as a bonding agent. Next, the sheet had to be rendered smooth enough to hold applied ink and pigment without bleeding or running. This was typically achieved with the smooth, flat surface of a burnishing tool.

The burnisher represented here fits snugly in the palm of the hand, its rounded edges allowing for a comfortable grip. The flat surface of the uninscribed reverse, and perhaps also the slightly rounded bottom, served as the burnishing surface. On the obverse, within two cartouches, or oval rings, that are positioned slightly off-center, the earlier form of the name of the god Aten, or sun's disk, appears in carefully incised hieroglyphs.[2] The text reads (right cartouche:) "May Re-Horakhty live, who rejoices in the horizon (left cartouche:) in his name of Shu, who dwells within the sun's disk."[3] Another burnisher was discovered by Howard Carter among a fairly complete set of scribal tools at Thebes from the late Second Intermediate Period or early New Kingdom.[4] A New Kingdom elliptical stone burnisher with convex sides, inscribed for the "*sem* priest and high priest of Ptah, Ptahmose," is in the Museum of Fine Arts, Boston.[5] But perhaps the best known papyrus burnisher, and certainly the most elegant, is the ornate ritual example with a long handle from the tomb of Tutankhamen.[6]

PDM

43

NOTES

[1] For more on the subject of papyrus and its manufacture, see Bridget Leach and John Tait, "Papyrus," in Paul T. Nicholson and Ian Shaw, eds., *Ancient Egyptian Materials and Technology* (Cambridge, 2000), pp. 227–53.

[2] For the Aten's names see Jürgen von Beckerath, *Handbuch der ägyptischen Königsnamen,* MÄS 29 (Berlin, 1984), pp. 86, 231; Rainer Hannig, *Großes Handwörterbuch Ägyptisch–Deutsch* (Mainz am Rhein, 1995), p. 1252.

[3] Additional examples of the cartouches appear on two orthostat slabs and a calcite plaque; see Rita E. Freed, Yvonne J. Markowitz, and Sue H. D'Auria, eds., *Pharaohs of the Sun: Akhenaten, Nefertiti, Tutankhamen* (Boston, 1999), pp. 231–32, cat. nos. 89–90, 93.

[4] Howard Carter and the Earl of Carnarvon, *Five Years' Explorations at Thebes. A record of work done 1907–1911* (Oxford, 1912), pl. 66; Richard Parkinson and Stephen Quirke, *Papyrus* (Austin, 1995), p. 34, fig. 19. A smaller set of scribal equipment was discovered by the Egyptian Expedition of the Metropolitan Museum of Art at Thebes; see Herbert E. Winlock, "A Set of Egyptian Writing Materials," in *BMMA* IX, no. 8 (August, 1914), pp. 181–82.

[5] MFA 72.789; cf. Edward Brovarski, Susan K. Doll, and Rita E. Freed, eds., *Egypt's Golden Age: The Art of Living in the New Kingdom 1558–1085 B.C.* (Boston, 1982), p. 286, cat. 395, and color illustration in Arne Eggebrecht, ed., *Ägyptens Aufstieg zur Weltmacht* (Mainz am Rhein, 1987), p. 130, cat. 37.

[6] I.E.S. Edwards, *Treasures of Tutankhamun* (New York, 1976), pl. 20, pp. 144–45, cat. no. 34.

44. Scribal palette

DYNASTY 19, REIGN OF RAMESSES II (1279–1213 BC)
PAINTED EBONY OR CEDAR
L. 37 CM; W. 4.0 CM (AS PRESERVED); D. 1.0 CM

THE PREVIOUS OBJECT (cat. 43) discussed the preparation of papyrus with a burnishing tool. Another essential piece of the literate Egyptian's equipment was the so-called scribal palette. This was a long, thin rectangular box, usually fashioned of wood, designed to hold reed pens and inkwells filled with solid cakes of red (red ochre) and black (carbon).[1] Other materials, such as ivory, stone, and faience, are also attested, often for model or ritual palettes,[2] and painter's palettes contain multiple inkwells for additional colors.[3] Palettes often appear in two-dimensional representations, in the hands of scribes at work, or accompanying the god Thoth, who records the results of the Egyptian equivalent of the last judgment scene: Spell 125 of the Book of the Dead, in which the deceased's heart is weighed against a feather of *maat* (truth).[4] The more elegant scribal palettes were inscribed with the names of their owners, sometimes including standard offering formulae and even the name of the reigning king.[5] Tabulations, economic accounts, scribbles and notes hastily added in cursive hieratic script on both front and back are likewise known.[6]

The Thalassic fragment displays portions of several ritual offering scene vignettes at the top, and three vertical offering formulae below. The carefully incised hieroglyphs, clearly New Kingdom in orthography, are filled with a yellow pigment, and vertical lines separate the columns of text. Frequently, such fragments remain the anonymous equipment of a forgotten individual. In this case, however, we fortunately have not only the name of the owner preserved three times at the bottoms of the columns, but the fragment may actually join additional pieces published in 1985.[7] While certain vignettes and inscriptions seem to form exact joins, other areas present restoration difficulties. The most likely conclusion is that we have fragments of (at least) two very similar palettes. Taken together, the fragments give us a firm date and provenance for the Thalassic piece: Theban tomb 296, built for the "king's scribe and deputy of the treasury of the lord of the two lands, Nefer-sekheru," during the second half of the reign of Ramesses II.

The Thalassic palette was inscribed on both obverse and reverse. The obverse, the more fragmentary side shown here (see 44b), preserves portions of the pigment from the red inkwell, perhaps part of the pen-holding slot in the center and, at the top, two images of Nefer-sekheru in elaborate, pleated garments. In both cases, he presents offerings—to Osiris on the left, and Thoth on the right, although both

figures appear only on the additional fragments from tomb 296.[8] Between the two images a vertical caption reads: "the Osiris and scribe, Nefer-sekheru, justified." Towards the bottom of the piece, the end of a vertical column in the lower left reads: "… Nefer-sekheru, justified in the West."

Turning now to the reverse (44a, and the hypothetical reconstruction, 44c), we learn from the tomb 296 fragments that a total of four vignettes show Nefer-sekheru again in prayerful pose with upraised arms, wearing an ankle-length garment. He stands before the deities, from left to right, Isis, Wenen-nefer (a form of Osiris), Re-Horakhty, and Ptah-Sokar. In each instance, Nefer-sekheru's figure is oriented with the inscription immediately below; when he faces right, so do the hieroglyphs (two left columns), and when he faces left, the signs again follow suit (two right columns). Above all the figures stretches the long horizontal *pet* sign, the hieroglyph for the heavens. As an example of one complete line of the inscription, hypothetically restored from both the Thalassic and tomb 296 fragments, the outermost right-hand column below once read (44c):

> [*Theban tomb 296 fragment, black hieroglyphs:*] An offering that the king gives to Ptah-Sokar, the great god who dwells in the necropolis, and to Anubis, the august one, foremost of the divine booth, and all the gods for eternity. May [*Thalassic fragment, red hieroglyphs:*] they grant all good and pure offerings consisting of bread, beer, oxen, fowl, libations, wine, and milk for ever and ever for the *ka* of the king's scribe, true of voice, his beloved, greatly praised of Wenen-nefer, Nefer-sekheru, justified and honored.

As the owner of an extremely elegant tomb in the Theban necropolis, Nefer-sekheru was one of the elite officials of the Ramesside era. His scribal palettes are clearly works of superior craftsmanship, despite some peculiarities of hieroglyphic syntax and spelling, that must have served him well in tending to his administrative duties. By depositing such equipment in his tomb, those who survived Nefer-sekheru deemed it worthy of accompanying him into the next world.

PDM

44A
reverse

44B
obverse

NOTES

[1] A good sampling of palettes is illustrated in S.R.K. Glanville, "Scribes' Palettes in the British Museum, Part I," *JEA* 18 (1932), pp. 53–60; and in Edward Brovarski et al., eds., *Egypt's Golden Age; The Art of Living in the New Kingdom 1558–1085 B.C.* (Boston, 1982), pp. 284–85, cat. nos. 390–92; Mohamed Saleh and Hourig Sourouzian, *The Egyptian Museum Cairo: Official Catalogue* (Mainz, 1987), cat. nos. 233 (two scribes' palettes). See also above, cat. no. 43, note 4. I am grateful to Henry G. Fischer for assistance with textual reconstructions, and to Hourig Sourouzian and Erika Feucht for their help from Cairo and Luxor.

[2] For a wood example showing the slot for the pens, cf. Arne Eggebrecht, ed., *Ägyptens Aufstieg zur Weltmacht* (Mainz am Rhein, 1987), pp. 130–31, cat. 38. A green slate palette is discussed in William C. Hayes, *The Scepter of Egypt* II (New York, 1959), pp. 274–75, fig. 168, and by Ludlow Bull, "A Group of Egyptian Antiquities," *BMMA* 27 (1932), pp. 130–31, fig. 1. For a mudstone model scribal palette with inlays of semiprecious stones for inkwells and ten glass model pens stuccoed to the palette, see Richard Parkinson, *Cracking Codes. The Rosetta Stone and Decipherment* (London, 1999), p. 146, cat. 60. Ivory palettes are illustrated in I.E.S. Edwards, *Treasures of Tutankhamun* (New York, 1976), pl. 20, pp. 144–45, cat. 34, and in Brovarski, Doll, and Freed, *op. cit.,* pp. 284–85, cat. 391. For a blue faience palette, cf. *ibid.,* pp. 284–85, cat. no. 392.

[3] Examples of painter's palettes with multiple colored inkwells include *ibid.,* pp. 287–89, cat. nos. 398–99; for color illustrations, see Eggebrecht, *op. cit.,* p. 135, cat. no. 44; Lawrence M. Berman, *Catalogue of Egyptian Art* (Cleveland, 1999), p. 57, fig. 24, pp. 311–12, cat. no. 249; Saleh and Sourouzian, *op. cit.,* cat. no. 234.

[4] For an example from a Fifth Dynasty Saqqara tomb, see William Kelly Simpson, *The Offering Chapel of Sekhemankhptah in the Museum of Fine Arts, Boston* (Boston, 1976), pl. 14a and foldout pl. D. For the Book of the Dead scene, cf. Herman te Velde, "Funerary Mythology," in Peter Lacovara, Sue D'Auria, and Catharine H. Roehrig, eds., *Mummies And Magic: The Funerary Arts of Ancient Egypt* (Boston, 1988), pp. 30–31, fig. 16.

[5] See Glanville, *op. cit.,* esp. pls. VI.3, VIII.1, 4.

[6] *Ibid.,* pls. IV.2–3, VII.2, and IX.1–4; William Kelly Simpson et al., *The Literature of Ancient Egypt,* second edition (New Haven and London, 1973), fig. 5; and Berman, *op. cit.,* p. 313, cat. no. 250.

[7] Erika Feucht, *Das Grab des Nefersecheru (TT 296),* Theben 2 (Mainz am Rhein, 1985), pp. 142–44, pls. 41, 66; Bertha Porter and Rosalind L.B. Moss, *Topographical Bibliography of Ancient Egyptian Hieroglyphic Texts, Reliefs and Paintings* 1, *The Theban Necropolis,* Part I. *Private Tombs,* second edition (Oxford, 1960), pp. 377–79.

[8] For the obverse, cf. Feucht, *op. cit.,* pp. 142–43, pls. 41, 66 (left), fragments A1 and A2.

44c *Hypothetical reconstruction of reverse palette fragments (red hieroglyphs = text preserved on Thalassic fragment)*

45

45. Black-topped jar

PREDYNASTIC PERIOD, NAQADA IIIA (3500–3100 BC)
CERAMIC
H. 37.8 CM; DIAM. 21.7 CM

THIS VESSEL ILLUSTRATES the degree of aesthetic skill already developed by artisans in the Nile Valley in remote, prehistoric times. Made by hand from Nile mud, this vessel had a coating of a fine, iron-rich clay applied to the surface as a slip that was then rubbed with a pebble to produce a glistening, shiny finish. The pot was fired in a simple kiln made of stacked fuel, with its mouth down in the ashes. When fired, the ash sealed the top part of the vessel from contact with oxygen and fired the surface black. The iron in the surface above the ashes oxidized and turned red.

This effect must have happened by accident at first, but clearly was intentional by this period. The pleasing color combination may have evoked Egypt's two main geographies, the "black land" of the Nile Valley and the "red land" of the surrounding desert. Vessels of this type are found in Upper Egypt and Lower Nubia, indicating the close connection between these two culture areas. They also occur in both settlement sites and in graves as offerings to the dead. Such a finely crafted and well preserved specimen was most likely a part of the tomb equipment. Its carefully made, rolled rim dates it to the beginning of the last developmental phase of the Predynastic Period.

PL

46. Fragment of an eyepaint tube

DYNASTY 18, REIGN OF AMENHOTEP III (1390–1353 BC)

EGYPTIAN BLUE

H. 9.0 CM; DIAM. 2.1 CM

Eye makeup was worn by both sexes in ancient Egypt to enhance appearance, avoid glare, and prevent eye disease—a persistent problem in that region of the world.[1] Green eyepaint was made from ground malachite, while black eyeliner was obtained from lead ore (galena). The powdered minerals were stored in small vessels in a variety of shapes and would have been mixed with water and/or resin before use.[2]

During the New Kingdom, a popular eyepaint container was the flute-shaped tube made of wood, ivory, or faience. The use of a form based on a musical instrument was most likely intentional, as Hathor, goddess of love and beauty, was also associated with dance and music. Often incorporated into the tube's design was a thin stick, thickened at one end to facilitate application of the paint.

Several faience examples of flute-shaped tubes, dating to the reign of Amenhotep III, bear the name of the king along with that of his chief royal wife, Queen Tiye.[3] This purple-blue fragment, inlaid with white faience, represents the lower two-thirds of one such tube. The inscription reads, "(The good god, lord of the two lands), Nebmaat(re) (and) the king's wife, Tiye, every day."

YJM

NOTES

[1] The active medicinal agents in green and black eyepaints were obtained from copper and antimony. See J. Worth Estes, *The Medical Skills of Ancient Egypt* (Canton, MA, 1993), pp. 109–12.

[2] Michal Dayagi-Mendels, *Perfumes and Cosmetics in the Ancient World* (Jerusalem, 1993), p. 36.

[3] For a similar tube from the Soprintendenza Museo Antichità Egizie, Turin, Italy (no. 6236), see Arielle Kozloff and Betsy Bryan, eds., *Egypt's Dazzling Sun: Amenhotep III and His World* (Cleveland, 1992), p. 400, cat. no. 102. Another vessel, gray-blue faience inlaid with pale green paste, is in the Hearst Museum of Anthropology, University of California, Berkeley (5-2100); cf. Edward Brovarski, Susan K. Doll, and Rita E. Freed, eds., *Egypt's Golden Age: The Art of Living in the New Kingdom, 1558–1085 B.C.* (Boston, 1982), p. 222, cat. no. 277.

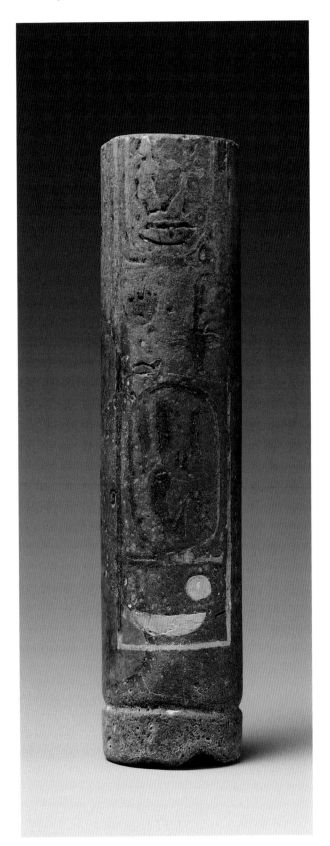

46

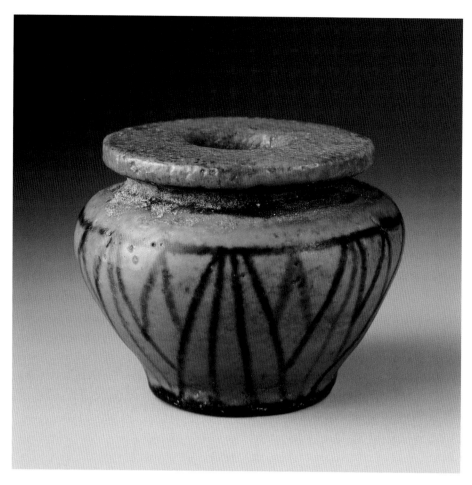

47

47. Cosmetic pot
DYNASTY 18 (1539–1295/92 BC)
FAIENCE
H. 3.5 CM; DIAM. 5.0 CM

SMALL, SQUAT VESSELS to hold powdered eye-paint called kohl were produced in large numbers in the Middle and New Kingdoms. The eye-paint held in these containers was often galena or another lead ore, but sometimes was simply black soot. A stick with a rounded end would be dipped into the round opening and then traced around the eyes and brows by both men and women. The liner would have protected the eyes from the glare of the sun, as well as enhanced the facial features.

Such vessels usually had disk-shaped lids with a plug to seal the hole at the top, and the squat shape would have prevented the spilling of the contents. This copper-blue faience example is ornamented with lines drawn in manganese purple–black to represent an open blue lotus flower. The lotus, which closes up at night and blooms anew each day, had powerful rebirth symbolism, and as such was an appropriate decoration for a type of vessel that was a frequent tomb offering. However, the rejuvenating function of the cosmetics suggest that such a vessel could have been appropriate for the living as well as the dead.

PL

48. Top of a cosmetic vessel

PTOLEMAIC–ROMAN PERIODS (332 BC–AD 642)
STEATITE
H. 4.2 CM; DIAM. 4.0 CM

THIS FRAGMENTARY, but appealing, small sculpture depicts a man seated on three human faces and clutching a hare. It belongs to a class of Late Period cosmetic vessels and figurines that depict the god Bes holding animals and seated or standing over human heads, apes or other versions of Bes.[1] This very human form of Bes must belong to a period well after he had already been syncretized with Dionysus. His ample torso squashing the heads beneath him harks back to images of Pharaoh dominating the enemies of Egypt. By the Graeco-Roman Period, this motif had come to symbolize mortal man's victory over death.[2] This deity and other figures depicted on similar objects are usually shown holding a small wild animal. The hare, not often encountered in Egyptian art, was revered as a fecundity symbol in Classical mythology.[3] The style of the composition suggests a very late date, probably in the later Roman Period.

PL

NOTES

[1] Jeanne Bulté, *Talismans égyptiens d'heureuse maternité* (Paris, 1991).

[2] Lorelei Corcoran, *Portrait Mummies from Roman Egypt* (Chicago, 1995).

[3] Dorothea Arnold, *An Egyptian Bestiary* (New York, 1995), p. 23.

48

49. Container in the form of a pregnant woman

DYNASTY 18 (1539–1295/92 BC)
CALCITE ("EGYPTIAN ALABASTER")
H. 14 CM; W. 9.0 CM; D. 9.0 CM

THIS EXQUISITELY CRAFTED small container belongs to a group of calcite vessels dating to Dynasty 18 that were fashioned in the shape of a pregnant woman. In this example the woman is depicted kneeling. The circular, flat-rimmed opening of the vessel is placed at the top of the head. A handle, now broken, ran from the back of the rim to the middle of the upper back. The long, thick hair is drawn back behind the shoulders into a single mass that terminates in a depiction of a hanging lotus flower.

The woman holds a container in the form of a horn on her lap. Such containers, usually used for medicines, were originally made from an animal horn, but the shape was also imitated in other materials, such as pottery and faience. The narrow end of the horn was pierced and sometimes shaped into a spoon for dispensing the liquid placed in it. In this vessel, the depiction of the horn vessel reinforces the medicinal role of the container, of which it is a part. It is thought that these vessels may have held oil used to massage the stomach of pregnant women in order to ease the tautness of the skin and help prevent stretch marks.

GR

BIBLIOGRAPHY

Sotheby's, New York, Important Antiquities from the Norbert Schimmel Collection, Sale Catalogue December 16, 1992. Lot no. 90; Sotheby, Wilkinson and Hodge, London, *The Mac-Gregor Collection of Egyptian Antiquities, June 26–July 3 1922,* no. 1003; Margaret A. Murray, "Figure Vases in Egypt," *Historical Studies,* British School of Archaeology in Egypt 1911, pl. 24, no. 47.

49

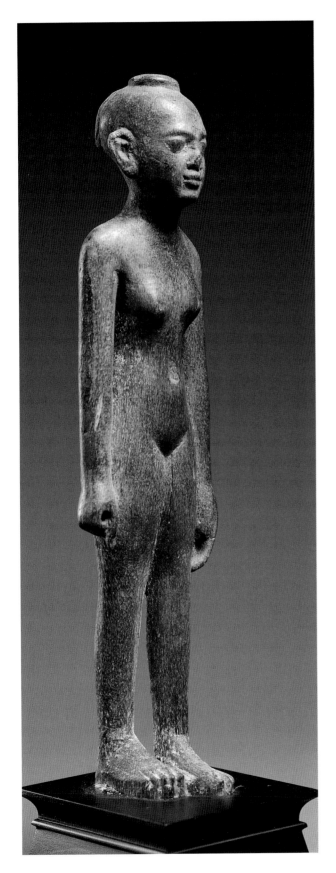

50. Statuette of a nude girl

Dynasty 18 (1539–1295/92 bc)
Wood
H. 17.7 cm; w. 4.8 cm; d. 3.7 cm

This small wooden statuette of a young girl belongs to a type common in the second part of Dynasty 18, especially during the reign of Amenhotep III. The elongated head is shaven except for a circular tuft of hair on top, from which a broad, short lock falls halfway down the back of the head, a hairstyle associated with Nubians, but popular among young Egyptian women in the Eighteenth Dynasty. The slight, taut breasts are delicately modeled, and the waist is high and slim. The navel is indicated by a depression at the top of the flat stomach, beneath which the pubic triangle is clearly marked. The figure stands in a frontal position with both arms hanging by the sides; the left hand is open and the right is clenched. The hole pierced in the fisted hand suggests it may originally have held an object. The feet are placed so that the left foot is very slightly in advance of the right. Although figures of this sort are often incorporated into cosmetic items, decorating spoons or carrying pots for eye make-up, or serving as mirror handles, the image of a nude, adolescent girl symbolizes notions of sexuality, fertility, birth, and rebirth into the next world.

The lack of any attachments to extraneous parts, with the exception of a hole in the fist of this statuette, suggests that it may have been a sculpture in and of itself rather than a decorative element. It may have been similar in style and function to a tomb statuette of the young boy Amenemheb now in the Metropolitan Museum of Art.[1] The subject there, also nude, holds a lotus in his fist and was found along with a statue of his brother in their mother's coffin and dedicated by their father.[2]

GR

Notes
[1] William C. Hayes, *The Scepter of Egypt* II, *The Hyksos Period and the New Kingdom (1675–1080 B.C.)* (New York, 1959), pp. 60–61.
[2] This identification was already suggested by Cyril Aldred in a letter dated August 26, 1982. Theodore Halkedis, personal communication.

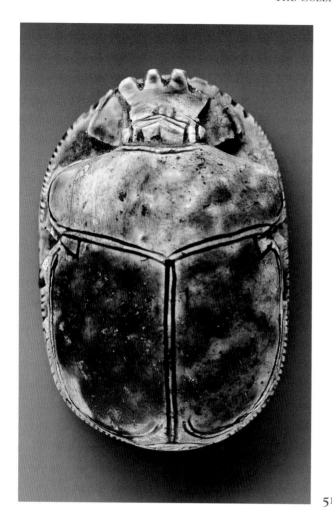
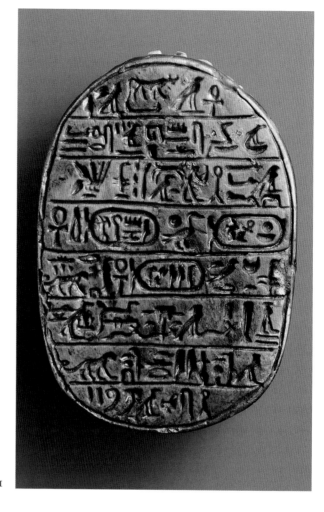

51

51. "Lion Hunt" scarab of Amenhotep III

Dynasty 18, reign of Amenhotep III (1390–1353 BC)
GLAZED STEATITE
L. 6.8 CM; W. 4.7 CM; H. 2.5 CM

DURING HIS LONG and prosperous reign, Amenhotep III issued a series of large commemorative scarabs with texts inscribed on the underside. These inscriptions, often described as propagandistic in nature, pay tribute to the king's prowess, achievements, and might. More than 200 of these scarabs are known, many recovered from sites both in and outside Egypt.[1] Five varieties have been identified, each memorializing an important event in the life of the king: his marriage to Queen Tiye, the wild bull hunt, the lion hunt, the arrival of Princess Gilukhepa (daughter of Mitanni King Shuttarna II), and the creation of an artificial lake for Queen Tiye.

The most common scarab in the series (more than 100) was issued during Amenhotep III's tenth regnal year and celebrates the lion hunt. The king, long identified with the lion, is described as having personally killed a total of 102 lions over a ten-year period. The text translates as follows:

(1) The living Horus: Strong bull appearing in truth; (2) the Two Ladies: establishing laws, pacifying the two lands; (3) the golden Horus: Great of valor, smiting the Asiatics; king of Upper and Lower Egypt; (4) Nebmaatre, son of Re: Amenhotep, ruler of Thebes, given life; (5) the great royal wife Tiye, may she live. Number of lions (6) taken by his majesty by his own shooting, (7) beginning from year one until year ten: (8) fierce lions 102.[2]

The commemorative scarabs of Amenhotep III are best understood within the context of the period, an age of internationalism and peaceful diplomacy. It was a time of empire-building and Egypt's sphere of

influence extended deep into Nubia and northeast to the Euphrates. Amenhotep III had declared himself a god on earth and managed the extreme ends of the empire with skilled diligence. The scarabs, many of which were presented as diplomatic gifts, validated his position as a world leader.[3]

<div align="right">YJM</div>

BIBLIOGRAPHY

Joyce Haynes and Yvonne Markowitz, *Scarabs and Design Amulets: A Glimpse of Ancient Egypt in Miniature*, nfa auction catalogue, New York, December 11, 1991.

NOTES

[1] They have been found as far south as Soleb (Sudan) and in western Asia (Syria); see Arielle Kozloff and Betsy Bryan, eds., *Egypt's Dazzling Sun: Amenhotep III and His World* (Cleveland, 1992), pp. 67–69; C. Blankenberg-van Delden, *The Large Commemorative Scarabs of Amenhotep III* (Leiden, 1969), pp. 166–68.

[2] Text translated by Joyce Haynes. See Joyce Haynes and Yvonne Markowitz, *Scarabs and Design Amulets: A Glimpse of Ancient Egypt in Miniature*, nfa auction catalogue (New York, December 11, 1991), cat. no. 115.

[3] For a discussion of international relations during the reign of Amenhotep III and his successor, see Timothy Kendall, "Foreign Relations," in Rita E. Freed, Yvonne J. Markowitz, and Sue H. D'Auria, eds., *Pharaohs of the Sun: Akhenaten, Nefertiti, Tutankhamen* (Boston, 1999), pp. 157–61.

52. Faience vessel fragments

A.
BOWL FRAGMENT WITH THE NAMES OF AMENHOTEP III AND QUEEN TIYE
DYNASTY 18, REIGN OF AMENHOTEP III (1390–1353 BC)
WHITE FAIENCE INLAID WITH BLUE FAIENCE
H. 5.2 CM; W. 3.8 CM; H. 1.0 CM

B.
VESSEL FRAGMENT WITH THE NAMES OF ATEN AND AKHENATEN
DYNASTY 18, REIGN OF AKHENATEN (1353–1336 BC)
WHITE FAIENCE INLAID WITH BLUE FAIENCE
H. 2.6 CM; W. 3.0 CM; D. 0.5 CM

LATE EIGHTEENTH DYNASTY FAIENCE was innovative on two levels. First, new colors were added to the traditional blue, black, and white; and second, sophisticated methods of manufacture were developed. One technique involved the inlaying of faience in complementary or contrasting colors into a hand-modeled, core-formed, or molded faience body. Once air-dried, the faience with its inlays was fired in a kiln. Depending upon the degree of moisture in the body prior to inlaying, the finished product would appear either painterly or with a distinct separation outlining the inlay.[1]

52A

52B

During the reigns of Amenhotep III and his son Amenhotep IV (later Akhenaten), faience vessels bearing the names of the royal couple—and in the case of Akhenaten, the name of the king and his god Aten—were among the luxury goods produced in royal faience workshops. The use of white as a background color may have been an allusion to silver, which the Egyptians called "white gold."[2] It is doubtful, however, that such items were used in daily life. In all likelihood, they were awarded to members of the court on special occasions or in appreciation for services rendered.[3]

YJM

Notes

[1] Paul T. Nicholson and Ian Shaw, eds., *Ancient Egyptian Materials and Technology* (Cambridge, 2000), pp. 182–83.

[2] For a fine example of white faience inlaid with blue hieroglyphic text, see Florence Friedman, ed., *Gifts of the Nile: Ancient Egyptian Faience* (Providence, 1998), cat. no. 24, p. 184.

[3] For an example of an inlaid faience vessel fragment featuring gazelles and floral motifs, *ibid.*, cat. no. 25, p. 184.

53. Alabastron

Persian Period, reign of Xerxes (485–465 bc)
Calcite ("Egyptian alabaster")
H. 33 cm; diam. (max.) 18 cm

The alabastron is a vessel that was so frequently made of calcite, or travertine, that it lent its name to the material, which was later confused with a fine-grained, white gypsum quarried in the Mediterranean region.

Precious commodities such as perfumed oils and unguents were contained in vessels such as these because the non-porous material could hold valuable liquids that would leach out of pottery containers over time. Alabastra ranged in size from tiny specimens a few centimeters high to enormous examples that would be difficult for several men to lift. Their distinctive shapes were also copied, in pottery as well as in faience and glass, by the Egyptians and throughout the Mediterranean world.

This particular example is inscribed with the name of the "Great King" Xerxes, in Old Persian, Elamite, Babylonian and Egyptian hieroglyphs, to indicate the far-flung empire of the Persians. It is one of several inscribed versions known.[1] Its slender, cylindrical form is typical of the period, as are its unpierced, projecting lug handles with dangling aprons. It would have contained some precious commodity that was carefully secured with a plaster seal, of which traces remain on the rim and neck.

PL

Notes

[1] Gerry D. Scott, *Egyptian Art at Yale* (New Haven, 1986), p. 145.

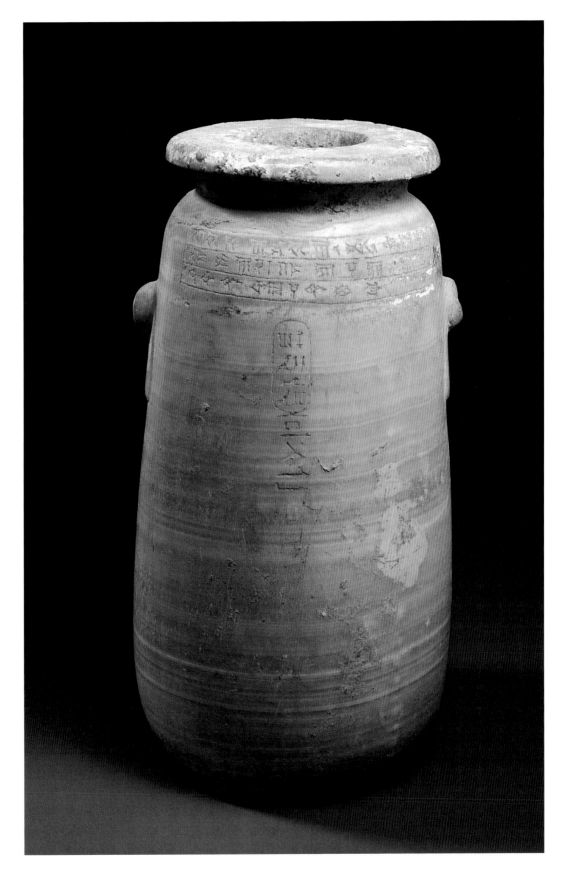

53

Jewelry

54. Gold weight
Dynasty 12, reign of Sesostris I or later,
(1919–1875 BC)
Quartz
H. 4.0 cm; w. 3.2 cm; d. 2.1 cm

Ancient Nubia, on the southern border of Egypt, was a rich source of gold. In fact, some scholars have suggested that the word Nubia was derived from the ancient Egyptian word for gold, *nub*. In order to secure the gold-producing area of the Second Cataract, the pharaoh Sesostris I erected a series of large fortresses that acted as both defensive structures and trading posts. Gold was also processed in some of these forts. Whether it was derived from placer deposits or mined from quartz veins out in barren desert, the gold was brought to the forts to be washed, purified, and assayed. The gold would be weighed on scales against weights of a standardized measure.

This weight is inscribed with the name of Sesostris I and wishes that he be given eternal life from his beloved god Ptah, patron of craftsmen. Beneath the inscription is the sign for gold, a collar with two drooping ties and six strokes. The six marks represent the number "6," which recorded the weight as six *beqa*, the standard unit for weighing gold, approximately equal to the 75 grams the piece weighs.[1] The choice of milky quartz for this example may evoke the gold-bearing quartz rock of the Eastern Desert. Few gold weights are as fine as this example and it may have served as a votive piece rather than a functional measure.

PL

Notes

[1] Karl M. Petruso, "Early Weights and Weighing in Egypt and the Indus Valley," *BMFA* 79 (1981), pp. 44–47.

54

55. Molds for producing personal ornaments

Probably Late Period (664–332 BC)
Steatite
A. H. 1.0 cm; L. 7.0 cm; W. 3.0 cm
B. H. 2.0 cm; L. 7.5 cm; W. 4.0 cm
C. H. 1.0 cm; L. 8.0 cm; W. 4.0 cm
D. H. 1.5 cm; L. 14 cm; W. 3.0 cm

The four molds were used to produce a variety of jewelry items as follows (arranged A–D from top to bottom in the accompanying photographs):
A: Four deities—Sekhmet, Amen(?), Hathor, Ptah. On the reverse are a solar barque, crown and pendant.
B: Taweret, Bes, solar barque, horned disk, uraeus, ring.
C: A band of uraei that would be bent into a diadem after casting. The reverse shows a pendant or earring.
D: A series of near-spherical beads. The reverse face has larger hemispheres.

Numerous stone molds and dies for jewelry have survived from Egypt, and can provide considerable information regarding modes of manufacture for jewelry and the contemporaneousness of forms (when for example, as here, several designs are included on a single mold.) The greatest problem is to determine exactly how they were used, and for what materials.

While mold D may well have been for impressing sheet gold or for forming spherical shapes in some other way, the other three molds were used in a casting process. According to traditional interpretations, each of these three represents a single half of an original two-part mold. The two halves of each mold would be clamped together and the metal poured in through the inlet "funnels" (these can best be seen above the heads of the deities on mold C). Once the molten metal had cooled and solidified, the two parts of the mold would be separated and the casting(s) removed. They would then need various finishing operations to tidy up their edges and surfaces.

An alternative is that such molds were used for producing wax models that were then in turn used to produce lost-wax castings in silver or another metal. More research is needed, but features of these and other surviving molds suggest that if this were the case, some may be complete objects, not missing their other halves, and the wax was pressed down into the design rather than fully melted and poured into a two-part mold. The inlet funnels and horizontal depressions that would have held a straw or similar "stick" to create suspension loops would not necessarily count against this. The complexity of molds A and B in particular, and their lack of locating holes to allow a second half to be accurately aligned, suggest that here, in any case, a second half, if it ever existed, was flat, not carved as a mirror image.

But what metals were the final objects made of? Gold was rarely cast in ancient times, especially for smaller items, because of wastage of metal due to the need for surface finishing, and also because relatively pure gold does not cast so well—it does not result in as detailed castings as silver, copper alloys or lead. Surviving Egyptian gold amulets in the forms shown on these molds are always made in wrought gold, typically quite thin sheet. Silver or copper alloys seem the most probable end product from these molds, and even lead cannot be excluded.

One other suggestion, that these molds were used for glass ornaments, may be possible in some cases (although terracotta molds were more usual for glass and faience), but the uraeus crown on mold C discounts this, since a glass casting could hardly be bent round into a circle, as seemingly required here.

These molds cannot be dated with any accuracy at present, but further research into the iconography of the designs may one day help. The various combinations of deities (as on mold A) might allow some suggestions as to location on the basis of associated cults at Egyptian temples.

JO

BIBLIOGRAPHY

Ancient Jewellery from the Near East and Egypt, Nefer Gallery (Zurich, 1993), cat. no. 76a–d.

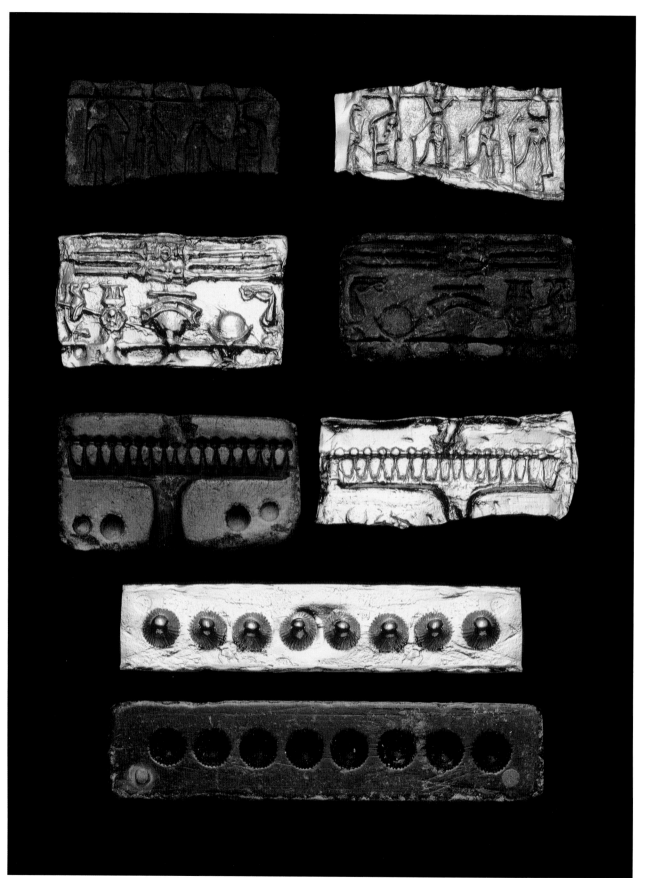

55 *Molds with modern gold castings*

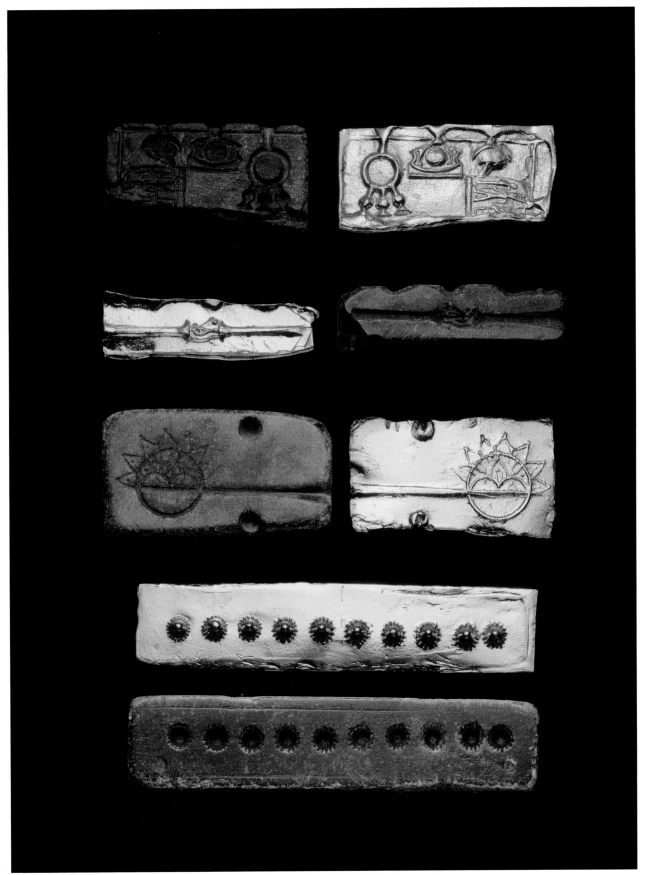

56. Amulet molds

DYNASTY 19 (1292–1190 BC)
FIRED CLAY
H. 5–3 CM; W. 4–2 CM; D. 4.5–1.2 CM

In Egypt, open-face molds of fired clay were used in the manufacture of small decorative objects, jewelry, and amulets. Hundreds of clay molds, used in the faience industry, were recovered from New Kingdom sites such as Malqata,[1] Amarna,[2] and Qantir.[3] Made of iron-rich Nilotic clay, they bear shallow impressions of a variety of motifs, including sacred images, signs, symbols, and inscriptions. Recent experiments suggest that the ancient craftsman pressed the moist faience mixture into the mold and removed it before it was completely dry. At this point, details could be enhanced or added. After the salts had effloresced to the surface, the faience would have been fired in a kiln.[4]

This group of twenty-one molds was once part of a larger collection from Qantir[5] that contained nearly two dozen impressions with royal names dating to Dynasty 19. These particular molds were undoubtedly used in the production of scarabs and small plaques. Other molds feature images of deities (Nefertum, Sekhmet, Bes, and Isis), amuletic signs (*ankh*, sacred eye, scarab beetle, and *sah*), and emblems (sacred bark, duck swag, *hes* vase, and sistrum). Many of the individual elements fabricated in these molds would have been incorporated into larger compositions such as broadcollars.

YJM

BIBLIOGRAPHY

Roger Khawam, "Un Ensemble de Moules en Terre-Cuite de la 19e Dynastie," *Bulletin de l'Institut Français d'Archéologie Orientale* 70 (1970), pp. 133–59.

NOTES

[1] For several molds from Malqata, see Florence Friedman, ed., *Gifts of the Nile: Ancient Egyptian Faience* (Providence, 1998), cat. no. 186, p. 257.

[2] For an example of a broadcollar terminal and the mold in which it was made, see Rita E. Freed, Yvonne J. Markowitz, and Sue H. D'Auria, eds., *Pharaohs of the Sun: Akhenaten, Nefertiti, Tutankhamen* (Boston, 1999), p. 262.

[3] Mahmud Hamza, "Excavations at Qantir," *ASAE* 30 (1930), pp. 53–62.

[4] Friedman, *op. cit.*, pp. 50–64.

[5] Roger Khawam, "Un Ensemble de Moules en Terre-Cuite de la 19ᵉ Dynastie," *BIFAO* 70 (1970), pp. 134–43.

56

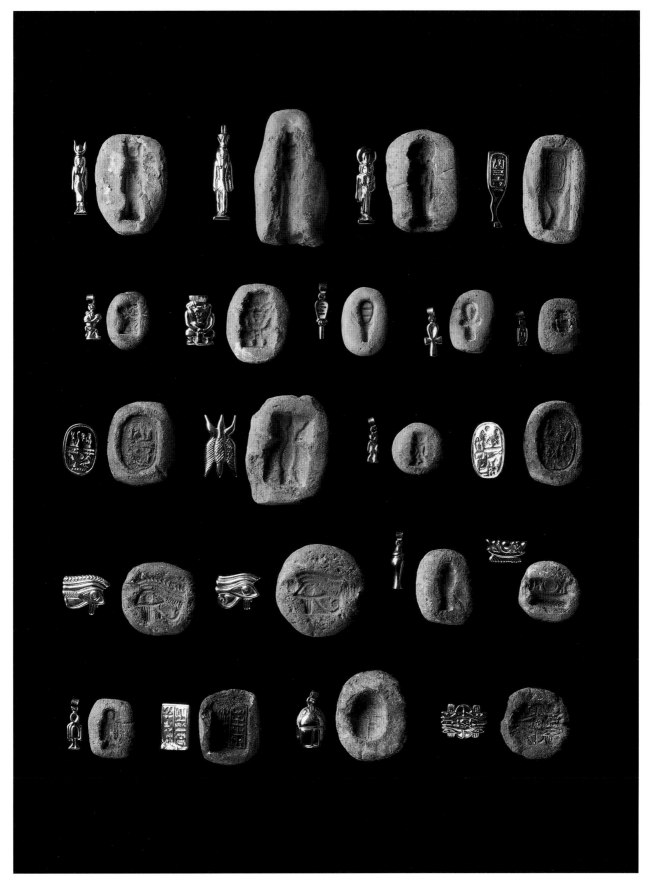

57

57. Scarab ring bearing the name of Amenemhet III

DYNASTY 12, REIGN OF AMENEMHET III,
(1818–1772 BC)
GOLD AND CARNELIAN
BEZEL LENGTH 1.79 CM

ALTHOUGH THERE WAS an Egyptian tradition of sophisticated jewelry dating back to the Old Kingdom and earlier, finger rings were a relatively late arrival. The present ring is among the earliest. It takes the form of a carnelian scarab held in a gold setting that was simply held about the finger by the hoop wire with its ends twisted together—in the manner of the simple scarabs tied to fingers with thread. Similar rings from Dahshur included examples with scarabs in lapis lazuli, amethyst and turquoise.[1]

The sheet-gold back of the setting bears a precisely formed hieroglyphic inscription with the name of the pharaoh Amenemhet III and the epithet "given life." The inscription was cut with a type of shallow gouging or incising technique, probably using a piece of flint, as has been noted in other early Egyptian gold objects. The shallowness of the hieroglyphs suggests that the ring was not intended to be used as a signet.

The setting is held on a gold wire about 1.0 mm in diameter, forming a hoop with the ends overlapped and twisted about each other.

The scarab is finely carved in line with the best traditions of Middle Kingdom hard stone working, in a coral-red carnelian which, where not protected by the gold setting, has bleached spots due to alkali contact during burial (possibly from the natural carbonate material, natron, used in mummification). The details of the beetle's anatomy are carefully delineated and the whole finely polished.

The ring closely compares with series of rings and scarabs from the burial of Queen Mereret, wife of King Sesostris III, Amenemhet's predecessor. Her tomb was discovered near Sesostris' pyramid at Dahshur in 1894. Several of these scarabs also bear the name of Amenemhet III, who ruled around 1800 BC, and it is quite possible that the present ring is from the same burial complex. It is thought that the epithet "given life" following the name of Amenemhet III indicates that the ring was made during his lifetime.

The Egyptians, as foreign rulers were often to note, had ample access to gold both to the east, in the eastern desert between the Nile and the Red Sea, and also to the south, in what is now the Sudan. Analysis

shows that the gold used for the ring is about 79% pure (around 19 carat in modern terms), with the balance mainly silver. This is in line with other Middle Kingdom goldwork. The composition of the ring, plus the evidence of the trace elements present, suggest that it is probably gold from the alluvial mines used "as found," without refining or alloying.[2] The carnelian is probably also from the Egyptian desert, although an import from further east is not impossible—lapis lazuli, for example was being traded all the way from Afghanistan.

JO

BIBLIOGRAPHY

Janine Bourriau, *Pharaohs and Mortals: Egyptian art in the Middle Kingdom* (Cambridge 1988), p. 157, pl. 4.1.

NOTES

[1] For the Dahshur rings see Emile Vernier, *Bijoux et orfèvreries,* Catalogue générale des antiquités égyptiennes du Musée du Caire, nos. 52258–52260 etc. (Cairo, 1927), and the references cited there.

[2] For the composition and sources of Egyptian gold see Jack M. Ogden, "Ancient Egyptian Metals," in Paul T. Nicholson and Ian Shaw, eds., *Ancient Egyptian Materials and Technology* (Cambridge, 2000), pp. 148–76.

58

58. Amulet of Harpocrates
THIRD INTERMEDIATE PERIOD–LATE PERIOD
(CA. 1075–332 BC)
GOLD
H. 2.75 CM; W. 0.6 CM

THIS SMALL GOLD AMULET with chased details depicts the god Horus-the-Child, son of Isis and Osiris, known to the Greeks as Harpocrates, in his characteristic semi-seated posture in which his thighs are scarcely out of the perpendicular and the knees hardly bent. His lower right leg is missing, as is the loop for suspension at the back of the neck. He wears the double crown, but the side-lock that was once attached to its right hand side is lost, denoting his youthfulness and the fact that he was heir to his father's throne.

Since the Egyptian artist was rarely able to depict children's proportions convincingly, the nakedness of the figure is an artistic convention to indicate that a

child is intended. Usually, especially if the piece were to date to the Graeco-Roman Period, Horus does not have a finger to his lips, a further conventional indication of his youth. The posture with arms by the sides, combined with the figure's physique with stylized rolls of fat, high waist and non-tripartite division of the torso, points towards a date for its manufacture earlier rather than later in the 1st millennium BC. The low purity of the gold and its high copper content would tend to confirm such a dating in the Third Intermediate Period.[1]

<div align="right">CA</div>

NOTES

[1] *The Cambridge Centre for Precious Metal Research,* Report no. 93341, September 10, 1993.

59. Signet ring bearing the name of Akhenaten

DYNASTY 18, REIGN OF AKHENATEN (1353–1336 BC)
ELECTRUM
L. OF BEZEL 1.0 CM

GOLD RINGS MADE their appearance in the Middle Kingdom (see cat. 57), but few seemed to have served the function of a signet, and even many of those set with engraved scarabs were probably purely amuletic. Scarab-set rings survived into, and through, the New Kingdom, but by about the time of Thutmose III they were joined by a class of all-metal rings, some of which were probably intended to be used as signets.

The earlier New Kingdom all-metal rings had fixed, flat rectangular or oval bezels soldered between the ends of the hoop and were engraved with a name or other depiction. By the reign of Amenhotep III, these had developed into the more massive "stirrup" type of ring as seen here. These are best known in the Amarna and immediate post-Amarna period.[1]

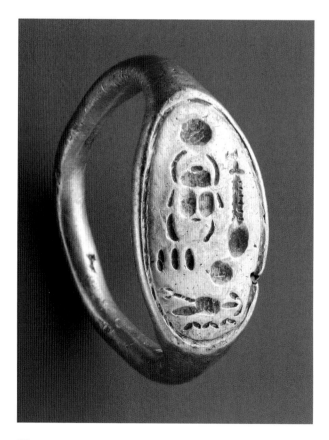

59

The fine electrum example described here bears the name of King Akhenaten—Nefer-kheperu-re Wah-en-re—deeply chased into the substantial oval bezel. As with the Amenemhet III ring (cat. 57), the name Akhenaten on these Amarna stirrup rings is typically enclosed in a simple oval, not a true royal cartouche.

The Egyptian New Kingdom stirrup rings were made in a variety of alloys. Some were of relatively high-purity gold (75%+). Some, like this example, were of electrum (a gold-silver alloy of pale silvery color), and some were of a deliberate red gold-copper alloy that is typical of the Amarna Period (and matched in Mycenaean Greece).[2] To some extent, the mode of manufacture reflected their composition. The gold-copper ones were always cast, the electrum ones often cast, while the purer gold ones were often made by soldering together a separately made hoop and bezel.

An interesting aspect of the Amarna "stirrup" rings is that they are almost as well attested outside of Egypt—in Cyprus and the Levant—as in Egypt itself. This must imply that they were of practical use in trade or were distributed by the king to native and foreign dignities, or both. That such rings were used as seals is demonstrated by surviving clay seal impressions from Amarna and elsewhere that have the typical elongated oval, very different in proportions to the characteristic Egyptian scarab. The widespread distribution of these rings also supports the modern view that, despite the later Egyptian propaganda regarding the heretical and weak reign of Akhenaten, foreign connections and trade were actually blossoming.

JO

NOTES

[1] For the development of Egyptian rings see Alix Wilkinson, *Ancient Egyptian Jewellery* (London, 1971), passim.

[2] For the gold alloys used in ancient Egypt see Jack M. Ogden, "Ancient Egyptian Metals," in Paul T. Nicholson and Ian Shaw, eds., *Ancient Egyptian Materials and Technology* (Cambridge, 2000), pp. 148–76.

60

60. Ring inscribed for Amenhotep III

DYNASTY 18, REIGN OF AMENHOTEP III (1390–1353 BC)
FAIENCE
L. 1.7 CM (BEZEL); W. 1.1 CM (BEZEL); DIAM. 2.0 CM (FRONT TO BACK)

ORNAMENTS OF BRIGHTLY COLORED faience were mass-produced during the reigns of Amenhotep III and his immediate successors. This was particularly true of finger rings, if we are to judge by the quantity of bezel and hoop fragments found at the Malqata palace complex[1] and Amarna,[2] the capital city founded by Amenhotep III's son, Akhenaten. The reason for the ring's popularity may be a technical one, as the introduction of glass technology during the reign of Thutmose III was soon followed by the appearance of a hard-bodied faience.[3] This would have made the wearing of faience rings a practical, low-cost alternative to the more traditional rings of stone and metal.

The reign of Amenhotep III also saw an expansion of the faience color palette. For centuries, brilliant blue, blue-green, black, and white were the standard colors produced in faience workshops. The addition of new mineral-oxide colorants to faience formulas resulted in purple-blue, apple-green, yellow, red,[4] and gray glazes on decorative tiles, inlays, vessels, and jewelry. Blue-green and purple-green were the most common colors for finger rings, while the cartouche was a popular form.[5] Boyce suggests that faience rings were distributed among ordinary citizens during festivals and would have placed the wearer under the protection of the king.[6] In addition to rings bearing the name Nebmaatre, broadcollar terminals, bracelets, beads, and scarab rings were also produced bearing the king's prenomen.[7]

YJM

NOTES

[1] There were 451 ring bezels inscribed for Amenhotep III at the site. See Edward Brovarski, Susan K. Doll, and Rita E. Freed, eds., *Egypt's Golden Age, The Art of Living in the New Kingdom 1558–1085 B.C.* (Boston, 1982), cat. no. 342, p. 248.

[2] Numerous molds were also recovered from the site. See W.M.F Petrie, *Tell el Amarna* (London, 1894), pl. XVIII.

[3] Andrew Boyce, "Notes on the Manufacture and Use of Faience Rings at Amarna," *Amarna Reports* V (1989), pp. 160–68.

[4] Reddish-brown faience beads were found at Giza by Reisner. These date to Dynasties 4–6 and were colorized by the addition of iron oxide. See *Masterworks from the Age the Pyramids*, Nagoya/Museum of Fine Arts Boston, exhibition catalog (forthcoming 2001).

[5] This is based on a distribution of ring bezels found at Amarna. See Ian Shaw, "Ring Bezels at El-Amarna," *Amarna Reports* I (1984), pp. 124–32.

[6] Boyce, *op. cit.*, pp. 160–68.

[7] For several examples, see Arielle Kozloff and Betsy Bryan with Lawrence Berman, *Egypt's Dazzling Sun: Amenhotep III and His World* (Cleveland, 1992), cat. nos. 124–26, 128, pp. 445–48.

61. Faience jewelry fragments

LATE DYNASTY 18 (1390–1292 BC)
YELLOW FAIENCE WITH POLYCHROME FAIENCE INLAYS
A. H. 2.0 CM; W. 1.9 CM; D. 0.3 CM
B. H. 1.3 CM; W. 1.6 CM; D. 0.3 CM

AMONG THE FAIENCE OBJECTS decorated with royal names using the inlaid faience technique are shabtis, small vessels, and jewelry. Bichrome examples, in which a colored body is inlaid with hieroglyphs in a contrasting color, are more common than polychrome wares. An extraordinary Eighteenth Dynasty example of a white faience body inlaid with multicolored inlays is the shabti of Lady Sati in the Brooklyn Museum of Art.[1] Its labor-intensive fabrication required considerable skill in that each color was prepared in a separate batch and then set into carved channels before firing in a kiln.

Unfortunately, very few examples of polychrome faience have survived,[2] existing fragments offering hints of truly magnificent *objets d'art*.[3] In the jewelry category, white and yellow were the preferred colors for bodies and may represent an attempt to simulate precious metals. These fragments may have once been part of a pectoral,[4] plaque, or broadcollar terminal. There are narrow borings for stringing material on both pieces and although the colors on both fragments are similar, they do not appear to be part of the same ornament.

YJM

61A, B

NOTES

[1] Florence Friedman, ed., *Gifts of the Nile: Ancient Egyptian Faience* (Providence, 1998), cat. no. 150, p. 240.

[2] For a truly exceptional cosmetic vessel of polychrome faience (yellow body with red and blue inlays) dating to the reign of Amenhotep III, see Arielle Kozloff and Betsy Bryan, eds., *Egypt's Dazzling Sun: Amenhotep III and His World* (Cleveland, 1992), cat. no. 100.

[3] An unidentified Eighteenth Dynasty fragment in a private collection with multiple colors forming a complex geometric pattern illustrates the sophistication of faience fabrication during the New Kingdom. See Friedman, *op. cit.*, cat. no. 196, p. 261.

[4] For an inlaid faience pectoral of Ramesside date, *ibid.*, cat. no. 161, p. 248.

62. Falcon-head and lotus-blossom inlays

A.
FALCON TERMINAL
PTOLEMAIC PERIOD (305–30 BC)
POLYCHROME GLASS
H. 4.0 CM; W. 4.0 CM

B.
TWO LOTUS-BLOSSOM INLAYS
PTOLEMAIC PERIOD (305–30 BC)
POLYCHROME GLASS
H. 3.0 CM; W. 2-2.5 CM

T HIS GLASS INLAY in the form of a falcon head is one of a pair of terminals from an inlaid funer-

ary collar. Although falcon-head terminals are represented in Old Kingdom reliefs,[1] the earliest surviving examples are Middle Kingdom in date.[2] One of the finest belonged to Neferuptah, a princess buried at Hawara. The falcon terminals on this collar are gold while the beads are largely semi-precious stones.[3] A counterpoise belonging to the princess, as well as several representations of counterpoises on the Middle Kingdom coffin of the physician Seni from el-Bersheh,[4] demonstrate that falcon heads were also incorporated into *menkhet* ornaments. For the young king Tutankhamen, a set of falcon-head terminals was attached to the surface of his famous gold mask.[5]

The use of falcon-head terminals on funerary collars continued throughout the first millennium. A

62

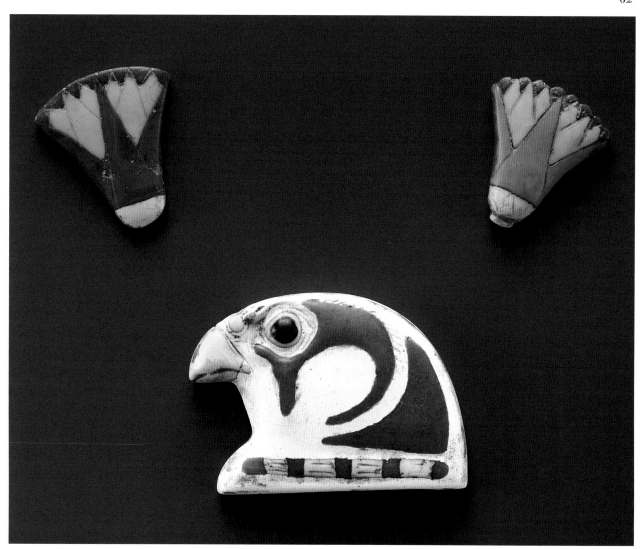

typical example is the neck ornament featured on the basalt sarcophagus of Kheperre,[6] a general who served the Saite ruler Amasis (570–526 BC). Later, with the resurgence of glassmaking under the Ptolemies, various elements of the broadcollar were made of glass. Falcon-head terminals of the period usually have an opaque white background and are inlaid with dark blue and bright yellow glass.[7] The first step in their fabrication involved forming the inlays from monochrome, polychrome, or mosaic glass. Next, these sections were set into a mold that was then filled with white glass. The final step consisted of firing in a kiln until fusion was achieved.

Other glass inlays, including the two polychrome lotus blossoms, were made in a similar manner. Such inlays would have been used to decorate walls, shrines, furniture, and wooden coffins.

YJM

NOTES

[1] For example, two collars with falcon terminals are illustrated in the tomb of Mereruka. See Hans Wolfgang Müller and Eberhard Thiem, *Gold of the Pharaohs* (Ithaca, 1999), p. 77, fig. 155.

[2] An early example of a collar and counterpoise with falcon-headed terminals was found in the tomb of Princess Itaweret (Dahshur). See Carol Andrews, *Ancient Egyptian Jewellery* (London, 1990), p. 120. Other examples include the collars of Senebtisi and Princess Khnemt, as well as the falcon-headed terminals of Princess Nebheteptikhrad. See Alix Wilkinson, *Ancient Egyptian Jewellery* (London, 1971), pp. 52, 55, 65.

3 Carol Andrews, *op. cit.*, p. 120.

4 British Museum 30841.

5 Cairo JE 60672.

[6] Museum of Fine Arts, Boston 30.834.

7 For comparable examples, see Sidney Goldstein, *Pre-Roman and Early Roman Glass in the Corning Museum* (Ithaca, 1979), no. 677, pp. 232–33 and Elizabeth Riefstahl, *Ancient Egyptian Glass and Glazes in the Brooklyn Museum* (Brooklyn, 1968), no. 74, p. 109.

63. Bird pendant
LATE MIDDLE KINGDOM–SECOND INTERMEDIATE PERIOD (1836–1539/23 BC)
FAIENCE
H. 1.9 CM; W. 2.2 CM; D. 0.3 CM

ANCIENT EGYPTIAN REPRESENTATIONS of animals are extraordinary in their attention to naturalistic detail. This small bird is unusually stylized and of a type not common in Egyptian art. It is, however, remarkably similar to Bronze Age Aegean jewelry elements, notably in the famous Aegina treasure.[1] The quality of the faience, the partial profile rendering of the figure, and its form, which is flat-backed and pierced horizontally, however, suggests Egyptian manufacture. The vogue for foreign styles, particularly Minoan motifs, characterized the arts of the Middle Bronze Age in the eastern Mediterranean and Egypt.

PL

NOTES

[1] F.H. Marshall, *Catalogue of the Jewellery, Greek, Etruscan and Roman in the Department of Antiquities, British Museum* (London, 1911), pp. 51–56.

63

64. Necklace

A. Leopard spacer
Dynasty 18 (1539–1295/92 BC)
Faience
H. 1.8 CM; W. 2.0 CM; D. 0.9 CM

B. Floral terminal
Dynasty 18 (1539–1295/92 BC)
Glassy faience
H. 0.8 CM; DIAM. 1.2 CM

C. Rosette
Dynasty 18 (1539–1295/92 BC)
Glassy faience
H. 0.9 CM; DIAM. 1.3 CM

The leopard head that forms the central element in this reconstructed necklace was a motif found on a number of types of Egyptian regalia. It was worn as an independent decorative element on the leopard skin cloak of a priest;[1] in groups of three, in a jeweled composition that included the royal name, also worn by priests;[2] and as part of a necklace, as restored here. Examples of this kind of pendant collar were discovered strung in their original order in New Kingdom tombs at the site of El-Ahaiwah.[3] The leopard head is also depicted on the ivory magic wands of the Middle Kingdom[4] as a protector. Its image on these personal adornments also suggests that they had some amuletic quality.

PL

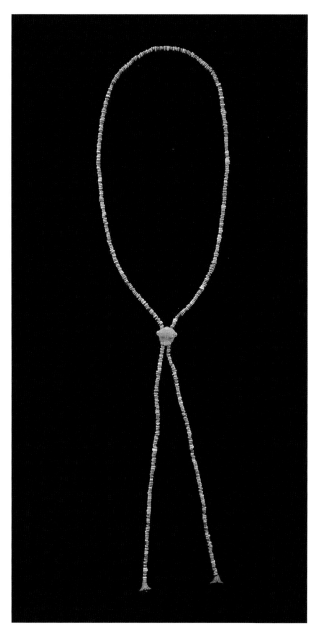

64A

Notes

[1] As in the tomb of Tutankhamen: Katharine Gilbert et al., eds., *Treasures of Tutankhamun* (New York, 1976), pl. 3, pp. 104–105.

[2] Arielle Kozloff and Betsy Bryan, eds., *Egypt's Dazzling Sun: Amenhotep III and his World* (Cleveland, 1992), pp. 248–49.

[3] Edward Brovarski, Susan K. Doll and Rita E. Freed, eds., *Egypt's Golden Age: The Art of Living in the New Kingdom 1558–1085 B.C.* (Boston, 1982), pp. 240–41.

[4] George Steindorff, "Ivory magic wands," *Journal of the Walters Art Gallery* (Baltimore, 1946), pp. 41–45.

65. Fist amulet

Late Old Kingdom to First Intermediate
Period (2350–1980 bc)
Carnelian
H. 1.0 cm; w. 0.8 cm; d. 0.3 cm

Carnelian amulets in the shape of hands and fists first appear in the Fifth Dynasty and are suggested to have conferred dexterity or other powers on the deceased.[1] Amulets of other body parts that develop during this period also may have served to revivify the various limbs and organs of the deceased. This example in carnelian is highly stylized but clearly belongs to the "debased fist" category (8W) of Brunton.[2]

PL

Notes

[1] Carol Andrews, *Amulets of Ancient Egypt* (London, 1994), pp. 70–71.

[2] Guy Brunton, *Qau and Badari* II (London, 1928), pl. XCIV.

66

65

66. Hair ring

New Kingdom (1539–1075 bc)
Red jasper
H. 0.9 cm; diam. 2.0 cm

Penannular rings with cleft openings are sometimes classified as earrings since their forms closely resemble ear ornaments with locking pins.[1] However, the cleft in these examples is wider, thereby facilitating attachment to the ear. Some earrings with sizable gaps, including a pair belonging to Queen Tausret, lack the locking pins.[2] In this case, the wearer would have slipped the ear lobe through the crevice and pushed the body of the ornament into the piercing.

Another explanation is that penannular rings with narrow clefts—some only 1 mm wide—were hair or wig ornaments. Adornments for the head were worn by royal and private individuals from the earliest times in Egypt. They include crowns, closed diadems, fillets, and tubes for tresses. An exceptional example of the latter comes from the Twelfth Dynasty burial of Princess Sithathoriunet (reign of Amenemhet III). Here the tubes are made of gold sheet and were probably threaded onto locks of hair.[3] Since jasper penannular rings come in a variety of sizes,[4] it is possible that the

smallest were worn at the top the head and the largest were secured around curls near the shoulder.

<div align="right">YJM</div>

BIBLIOGRAPHY

Christie's, New York, Friday, June 4, 1995.

NOTES

[1] See, for example, Edward Brovarski, Susan K. Doll, and Rita E. Freed, *Egypt's Golden Age: The Art of Living in the New Kingdom, 1558–1085 B.C.* (Boston, 1982), cat. nos. 295–98, pp. 229–30; and Carol Andrews, *Ancient Egyptian Jewellery* (London, 1990), pp. 116–17, fig. 96f, h.

[2] Cyril Aldred, *Jewels of the Pharaohs* (London, 1971), no. 171, p. 234.

[3] The gold tubes were found underneath a wig, near the remains of Sithathoriunet's jewelry box, which once held a gold and semi-precious stone diadem. See Guy Brunton, *Lahun* I: *The Treasure* (London, 1920); for a reconstruction of the head ornaments with wig, see Alix Wilkinson, *Ancient Egyptian Jewellery* (London, 1971), pl. IX.

[4] For an illustration of the size range, see Hans Wolfgang Müller and Eberhard Thiem, *Gold of the Pharaohs* (Ithaca, 1999), fig. 359, p. 166.

67. Rosette ear stud
MIDDLE TO LATE DYNASTY 18 (1390–1292 BC)
FAIENCE
H. 0.6 CM; DIAM. 2.2 CM

ORNAMENTS OF POLYCHROME faience were popular items of adornment during the second half of Dynasty 18. A number of these everyday jewels have yellow or white backgrounds, suggesting that they were meant to imitate ornaments of precious metal.[1] The white was a substitute for silver,[2] an imported material the Egyptians called "white gold." The boss of this ear stud (the plug is missing) is inlaid with blue faience and enhanced by a layer of red faience in the center. The blue and red may have represented lapis lazuli and carnelian, semi-precious stones used in luxury goods and valued for their symbolic associations.

The rosette is a decorative motif with a long and rich history along the Nile Valley. In jewelry, it appears on a wrist ornament of King Sneferu,[3] a circlet of Princess Nofret,[4] a diadem of Princess Khnumet,[5] a diadem of Queen Tausret,[6] and the ear studs of a Twenty-first Dynasty lady.[7] The rosette is a mandala, a symbol of unity and cohesion. In ancient Egypt, it may have been a stylized solar representation.

<div align="right">YJM</div>

67

BIBLIOGRAPHY:

Christie's, New York, Friday, June 4, 1995.

NOTES

[1] For a comparable set of rosette ear studs excavated at Amarna, see Rita E. Freed, Yvonne J. Markowitz, and Sue H. D'Auria, eds., *Pharaohs of the Sun: Akhenaten, Nefertiti, Tutankhamen* (Boston, 1999), cat. no. 198; and

Carol Andrews, *Ancient Egyptian Jewellery* (London, 1990), pp. 116–17, fig. 96l.

[2] Alfred Lucas and John R. Harris, *Ancient Egyptian Materials and Industries*, fourth ed. (London, 1962), p. 248.

[3] From a fragment of a relief in the valley temple of the Bent Pyramid at Dahshur. For a drawing of the ornament, see Hans Wolfgang Müller and Eberhard Thiem, *Gold of the Pharaohs* (Ithaca, 1999), fig. 124, p. 65.

[4] Painted limestone statue from Meidum, Cairo CG 4.

[5] The gold and semi-precious stone diadem of Princess Khnumet from Dahshur, Cairo CG 52860.

[6] The gold rosette circlet with the names of the queen and her husband, Seti II, from pit-tomb 56, Valley of the Kings, Western Thebes, Cairo 52644.

[7] These large studs are painted on the lid of an anthropoid coffin from Thebes, British Museum 24907.

68. Broad collar elements

A. GRAPE CLUSTER
DYNASTY 18 (1539–1295/92 BC)
FAIENCE
H. 1.8 CM; W. 1.0 CM; D. 0.5 CM

B. DATE PENDANT
DYNASTY 18 (1539–1295/92 BC)
FAIENCE
H. 0.75 CM; L. 1.8 CM; W. 0.75 CM

C. LEAF PENDANT
DYNASTY 18 (1539–1295/92 BC)
FAIENCE
H. 0.4 CM; L. 2.3 CM; W. 0.8 CM

THE DEVELOPMENT OF polychrome faience in the late Eighteenth Dynasty enabled the production of imitation floral collars with a rich variety of vegetal ornaments.[1] The tomb of Tutankhamen held an array of collars of various compositions. These pendants would have been strung with a large number of similar pendants through rings attached to the top and bottom of the elements, and separated by tiny ring beads. Rows of different colors and shapes produced stunningly beautiful neck ornaments, decorative for the living and symbolizing the hope of rebirth for the dead.

PL

NOTES

[1] Andrew Boyce, "Collar and necklace designs at Amarna: a preliminary study of faience pendants." *Amarna Reports* VI (London, 1995), pp. 336–77.

68

Funerary, ritual, and magic

69. Deceased on a bier

DYNASTY 18, REIGN OF AMENHOTEP III (1390–1353 BC)
STEATITE

H. 3.9 CM; W. 5.0 CM; D. 2.2 CM

CARVED FIGURES IN THE FORM of a mummified person lying on a lion-legged bier are found beginning in the reign of Amenhotep III.[1] This small statuette belonged to "Osiris, the mistress of the house, Any" who is depicted as a mummy wearing a tripartite wig and *wesekh* collar. The outline of her arms ends at the elbow with no forearms or hands indicated. Beside her, a human-headed *ba*-bird stands with its arms outstretched across her breast. The bed has lion-shaped legs and feet that rest on a rectangular base. The foot of the bed projects upwards, with the outside carved into six slats. The space between the legs is solid, and is spanned by an incised crossbar on the short sides and text on the long sides. The inscription is a variation of Chapter 30b of the *Book of the Dead,* commonly inscribed on heart scarabs, which prevented the heart from testifying against its owner before the divine tribunal during the weighing of the heart.[2] The text reads: "Heart of my mother, heart of my mother, heart of (my) form, don't stand to witness against (me), don't make oppo<sition to me>…."

The iconography and inscriptions of the deceased on a bier relate to the owner's desire for maintenance in the next world.[3] The deceased is depicted as an Osirianized mummy, which identifies her with the god of the underworld, and conveys her desire to be reborn as Osiris was reborn. The representation of the *ba*-bird (soul of mobility) beside the mummy acted as sympathetic magic designed to help the *ba* recognize, reunite with, and recharge the actual body. The placement of the *ba*'s arms on the chest of the deceased's mummiform body visually recalls Chapter 89 of the *Book of the Dead,* which recommends that a golden *ba*-bird be laid on the breast of the body to facilitate reunion.[4] The heart scarab spell offers Any additional insurance that her heart will not speak against her, so that she will be judged virtuous and pass into the world of the resurrected dead.

Similar statuettes of mummiform figures on lion-legged biers from the Eighteenth Dynasty are found in the Egyptian Museum, Cairo;[5] the Ny Carlsberg Glyptotek, Copenhagen;[6] and the Louvre.[7] The facial features of the mummiform figure in the Thalassic Collection are reminiscent of statuary dating to the reign of Amenhotep III, which indicates this deceased on a bier is one of the earliest examples of its type.

MKH

NOTES

[1] Rita E. Freed, Yvonne J. Markowitz, and Sue H. D'Auria, eds., *Pharaohs of the Sun: Akhenaten, Nefertiti, Tutankhamen* (Boston, 1999), p. 205, cat. no. 15. Corresponds to Class VIIC, "Single mummy or pair of mummies on bier, with *ba*-bird and/or goddess" in Hans D. Schneider, *Shabtis,* vol. I (Leiden, 1977), pp. 163–64, 214–16; and "chaouabtis 'gisants'" in J.-F. Aubert and L. Aubert, *Statuettes égyptiennes—chaouabtis, ouchebtis* (Paris, 1974), pp. 71–73.

[2] Sue D'Auria, Peter Lacovara, and Catharine H. Roehrig, eds., *Mummies & Magic: The Funerary Arts of Ancient Egypt* (Boston, 1988), pp. 223–24, cat. no. 176.

[3] Christian Loeben, "Ein Rundbild als Textillustration: Turin 2805 und zur Gruppe der sogenannten 'Bahrenuschebtis'," in Jürgen Osing and Günter Dreyer, eds., *Form und Mass: Beiträge zur Literatur, Sprache und Kunst des alten Ägypten, Festschrift für Gerhard Fecht,* ÄAT 12 (Wiesbaden, 1987), pp. 299–300.

[4] Raymond Faulkner, *The Egyptian Book of the Dead,* with introduction and commentaries by Ogden Goelet (San Francisco, 1994), pl. 17.

[5] JE 48483, Percy Newberry, *Funerary Statuettes and Model Sarcophagi* (Cairo, 1930), p. 372–73, pl. XXX.

[6] AEIN 1598, Otto Koefoed-Petersen, *Catalogue des statues et statuettes égyptiennes* (Copenhagen, 1950), p. 50, no. 82, pl. 94.

[7] N 2660, Christiane Desroches-Noblecourt, "Le *Ba* de la divine Hathor," *La revue du Louvre et des Musées de France* 31.3 (1982), p 192, fig. 14.

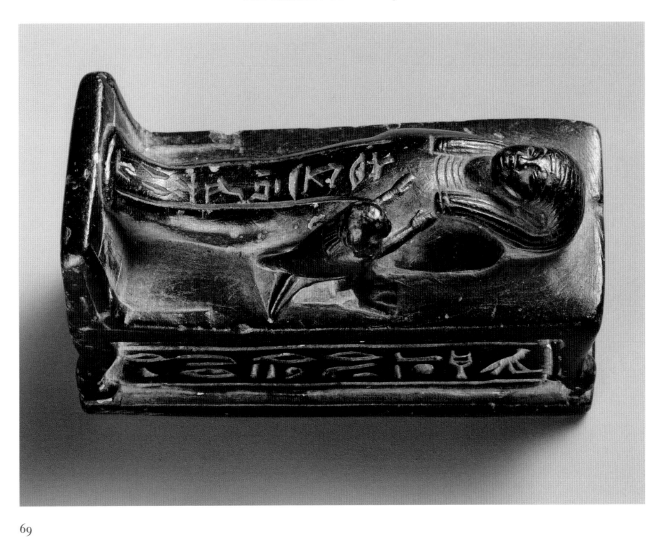

69

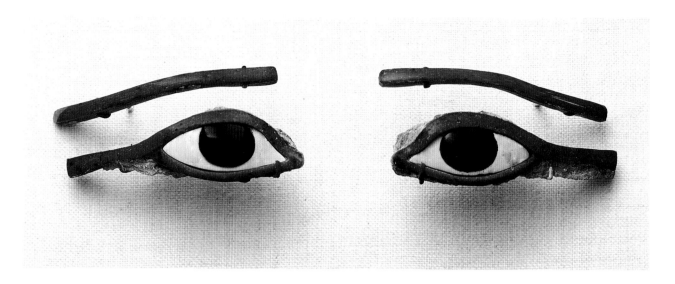

70

70. Inlaid eyes

LATE DYNASTY 18 (1390–1295/92 BC)
GLASS, CALCITE ("EGYPTIAN ALABASTER"), GOLD LEAF
H. (TOTAL) 4.2 CM; L. (TOTAL) 18 CM; D. (TOTAL) 2.8 CM

THE EIGHTEENTH DYNASTY saw the first large-scale glass production in Egypt, although it still remained a rare and prized commodity. As faience before it, glass was used for a wide variety of decorative purposes, including coffin inlays. This pair of eyes would have come from a very fine anthropoid coffin of the late Eighteenth Dynasty. They would have been set into a gilded wood face; traces of the original gilding and its decayed wooden substrate still adhere to the edges of the eyes.

The brows and liners of the eyes are composed of blue glass curved to fit the contours of the face. The whites of the eyes are made of creamy, white calcite with insets for the irises cut from black glass—possibly obsidian. The eyes gaze slightly upward, giving them an otherworldly aspect. Similar eyes can be found on the coffins of Yuya and Tuya, the parents of Amenhotep III's powerful queen, Tiye.[1] Such exquisite inlays would have belonged to the burial of another great notable.

PL

NOTES

[1] Nicholas Reeves and Richard Wilkinson, *The Complete Valley of the Kings* (London, 1996), pp. 174–77.

71. Bronze *djed* pillar

DYNASTY 26, REIGN OF PSAMTIK I (664–610 BC)

BRONZE, ELECTRUM

H. 9.0 CM; W. 4.0 CM

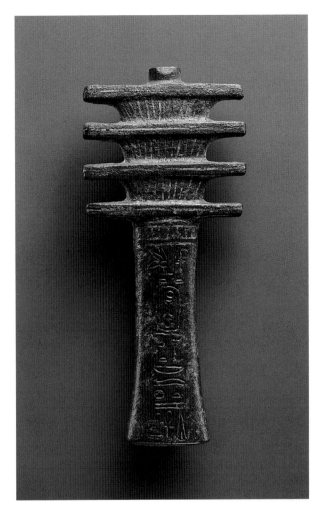

71

THE DJED-PILLAR IS ATTESTED as early as the Third Dynasty, although its origins remain a mystery. By the New Kingdom, the symbol was closely connected to Osiris and supposedly represented the backbone of the god. In both amuletic and linguistic usage, the *djed* conveyed the notion of endurance and stability.

This example is inscribed down the front for the "King of Upper and Lower Egypt, Wahibre,"[1] though it is possible that the inscription and column are not contemporary.[2] The top of the column is finely detailed with inlaid electrum. Tangs on the reverse at top and bottom indicate that the column was fastened to another object, perhaps a piece of furniture or a screen.

BTT

BIBLIOGRAPHY

Christie's London, July 8, 1992. Lot no. 218, p. 82.

NOTES

[1] Although both Psamtik I and Apries of the Twenty-sixth Dynasty bore the name Wahibre, the column probably refers to the former. Wahibre was the prenomen of Psamtik and the nomen of Apries; the "king of Upper and Lower Egypt" title typically accompanies the prenomen. Cf. Jack Ogden, "An Egyptian Copper-Alloy *Djet* Column with Inlay and Inscription," IAR Report 93338 (Cambridge, 1993), p. 2.

[2] The absence of inlay in the inscription along with its perfunctory carving suggest that it might not be contemporary with the precisely fashioned column; *ibid.*, p. 3.

72. Two fingers amulet

Late Period, after 600 bc

Jadeite

L. 10.5 cm; w. 3.0 cm

The two fingers amulet, representing the index and middle fingers, often with the nails and joints clearly defined, as here, occurs only in burials of the Late Period. Either the right- or left-hand fingers can be represented. The material is almost always a dark, hard stone such as basalt, steatite or obsidian (or black glass in imitation), precisely in accordance with the description in an amulet list on one side of a Late Period funerary papyrus for a woman, the so-called MacGregor Papyrus.[1] The translucent olive-green and opaque black stone from which this example is made has been identified as jadeite.[2] However, the few Egyptian amulets and jewelry elements formerly believed to have been made from this very rare material have in many cases been subsequently re-identified.

The two fingers amulet is most frequently found on the mummy near the embalming incision. This has led to the suggestion that it represents the two fingers of the embalmer and was intended to reconfirm the mummification process, perhaps providing extra magical protection to this most vulnerable part of the corpse.

CA

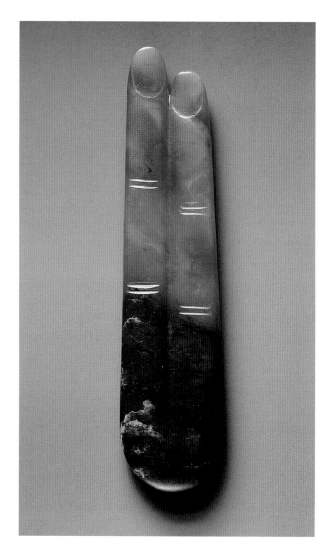

72

Notes

[1] Jean Capart, "Une liste d'amulettes," *ZÄS* 45 (1908), p. 20, no. 58.

[2] Deposits of jadeite are known from Oman, William Size, personal communication; and from Anatolia; cf. Paul T. Nicholson and Ian Shaw, eds., *Ancient Egyptian Materials and Technology* (Cambridge, 2000), pp. 38–39.

73. Cup of Nesykhonsu
Dynasty 21 (1075–945 bc)
Faience
H. 6.4 cm; diam. 7.4 cm
Deir el-Bahri Cache (DB 320)

This small cup is inscribed for Nesykhonsu, wife of the High Priest of Amen, Pinedjem II. More than sixty such vessels accompanied her burial in the Deir el-Bahri Cache.[1] The cup is formed from the same brilliant turquoise faience that characterizes the shabtis of Nesykhonsu and the nobles of the Twenty-first Dynasty.

Two framed lines of text decorate one side of the cup, reading "the Osiris, first chief of the *kheneru* of Amen, Nesykhonsu, justified of voice." In addition to her position among the Amen clergy, Nesykhonsu was the last individual to hold the title "viceroy of Nubia."[2] Though it is unlikely that Nesykhonsu excercised any duties as viceroy, the designation emphasizes the stature of the Theban clergy during the Third Intermediate Period.

BTT

BIBLIOGRAPHY

Christie's London, July 10, 1991. Lot no. 78.

NOTES

[1] Other examples may be found in the Brooklyn Museum of Art (16.73), the Walters Art Gallery (48.412), and the Myers Museum at Eton College (ECM 1677, 1678, 1679, 1680), among others.

[2] Kenneth A. Kitchen, *The Third Intermediate Period in Egypt* (Warminster, 1986), p. 66; Saphinaz-Amal Naguib, *Le clergé féminin d'Amon Thébain à la 21e Dynasty* (Leuven, 1990), pp. 168–71.

73

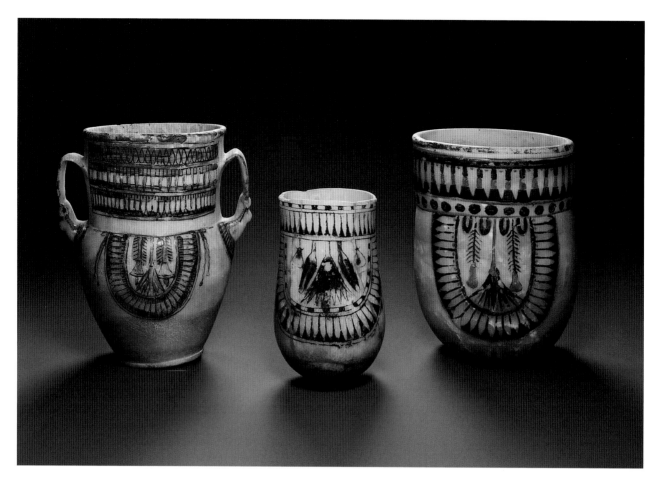

74A, C, B

74. Decorated vessels

A.

JAR WITH SIDE STRAP-HANDLES
DYNASTY 19, REIGN OF RAMESSES II (1279–1213 BC)
CALCITE ("EGYPTIAN ALABASTER") WITH PIGMENT
H. 35 CM; DIAM. (MAX.) 32 CM

B.

WIDE-BODIED AMPHORA
DYNASTY 19, REIGN OF RAMESSES II (1279–1213 BC)
CALCITE ("EGYPTIAN ALABASTER") WITH PIGMENT
H. 33 CM; DIAM. (MAX.) 24 CM

C.

AMPHORA
DYNASTY 19, REIGN OF RAMESSES II (1279–1213 BC)
CALCITE ("EGYPTIAN ALABASTER") WITH PIGMENT
H. 26 CM; DIAM. (MAX.) 15 CM

THESE THREE REMARKABLE vessels undoubtedly all form a group related to the burial of Ramesses II. A number of similar vessels are known, including a group excavated in the Valley of the Kings, associated with the funeral of Ramesses' son and successor, Merneptah.[1]

The material used in preparing the mummy, although unclean, was still connected to the sacred rites of the dead, and was gathered up and placed in jars buried in a pit near the tomb. These collections, known as embalmer's caches, have been found in a number of cemetery sites in Egypt, but the most elaborate ones are known from the Valley of the Kings at Thebes. The excavation of a cache from the burial of Tutankhamen eventually led to the discovery of his tomb. In the Ramesside Period, the pottery vessels found in earlier embalmer's caches appear to have been replaced by more elaborate alabaster ones. A group of similar vases, including one inscribed for Ramesses II

from Ard el-Naam Mataria, still retained the original contents, which included: linen, sand, natron, resin and organic debris associated with mummification.[2]

The examples in the Thalassic Collection miraculously preserve much of their original painted decoration. The pigments included blue derived from powdered blue frit, green from ground malachite, yellow that was made from an arsenic sulphide known as "orpiment," red from iron oxide as in red ochre, and black from simple carbon black. The pigments were mixed in a medium of beeswax, which adhered well to the surface of the stone and was also used on alabaster shabtis of the later Ramesside Period. Wax also had special magical properties and was often associated with funerary objects.

The designs on the vessels vary somewhat, but all depict the lotus petal garlands used earlier to decorate plain pottery amphorae at feasts. The lotus decoration was not only attractive, but also evoked rebirth, as the lotus opens anew each day with the sunrise. The petal decoration could be combined with other floral motifs, such as lily or papyrus blossoms, which were also symbols of rebirth.

The most elaborate decoration is seen on the large amphora with strap handles terminating in ibex heads. The high neck is decorated with bands of blue lotus petals, and on the front with a floral necklace, known as a *wah*-collar. Actual examples of these ornaments have been found as burial equipment and in Tutankhamen's embalming cache. The ibex handles are also known from similar vases found in the Valley of the Kings. The ones on this example retain much of their original pigment and have traces of the horns that were cemented into sockets at the tops of their heads, and each wears its own floral collar. The ibex was a symbol of renewal and as such would evoke rebirth when associated with funerary offerings.

The large amphora is decorated at the neck with a band of petals and round flowers, possibly marguerites. Another floral collar is represented on the front along with a pendant lotus and papyrus stalks. The smallest vase is similarly decorated on the front, but the back is inscribed with the names of Ramesses II and wishes that he be given life eternal.

PL

NOTES

[1] Nicholas Reeves and Richard Wilkinson, *The Complete Valley of the Kings* (London, 1996), p. 148.

[2] Zaky Iskander and Abd el Moeiz Shaheen, "Temporary stuffing materials used in the process of mummification in Egypt," *ASAE* 58 (1964), pp. 197–208.

75. Baboon
Middle Kingdom (1980–1630 bc)
Faience
H. 5.2 cm; w. 2.0 cm; d. 2.5 cm

Small figurines of animals, usually in faience, are found in non-royal burials of the Middle Kingdom.[1] These include hippos, dogs and cats, lions, hedgehogs and apes. Their significance is unclear. It has been suggested that they represent the wild animals of the desert found in the wall paintings of more elaborate tombs, or they may be protective deities, as found on other apotropaic objects, such as the "magic wands."

This wonderfully well-preserved figure represents a baboon (*Papio hamadryas*), held sacred to the Egyptians because of its intelligence and its seeming reverence for the sun. Baboons will hold up their palms to the rising sun in the morning to warm them, a gesture taken as praying to the sun god. The details of the Hamadryas baboon, including his heavy brow, broad ruff and spotted coat are all carefully rendered in this example. He is shown crouched and nibbling on a fruit, suggesting the continuation of life.

PL

Notes

[1] Janine Bourriau, *Pharaohs and Mortals: Egyptian Art in the Middle Kingdom* (Cambridge, 1988), pp. 116–17.

75

76. Shabti of Iay
Third Intermediate Period (1075–656 bc)
Bronze
H. 8.3 cm; w. 2.7 cm; d. 1.5 cm

Although countless shabtis were manufactured for Egyptian burials, very few were made of bronze, especially for private individuals.[1] Bronze shabtis were also not commonly produced for royalty, with one attested for Ramesses II and five for Ramesses III. A larger number is attributed to Psusennes, though the exact total is unknown.[2] From the Third Intermediate Period onward, the majority of shabtis were mass-produced in faience, making this figurine rather unusual.

The compact mummiform figure wears a tripartite wig, falling just above the incised brows. The crossed hands are indicated in low relief, though the arms are completely covered by the mummy-wrapping. A crudely carved column of text on the front names the owner of the shabti as "the Osiris Iay…."[3]

BTT

Notes

[1] Peter Clayton, "Royal Bronze Shawabti Figures," *JEA* 58 (1972), p. 167.

[2] Accounts enumerating the shabtis found at Tanis are incomplete and the majority of the figurines were stolen from the excavation magazines in 1943; *ibid.*, p. 172.

[3] This name is not attested in Hermann Ranke, *Die ägyptischen Personennamen* (Glückstadt, 1935), though another figurine inscribed for this individual is listed as lot no. 249, *Christie's New York, June 4, 1999.*

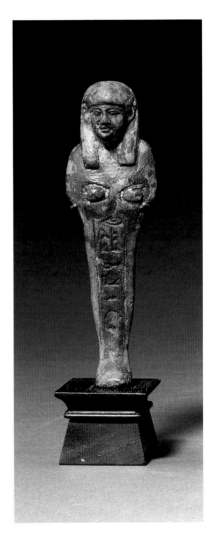

76

77. Shabtis

A. PAY
DYNASTY 21 (1075–945 BC)
FAIENCE
H. 16.8 CM; W. (AT ELBOWS) 5.2 CM

B. *Reis* SHABTI
DYNASTY 21 (1075–945 BC)
FAIENCE
H. 14.9 CM; W. (MAXIMUM) 5.2 CM

C. HENNUTTAWY
DYNASTY 21 (1075–945 BC)
FAIENCE
H. 11.8 CM; W. (AT ELBOWS) 4.5 CM
DEIR EL-BAHRI CACHE (DB 320)

D. NESYTANEBETISHERU
DYNASTY 21 (1075–945 BC)
FAIENCE
H. 14.5 CM; W. (AT ELBOWS) 5.5 CM
DEIR EL-BAHRI CACHE (DB 320)

THE SHABTIS OF THE Third Intermediate Period, particularly those belonging to the members of the Amen priesthood at Thebes, are very distinctive in appearance. Hundreds of figurines, characterized by their deep turquoise color and brilliant glaze, were found in the Royal Cache of Deir el-Bahri (DB 320).[1] Beginning in the late New Kingdom, the deceased was provided with one shabti for each day of the year. Since managing such a sizable workforce was laborious in itself, the deceased employed overseer, or *reis*, shabtis for every ten slaves. As a result, the shabti gangs numbered 401: 36 overseers and 365 slaves.[2]

The greater quantities of figures required for the burial assemblage stimulated mass-production, con-

77A, B

tributing to the similar appearance of the Third Intermediate Period examples. The figures were formed in open molds, with additional paste applied to the back and then modeled. In some cases, the back was simply flattened while still in the mold.

The first shabti in the group, a mummiform figure belonging to a man named Pay, wears the *seshed*-band frequently found on shabtis of this period. The second figure, inscribed for an overseer of the *kheneru* of Amen, exemplifies the *reis* type introduced in the Third Intermediate Period. This form is characterized by a daily-wear wig, long kilt with protruding front panel, and a whip grasped in one hand. The two final shabtis in the group belong to royal women of the Twenty-first Dynasty, Hennuttawy and Nesytanebetisheru.[3] As the

wife of the High Priest of Amen, Pinedjem I, Hennuttawy was among the Theban nobles interred in the Deir el-Bahri Cache. This figurine, with its heavy black wig and blue uraeus, is typical of her shabtis. The shabti of Nesytanebetisheru, a daughter of the High Priest Pinedjem II and Nesykhonsu, is distinguished by the columns of text encircling the lower portion of the body.

BTT

NOTES

[1] Gaston Maspero, *Les momies royales de Déir el-Bahari* (Cairo, 1889), p. 511ff.

[2] Hans Schneider, *Shabtis* (Leiden, 1977), p. v320.

[3] Kenneth A. Kitchen, *The Third Intermediate Period in Egypt* (Warminster, 1986), pp. 47–55; 65–66; Table 8.

77C, D

78. Shabti of Senkamenisken

643–623 BC
SERPENTINE[1]
H. 17 CM; W. 6.0 CM; D. 4.0 CM
FROM NURI, PYRAMID 3[2]

THIS SUPERBLY MODELED piece is a fine example of the individually carved stone shabtis of this king. Each of the shabtis in this group is a work of art in its own right. Senkamenisken was the grandson of Taharqa. Like Taharqa, he adopted the use of hard stone shabtis for his pyramid tomb. Senkamenisken's shabtis were found in his burial chamber, Room B, the stone shabtis clustered together and the faience pieces lined up against the walls of the chamber.

King Senkamenisken had more shabtis made for his tomb than any Nubian or Egyptian king. George Reisner found a record-breaking 1277[3] shabtis, 410 carved of serpentine and 867 made of faience, in his burial chambers in Nuri pyramid 3.[4]

The king wears a plain royal *nemes* headdress with double uraeus.[5] Curiously, the double uraeus, which is ubiquitous on royal Nubian sculpture, is not found on shabtis other than those of King Senkamenisken. A chin strap secures his plaited beard. Small sections of a broad collar are visible between the lappets of the *nemes* and the beard. He holds the archaizing broad hoe in the left hand and a narrow-bladed one in the right. These particular agricultural tools had not been used on shabtis since the New Kingdom. A cord to a small seed bag slung over the left shoulder is also held in the right hand.[6] It is likely that this type of seed bag, which first appeared at the end of Dynasty 25 on shabtis, was inspired by the Nubians.[7]

There are six incised horizontal registers of hieroglyphs bordered by incised register lines. The text is Dunham's Type A, one of the three variants of inscriptions found on Senkamenisken's shabtis.[8] It is Chapter VI from The *Book of the Dead*:

> (1) The illuminated one, the Osiris, the good god, lord of the two lands, King Sekheper|en|re, true of voice. He says: "O this shabti, (2) if anyone summons the Osiris, the King Senkamenisken, true of voice, in order to do any work (3) which is to be done in the necropolis, to cultivate the fields, (4) to

irrigate the canals, to carry sand (5) from the east to the west and vice versa, (6) 'Here I am,' you say."

Unlike their Egyptian counterparts, Nubian shabtis were made solely for royal burials. The iconography of Senkamenisken and other Nubian shabtis is a unique product, blending Egyptian and Nubian motifs. While there were borrowings from Egyptian shabtis, no single type was used as a model. The Nubian craftsmen desired to create a distinctive style, separate from that of the Egyptians.

JLH

BIBLIOGRAPHY

Grogan and Company. The December Auction (1991), Sale #33, no. 754.

NOTES

[1] The Department of Mineralogy of the Royal Ontario Museum analyzed their stone shabti of Senkamenisken ROM 926.15.1 and found it to be serpentine and not steatite, which this stone has often been referred to in Steffin Wenig, *Africa in Antiquity,* vol. II (Brooklyn, 1978), cat. no. 87, p. 175, and Robert S. Bianchi in *Ancient Egyptian Art in the Brooklyn Museum* (Brooklyn, 1989), cat. no. 74.

[2] Formerly in the Egyptian collection of the Museum of Fine Arts, Boston and then sold to the Holyoke Public Library, Holyoke, Massachusetts. Its original Field Number is 17-2-1185.

[3] While vast numbers of shabtis are frequently referred to, it is noteworthy that shabtis for only Senkamenisken with 1,277 and Taharqa with 1,070 were produced in vast numbers. In nearly all the rest of the Nuri tombs, the numbers of shabtis actually were closer to an Egyptian norm, with 50 to 400 shabtis.

[4] Dows Dunham, *The Royal Cemeteries of Kush,* vol. 2, *Nuri* (Boston, 1955), p. 43, 280, fig. 197 I 4d, p. 256, fig. 200; p. 280; pl. CXL, I 4d.

[5] Bianchi, *op. cit.,* cat. no. 74, and other scholars have cited two wooden shabtis of Ramesses VI in the British Museum, nos. 29998 and 29999, as the first Egyptian king to wear the double uraeus. However, on closer examination, it is clear that these shabtis of Ramesses VI wear the vulture and cobra, and not the double uraeus.

[6] Typology after Dunham, *op. cit.,* p. 255, fig. 199, I 4d.

[7] Joyce L. Haynes and Ronald J. Leprohon, "Napatan Shawabtis in the Royal Ontario Museum," *JSSEA* XVII, nos. 1–2 (1987), p. 26, notes 67, 68. However, note minor variations in the details of the bag.

[8] Dunham, *op. cit.,* p. 256, fig. 200.

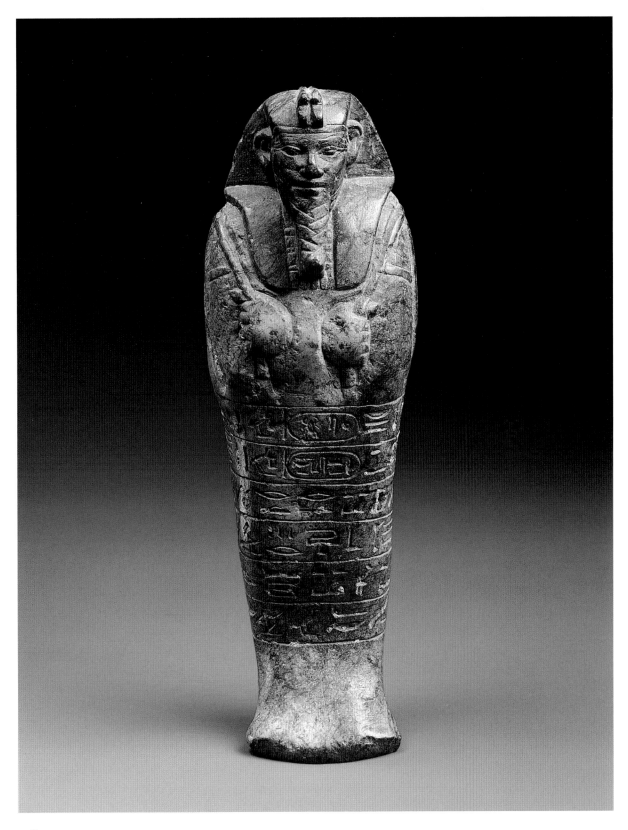

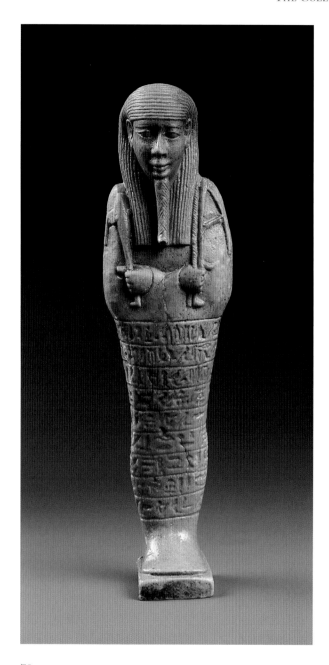

79

79. Shabti of a woman named Semset

PTOLEMAIC PERIOD (332–30 BC)
FAIENCE
H. 16.5 CM; W. 4.4 CM; D. 3.0 CM

THIS SHABTI IS FINELY detailed with a distinctive face. The mummiform figure is in the pose of the typical Late Period shabti. The tripartite hair is striated and the beard plaited. The arms are crossed, right over left. The left hand holds a pick, and the right hand holds a hoe and the cord of a small, square seed bag slung over the left shoulder. The tools are crisply modeled in high relief. The figure is supported by a narrow back pillar and small square base.

There are nine rows of incised hieroglyphs that recount the shabti spell, Chapter 6 from the *Book of the Dead*. The very long, thin beard, full cheeks and the use of the *maat* feather in the expression *maat kheru* suggest an early Ptolemaic date for this piece. This shabti belongs to a woman named Semset.[1] Another early Ptolemaic shabti with this name, whose mother's name is Nefert-Renpet,[2] comes from the collection at the Musée George Labit in Toulouse (Inv.–nr. 49–38).[3] While the mother's name on the Thalassic piece is difficult to read, it is possible that this shabti represents the same individual.

JLH

NOTES

[1] Hermann Ranke, *Die ägyptischen Personnenamen* I (Glückstadt, 1935), 307.27.

[2] *Ibid.*, 224.11.

[3] Hermann A. Schlögl and Christa Meves-Schlögl publish three shabtis of this individual; cf. *Uschebti. Arbeiter im ägyptischen Totenreich* (Wiesbaden, 1993): no. 22, p. 62; no. 22a, p. 68; and 22b, pp. 71–72.

80. Figure of a cat

LATE-PTOLEMAIC PERIODS (664–30 BC)
BRONZE
H. 10.4 CM; W. 4.6 CM; D. 8.2 CM

In the Late Period and thereafter, sacred animals were bred, mummified and presented as offerings in temples before being buried in special necropoleis. The coffins for these mummies took two forms: a narrow box with a figure of the animal on the lid, or the shape of the animal itself. The diminutive size of this figure precludes its use as a container; tangs below the tail and forepaws further indicate that the cat decorated a bronze or wood coffin.

The cat (*Felis sylvestris libyca*) sits upright, with the ears, both incised and pierced, turned forward alertly. The face is elegantly modeled, and a scarab is engraved on the top of the head. The cat wears an aegis hanging from a strand of cowrie shells. The necklace is tied at the nape of the neck, with three tassels that fall alongside a suspension loop.

BTT

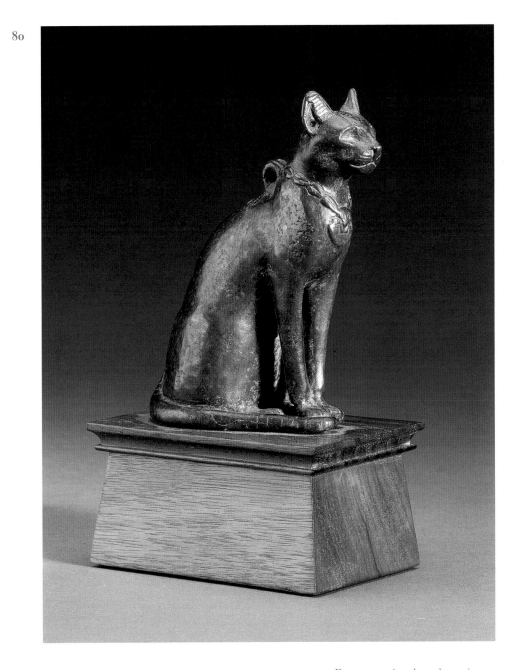

80

81. Falcon-head terminal

THIRD INTERMEDIATE PERIOD (1075–656 BC)
BRONZE, GOLD
H. 4.1 CM; W. 3.2 CM; D. 5.4 CM

THIS SMALL BRONZE FITTING depicts the head of a falcon (*Falco biarmicus* or *F. peregrinus*), wearing a striated, divine wig and broad collar, the stripes of both inlaid with gold. The eyes, beak and distinctive facial markings of the falcon are precisely incised. The god most frequently portrayed as a falcon is Horus, though the absence of a distinguishing headdress prevents certain identification.[1]

The function of the piece remains unclear. Its base extends backward, with remains of another projection at the lower edge of the wig, forming a rectangular opening. Since the base is solid, the head could not have surmounted an item such as a staff, but may have fitted over the end of a horizontally-oriented object. The head may have adorned of a piece of temple equipment, perhaps used to transport a divine image in procession.[2]

BTT

NOTES

[1] There are no remnants of a headdress, such as a break or hole atop the head.

[2] Günther Roeder, *Ägyptische Bronzefiguren* (Berlin, 1956), pp. 479–80, fig. 736.

81

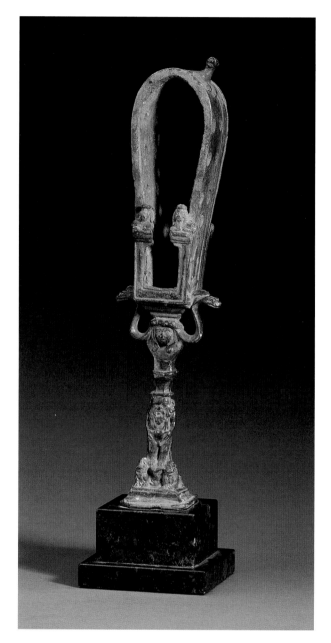

82

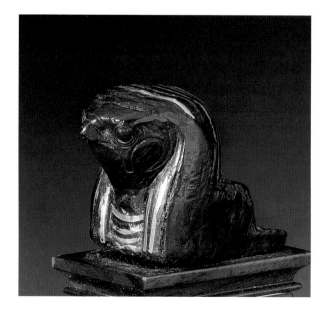

82. Sistrum

FIRST–SECOND CENTURY AD
BRONZE
H. 30.2 CM; W. 7.9 CM; D. 6.2 CM

A CEREMONIAL INSTRUMENT, the sistrum, a type of rattle, was played during various religious rituals. It is primarily associated with the goddess Hathor, but the cat-headed goddess Bastet also carried the sistrum as one of her attributes.

The handle of this highly decorated sistrum is in the shape of the dwarf god, Bes, who is flanked by a pair of lions on the base. Bes's crown supports Janiform Hathor heads and cobra heads, *uraei* that extend up to the base of the soundbox. The sides of the sound-box have perforations for the four wire rattles that are now missing. A pair of sphinxes adorns the front of the soundbox and a cat nursing her kittens on the top is an apparent reference to Bastet.

PR

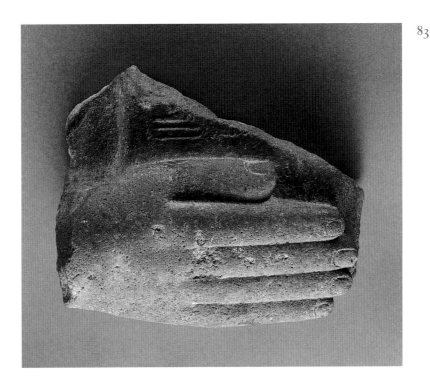

83

83. Hand from a naophorous statue

Dynasties 19–20 (1292–1075 bc)
Quartzite
H. 8.0 cm; w. 12.5 cm

This fragment of an outstretched hand originally belonged to a naophorous statue. A ledge extends at a right angle from the thumb, and contains the remains of two vertical columns of text that would have adorned the side of the naos. The near column is broken away, presumably after the owner's name, as indicated by the remains of a seated noble with a flail[1] followed by the word *maa-kheru*, "justified." In the far column, only an *n* is preserved. The undercutting of the edge suggests that the naos would have been connected to the body of the supplicant by a small bridge of stone.[2]

Naophorous statues appear in the Eighteenth Dynasty, and become extremely popular in the later New Kingdom and Late Period, where they depict the owner standing or kneeling.[3] The use of quartzite, the placement of the hand, and its relationship to the naos ledge suggest that this fragment once belonged to a Ramesside ensemble in which the deceased embraced a naos or chapel that contained the figure or emblem of a deity.[4] Depicted in this posture, the statue owner

both protected and renewed the god or goddess, and thereby assured his own rebirth.[5]

MKH

NOTES

[1] Alan H. Gardiner, *Egyptian Grammar* (Oxford, 1957), p. 447, Sign-list A 52.

[2] As for example in the naophorous statue of Gemnefhorbak, Vienna, Kunsthistorisches Museum, ÄS 62, in Wilfried Seipel, *Gott. Mensch. Pharao. Viertausend Jahre Menschenbild in der Skulptur des Alten Ägypten* (Vienna, 1992), pp. 394–95, cat. no. 158.

[3] Jacques Vandier, *Manuel d'Archéologie Egyptienne*, vol. III: *Les Grandes Epoques, La Statuaire* (Paris, 1972), pp. 468–71.

[4] Compare Cairo Museum, CG 42175 (Georges Legrain, *Statues et Statuettes de rois et de particuliers Nos. 42001–42250*, Catalogue Général, vol. 2 (Cairo, 1909), p. 41, pl. XXXIX); Cairo Museum CG 42147 (Mohamed Saleh and Hourig Sourouzian, *The Egyptian Museum, Cairo: Official Catalogue* [Mainz, 1987], no. 209).

[5] Hans D. Schneider, *Life and Death under the Pharaohs: Egyptian Art from the National Museum of Antiquities in Leiden, The Netherlands* (Perth, 1996), p. 72, no. 93.

The Bastis Magical Head
84. Magical head[1]
DYNASTY 30–EARLY PTOLEMAIC PERIOD (381–282 BC)
GRAY TO LIGHT BROWN HARD, HOMOGENEOUS STONE
(POSSIBLY A FELDSPATHIC ROCK)
H. 4.5 CM; W. 3.7 CM; D. 4.4 CM

CARVED FROM A STONE rarely used for Egyptian sculpture, this head of a man wears what Egyptologists call a bag wig because of its shape. To judge from the style of the face and the precise carving of both it and the figures that adorn it, the head probably dates to the fourth century BC, although it could possibly be from the very early third century BC.

The figures of deities on the wig and the remnant of the back pillar are part of a corpus of magical texts and illustrations. The identity of the deities is often difficult to determine because, as here, they lack identifying labels and some figures could represent more than one deity.[2] What can be said is that the winged scarab beetle on the forehead (possibly once gilded) is a symbol of generation and regeneration, and that the other deities can be associated with similar concepts and with divine protection. It is the presence of these images on the head and, quite possibly, over the missing parts of the figure, that demonstrates it came from a magical healing statue.

For the ancient Egyptians, *heka,* the word Egyptologists translate as "magic," was real and a part of the natural scheme of things. Personified as a god, *heka* was the power used by the creator, was also possessed by the gods, and could be used by human beings as well.[3] It is thus not surprising that *heka* and medicine were inextricably linked in ancient Egypt, perhaps especially in connection with the venomous stings and bites of scorpions, snakes and other noxious beasts not easily curable by the scientific medical knowledge of pharaonic Egypt.[4] As a result, magical texts and images aimed at preventing or curing such wounds are known from ancient Egypt long before the Bastis magical head was created.

A great many of the texts and images just mentioned came to relate to the myth of the goddess Isis and her son Horus (see cat. 87a–c), who was cured by magic from the bites of noxious animals and hence gained power over such afflictions. With the increas-

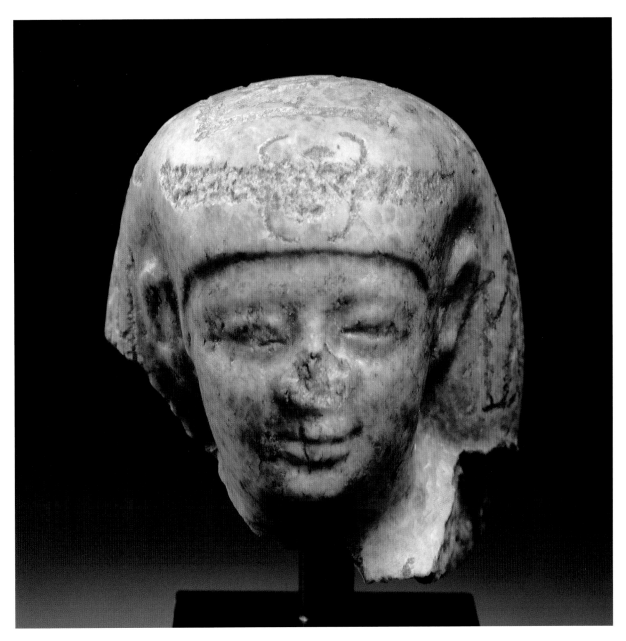

84

ing emphasis on child gods that began in the first millennium BC[5] came the rise in popularity of healing stelae, called *cippi*, adorned with magical spells, a figure of the child Horus controlling dangerous animals.[6] Other deities may also be depicted with Horus. Magical healing statues of the type from which the Bastis magical head came normally held an image of a *cippus* before them. Except for the face, hands and feet, the rest of the figure would have been covered with magical texts and figures. Such statues were apparently a later invention than *cippi*, the earliest

dated examples being of the fourth century BC. Some of these statues had mature and realistic faces, some were totally idealizing, and some, like the Bastis magical head, display features of a mature cast that are neither highly realistic nor the standard idealizing features known from other sculptures of its age.[7]

It must also be noted that there may have been earlier prototypes of sorts for magical healing statues.[8] Adorning the wigs and robes of sculptures with images of deities is certainly known in the New Kingdom and began to become more common soon there-

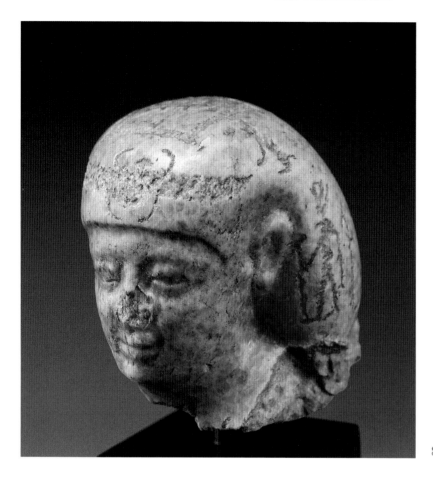

84

after. For example, one private statue of the Third Intermediate Period (Dynasties 21–25) in the British Museum, and another in Berlin that is possibly of that era, have three-dimensional images of scarabs atop their wigs, and deities on the sides of their wigs. The Berlin figure is a head from a statue of a priest and a physician.[9]

It is not known precisely how *cippi* and healing statues were used. In some cases liquid, probably most often water, was poured over the sculpture, possibly accompanied by the recitation of the proper spells. The liquid, having absorbed the power of the inscriptions, was then drunk or perhaps applied to the body or wound. There may have been attempts to access the same power by kissing or touching the statue or stela or touching it to the afflicted part of the body.

Evidence suggests a number of locations where such statues and stelae were used, including both temples and cemeteries. In a cemetery, the healing or preventive magic might benefit both living visitors to the tomb and the dead buried there. For temples, there is some evidence, although limited, of small chapels of healing magic that may have held such monuments. While there is little evidence that they have any direct relationship to the specific deity of a temple,[10] in at least two cases healing monuments can be related to structures dedicated to a child god, Khonsu-the-Child, who can himself be associated with Horus-the-Child.[11]

Whatever its origin, the Bastis magical head is not only a finely carved "miniature" object in hard stone, it is also a relatively rare object. A recent catalogue of healing statues of private people (as opposed to deities) includes just over fifty examples, a significant number of which are fragments lacking heads.[12]

RF

Bibliography

See notes 1, 2, 11; Jaromír Málek, assisted by Diana Magee and Elizabeth Miles, *Topographical Bibliography of Ancient Egyptian Hieroglyphic Texts, Statues, Reliefs and Paintings,* vol. VIII, Part 2 (Oxford, 1999), p. 886, no. 801-765-162; *Antiquities from the Collection of the Late Christos G. Bastis,* sales cat., *Sotheby's, New York, December 9, 1999,* p. 42, lot. 23.

Notes

[1] Acquired by Christos G. Bastis from Charles Dikran Kelekian in 1975, acquired by the Thalassic Collection in 1999.

[2] Cf. Robert Bianchi, "Egyptian Art from the Bastis Collection," *Apollo* CVII (1978), pp. 153–54; and Bernard V. Bothmer in Dietrich von Bothmer *et al., Antiquities from the Collection of Christos G. Bastis* (Mainz am Rhein, 1987), pp. 67–69, for two attempts at partial identifications of the figures. Bothmer is incorrect in seeing the serpent in a mound as wearing an *atef*-crown: all that is represented are horns surmounted by a solar disk.

[3] Two recent works in English on ancient Egyptian magic are Robert Ritner, *The Mechanics of Ancient Egyptian Magical Practice,* SAOC 54 (Chicago, 1993); and Geraldine Pinch, *Magic in Ancient Egypt* (London, 1994).

[4] László Kákosy, *Egyptian Healing Statues in Three Museums in Italy (Turin, Florence, Naples),* Catalogo de Museo Egizio di Torino, Serie Prima—Monumenti e Testi, vol. IX (Turin, 1999), p. 9. The Bastis magical head is mentioned on p. 17.

[5] Cf. Richard Fazzini, *Egypt, Dynasty XXII–XXV,* Iconography of Religions XVI, 10 (Leiden, 1988), p. 9, with references.

[6] For a major study of healing stelae, see now Heike Sternberg-El Hotabi, *Untersuchungen zur Überlieferungsgeschichte der Horusstelen. Ein Beitrag zur Religionsgeschichte Ägyptens im 1. Jahrtausend v.Chr,* I–II, ÄA 62 (Wiesbaden, 1999).

[7] Bianchi, *op. cit.,* p. 153; Bothmer *op. cit.,* p. 67.

[8] Cf. Sternberg-El Hotabi, *op. cit.,* vol. II, p. 108 (Oxford, Ashmolean Museum: Stelophoros Inv.-Nr. 1990.60), p. 101 (Debreen [Hungary], Museum Déri: Kniender Mann mit Horusstele). To judge from the photograph in the Corpus of Late Egyptian Sculpture, the Museum Déri figure, which has relatively few figures on the body and holds a naos containing Horus on crocodiles, could be earlier than the fourth century BC. Also cf. Sternberg-El Hotabi's comments on p. 98 of her vol. I, concerning the combination of statuette and Horus stela being an innovation of Dynasty 26.

[9] British Museum 2007 (also decorated on the sides of the body): Regine Schulz, *Die Entwicklung und Bedeutung des kuboiden Statuentypus. Eine Untersuchung zu den sogenannten "Würfelhockern,"* II, HÄB 34 (Hildesheim, 1992), pp. 598, 623–24, and pl. 144b; and Berlin 253: *ibid.,* pp. 623–24, and pl. 145a–b. For the possible Third Intermediate Period date of Berlin 253, see B. van de Walle and Herman De Meulenaere, "Compléments à la prosopographie médicale," *RdE* 25 (1973): p. 62, where it is identified as Jonckheere No. 23: Pa-ân-meniou. In the Third Intermediate Period, an incised winged scarab and several deities were added to the wig of a New Kingdom block statue from the Karnak Cachette (JE 36994, K. 138, not illustrated in photographs). For the date see Claude Traunecker, "Un document inédit sur une famille de militaires contemporaine de la XXIIe Dynastie," *BIFAO* 69 (1970), p. 234.

[10] Claude Traunecker, "Une Chapelle de magie guérisseuse sur le parvis du temple de Mout à Karnak," *JARCE* 20 (1983), p. 76.

[11] *Ibid.* (with introduction by Richard Fazzini and William Peck), pp. 65–92; Heike Sternberg el-Hotabi, "Magische Stele," *JSSEA* 18 (1988), pp. 14–18 = Appendix I to Donald Redford, "The Excavation of Temple C: First Preliminary Report," pp. 1–23.

[12] Sternberg-El Hotabi, *op. cit.* (1999), vols I–II. Pp. 99–111 of vol. II is a catalogue of healing statues, with the Bastis magical head included on p. 107.

84

Divine amulets

85A

identified as a child by his nakedness and the hairstyle of youth, a side-lock.

This triad amulet was especially popular in the Saite Period. A loop for suspension at the top allowed it to be worn in daily life as well as included in the funerary trappings. This Osirian image was a powerful symbol of rebirth and resurrection.[1]

JLH

NOTES

[1] For other examples see Carol Andrews, *Amulets of Ancient Egypt* (London, 1994), back cover; W.M.F. Petrie, *Amulets* (London, 1914), pl. XXVII, no. 152 a–b; Birgit Schlick-Nolte and Vera von Droste zu Hülshoff, *Liebieghaus, Museum Alter Plastik.* Vol. I: *Skarabäen, Amulette und Schmuck* (Melsungen, 1990), pp. 214–17, cat. nos. 170–74.

85. Triad amulet of Isis, Horus-the-Child and Nephthys

A.
LATE PERIOD (664–332 BC)
FAIENCE
H. 4.7 CM; L. 2.6 CM; D. 1.0 CM

B.
LATE PERIOD (664–332 BC)
FAIENCE
H. 3.6 CM; L. 2.1 CM; D. 1.1 CM

C.
LATE PERIOD (664–332 BC)
FAIENCE
H. 4.2 CM; L. 3.3 CM; D. 1.4 CM

D.
LATE PERIOD (664–332 BC)
FAIENCE
H. 2.2 CM; L. 1.4 CM; D. 0.4 CM

AMULET A

THIS AMULET BEARS the powerful Osirian triad, consisting of Isis, the wife of Osiris; her sister, Nephthys; and Horus, the child of Osiris. The two goddesses flank the child-god and hold his hands. The striding figures are in high relief against a large plaque. The goddesses wear their hieroglyphic symbols as crowns, and classic sheath dresses. Horus is

86

86. Amulet of Isis

LATE PERIOD (664–332 BC)
FAIENCE
H. 2.2 CM; W. 0.7 CM; D. 1.0 CM

IMAGES OF THE STANDING ISIS were worn as amulets as early as the New Kingdom. However, they were most popular from Dynasty 26 to the early Ptolemaic Period.[1] At this time, figures representing funerary gods and goddesses were especially popular and found in large groups on the mummy. Isis, the wife of Osiris, was a prominent figure as she was responsible for mourning over Osiris and preparing him for mummification. In this way she aided in his burial and resurrection. Wearing the figure of Isis would bring to the deceased assurance of rebirth in the Next World, as well as protection. This striding figure wears the symbol of her name, the throne, as her crown and the classic sheath dress and tripartite hairstyle. The arms

rest at her sides with an open space between the arms and body. The figure stands on a small base and has a back pillar that is pierced for suspension.[2]

JLH

NOTES

[1] Sue D'Auria, Peter Lacovara, and Catharine H. Roehrig, eds., *Mummies and Magic: The Funerary Arts of Ancient Egypt* (Boston, 1988), p. 182.

[2] For parallels, *ibid.*, p. 181, fig. 129 l and W.M.F. Petrie, *Amulets* (London, 1914), p. 35, pl. XXVI, no. 149.

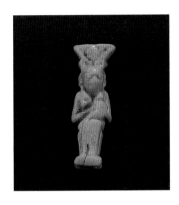

87A

87. Amulet of Isis suckling Horus

A. WEARING CROWN OF SUN DISK AND HORNS
THIRD INTERMEDIATE PERIOD (1075–656 BC)
FAIENCE
H. 2.2 CM; W. 0.7 CM; D. 1.0 CM

B. WEARING CROWN OF SUN DISK AND HORNS
THIRD INTERMEDIATE PERIOD (1075–656 BC)
FAIENCE
H. 2.3 CM; W. 0.8 CM; D. 1.2 CM

C. FRAGMENT WEARING THE THRONE AS CROWN
LATE PERIOD (664–332 BC)
FAIENCE
H. 3.3 CM; W. 1.4 CM; D. 1.5 CM

AMULET A

ISIS WAS THE ARCHETYPAL mother goddess. Here in her most characteristic pose, the seated goddess holds her infant Horus to her breast, supporting his head with her left hand.[1] As one version of the legend of Isis and Osiris recounts, Isis conceived Horus after briefly reviving Osiris from the dead. The child Horus

avenged his murdered father Osiris, and became the next king on earth. Symbolically all kings were likened to Horus, and considered divine. Images of this type were found as early as the Ramesside Period, but became popular in the Third Intermediate Period and later.[2] Here the Goddess Isis wears the crown consisting of horns and sun disk, which can also be worn by Hathor and other goddesses. Behind the unadorned throne, the back pillar is pierced for suspension.

JLH

NOTES

[1] Compare W.M.F. Petrie, *Amulets* (London, 1914), pl. XXVI, 148c–g.

[2] Carol Andrews, *Amulets of Ancient Egypt* (London, 1994), p. 48.

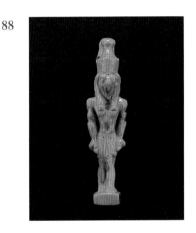

88

88. Amulet of striding Horus

LATE PERIOD (664–332 BC)
FAIENCE
H. 2.9 CM; W. 0.6 CM; D. 0.9 CM

WHILE MANY DIFFERENT falcon-headed gods exist, the double crown suggests that this finely featured, striding falcon-headed male represents Horus, son of Osiris. Wearing this amulet would give one the protection of Horus, avenger of his father. During the Late Period, the falcon amulet was often placed on the chest of the mummy.[1]

Here Horus is wearing a tripartite hairstyle and a short pleated kilt.[2] His muscular body is well defined with the smallest details delineated, such as calf muscles and incised toes. The facial features are also carefully

modeled. The figure stands on a small base and has a back pillar that is pierced for suspension.

JLH

Notes

[1] Sue D'Auria, Peter Lacovara, and Catharine H. Roehrig, eds., *Mummies and Magic: The Funerary Arts of Ancient Egypt* (Boston, 1988), p. 183.

[2] Compare Carol Andrews, *Amulets of Ancient Egypt* (London, 1994), fig. 26c; W.M.F. Petrie, *Amulets* (London, 1914), pl. XXXI, 180h, and Lawrence M. Berman, *Catalogue of Egyptian Art* (Cleveland, 1999), cat. no. 446.

89

89. Seated falcon amulet

Late Period (664–332 BC)
Green feldspar (amazonite)
H. 2.9 CM; W. 1.2 CM; D. 1.9 CM

Amulets in the form of a falcon, or a falcon-headed man, represent the god Horus, son of Osiris and Isis, and the earliest state god of Egypt. The king, a mediator between god and man, was "the living Horus" and the healing "eye of Horus" was one of Egypt's most popular amulets. As the avenger of his father's murder by Osiris's malevolent brother Seth, Horus was a symbol of the triumph of life over death, of goodness over evil.

Animal-headed deities were depicted seated and standing, alone or in multiples, and with or without a headdress.[1] For falcon gods, the headdresses include the solar disk,[2] double plumes with sun disk,[3] and

atef crown. An early falcon-headed amulet with no headdress, worn by young king Tutankhamen, was crafted of gold inlaid with lapis lazuli. This falcon, made of pale green feldspar, would have placed the wearer under the protection of this powerful, mythic god.

YJM

Notes

[1] Carol Andrews, *Amulets of Ancient Egypt* (Austin, 1994), p. 28.

[2] The falcon with solar disk represents Re-Horakhty—Horus of the Horizon.

[3] The falcon god wearing a double-plume headdress with sun disk represents Montu, the Theban war god.

90A

90. Falcon-headed amulets

A.
Late Period (664–332 BC)
Faience
H. 2.9 CM; W. 1.2 CM; D. 0.8 CM

B.
Late Period (664–332 BC)
Faience
H. 2.4 CM; W. 0.6 CM; D. 0.7 CM

Falcon-headed amulets wearing solar disks with uraei represent the god Re-Horakhty, a manifestation of the sun god whose cult center was Heliopolis. A composite of Re—supreme god of the ennead—and Horakhty—Horus of the Horizon—this cosmic deity symbolized the morning sun and was therefore part of a renewable cycle of birth, life, and death.[1]

Re-Horakhty received special attention during the early years of King Akhenaten's reign at Karnak.

A relief block with the god's image illustrates the royal preference for solar deities that evolve into the universal sun god Aten after the king and his court move to the new capital city in middle Egypt.[2] While Atenism disappears shortly after the king's death, solar religion and its various manifestations continue as a dominant force in Egyptian religious thought.

Funerary amulets depicting Re-Horakhty, made of precious materials, appear first in royal burials dating to the Third Intermediate Period. By the Late Period, faience examples are commonly included among the set of amulets sewn onto mummy wrappings.[3]

<div align="right">YJM</div>

NOTES

[1] Angela P. Thomas, *Egyptian Gods and Myths* (Aylesbury, 1986), pp. 19, 60.

[2] Rita E. Freed, Yvonne J. Markowitz, and Sue H. D'Auria, eds., *Pharaohs of the Sun: Akhenaten, Nefertiti, Tutankhamen* (Boston, 1999), cat. no. 20, p. 207.

[3] Carol Andrews, *Amulets of Ancient Egypt* (Austin, 1994), p. 29.

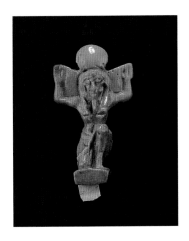

91A

91. Amulets of Shu
A.
LATE PERIOD (664–332 BC)
FAIENCE
H. 2.5 CM; W. 1.3 CM; D. 1.2 CM

B.
LATE PERIOD (664–332 BC)
FAIENCE
H. 2.6 CM; W. 1.7 CM; D. 1.2 CM

AMULET A

THE GOD SHU IS REPRESENTED here with right knee bent and arms raised, palms forward in the *ka* sign. In the Heliopolitan version of creation, Shu was one of the first gods created by the sun god. He represented air, and with his consort Tefnut, who represented moisture, created the earth god, Geb, and the sky goddess, Nut. Shu, the air, separated the sky from the earth. In this pose he is symbolically holding up the sky, which the Egyptians envisioned as a canopy over the earth. Examples of this type of amulet are found most commonly in Dynasty 26, and they are placed over the lower torso of the mummy.[1]

Here Shu is crowned with a uraeus and sun disk. He wears a short kilt and has a tripartite hairstyle and long beard. The back is contoured with a loop for suspension.[2]

<div align="right">JLH</div>

NOTES

[1] Carol Andrews, *Amulets of Ancient Egypt* (London, 1994), p. 19.

[2] Compare *ibid.,* fig. 11e, and W.M.F. Petrie, *Amulets* (London, 1914), pl. XXX, nos. 167d, e.

92. Nefertum

LATE PERIOD (664–332 BC)
FAIENCE
H. 5.7 CM; W. 1.0 CM; D. 1.8 CM

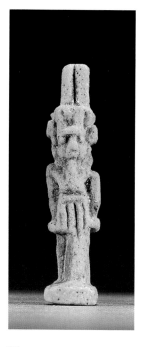

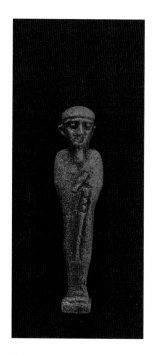

92 93

NEFERTUM, AN EARLY GOD of Lower Egypt, was usually represented as a man wearing a lotus-blossom headdress surmounted by double plumes and two necklace counterpoises (*menat*s). Other features include a long wig, pleated kilt, and divine beard. The Egyptians believed that he emerged from the sacred blue lotus as it floated on the dark waters of Nun. As the personification of this fragrant flower, his perfume was inhaled each morning by the sun-god Re.[1]

According to another legend, Nefertum was the son of the god Ptah and his consort, the lion-goddess Sakhmet. Together, the three deities formed the divine triad associated with the Memphite region.[2] Standing and seated amulets of Nefertum first occur in the Third Intermediate Period and are made of a variety of materials, including gilt silver, silver, bronze, and faience.[3] Occasionally, the god is shown standing on a recumbent lion—a syncretism between Nefertum and Mahes, a lion deity venerated in the Delta.[4]

YJM

BIBLIOGRAPHY

Christie's, New York, Friday, June 4, 1995.

NOTES

[1] Florence Friedman, ed., *Gifts of the Nile: Ancient Egyptian Faience* (Providence, 1998), cat. no. 120, p. 227.

[2] Carol Andrews, *Amulets of Ancient Egypt* (Austin, 1994), pp. 18–19.

[3] Georg Steindorff, *Catalogue of the Egyptian Sculpture at the Walters Art Gallery* (Baltimore, 1946), pp. 125–26, pl. 83.

[4] A particularly fine example was discovered in the burial (G 7510 Z) of a Late Period official by George Reisner at Giza (MFA 1927.1014). For a Third Intermediate Period example of Mahes wearing the crown of Nefertum, see Andrews, *op. cit.*, p. 24, no. 21d.

93. Amulet of Ptah

LATE PERIOD (664–332 BC)
FAIENCE
H. 4.2 CM; W. 0.9 CM; D. 0.7 CM

THE CREATOR-GOD PTAH of Memphis is commonly represented in mummiform shape with hands emerging to grasp a *was* scepter. He wears a skull cap and straight beard.[1] Amulets of Ptah, however, are not common.

This figure stands on a small base and is supported by a very narrow and deep back pillar, which is pierced so that the amulet could be suspended and worn on a cord.

JLH

NOTES

[1] Compare Carol Andrews, *Amulets of Ancient Egypt* (London, 1994), fig. 11c, and W.M.F. Petrie, *Amulets* (London, 1914), pl. XXXI, no. 177.

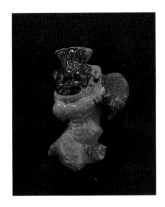

94A

B, C. AMULETS OF STANDING BES
THIRD INTERMEDIATE PERIOD–LATE PERIOD,
(1075–332 BC)
FAIENCE
AMULET B: H. 6.1 CM; W. 1.8 CM; D. 2.0 CM
AMULET C: H. 2.8 CM; W. 1.3 CM; D. 0.8 CM

AMULET B

Bes stands facing front with his hands on his thighs, naked except for his characteristic feather headdress, perhaps his most typical form. The half-lion, half-man protector-god is shown here grimacing with deeply arched eyebrows that together form a 'V' that reaches to the base of the crown. He has rounded lion ears and a broad feline nose. The ruff around the face looks more like a beard in this example. He has an indented round navel, and his genitals are indicated. His tail hangs down between the legs. The crown is composed of a base of standing uraei topped with striated feathers. The faience has a reddish-purple body with deep blue glaze. Amulets of Bes can be found into Roman times, and this form of Bes is common from the Third Intermediate to the Late Period. Images of Bes were especially worn in daily life, but they also were a protective amulet in the tomb.[3]

JLH

94. Amulets of Bes
A.
DANCING BES
NEW KINGDOM (1539–1075 BC)
POLYCHROME FAIENCE
H. 2.6 CM; W. 1.8 CM; D. 0.8 CM

Bes was the personal protector-god of women in childbirth, children and the innocent sleeper. His images were found in the home and were commonly worn by the living as protection. He is part lion and part man, always naked. The grimacing face is frontal with a ruff around it, and a mane falls behind his rounded lion ears. Bes was one's own fierce protector. The feathered crown is a characteristic feature of this god.

Amulets of Bes first occurred in the New Kingdom. This fine example of the dancing Bes is one New Kingdom type. In this lively contraposto pose, the god beats a tambourine and dances. Molds to make amulets for the dancing Bes figure have been found in Malqata and Amarna.[1] In texts from Hathor's temple in Philae and Dendera, the god states that he dances to please Hathor, and he beats the tambourine for her *ka*.[2] The figure of the dancing Bes with tambourine can be found in relief and sculpture until the Ptolemaic Period.

Noteworthy is the colorful dark blue glaze for the face and crown and red for the tambourine. Curiously, the left forearm has pale blue glaze on it. The bracelet on the right wrist is indicated by incised lines, as is the rib cage. The back of the figure is sculptural, and the holes for suspension are pierced side–to–side through the top of the crown. The legs and long lion's tail are broken off.

JLH

94B

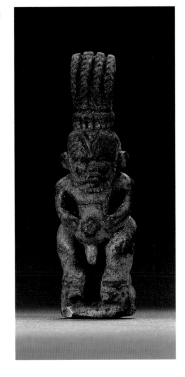

D, E. Amulets of head of Bes
Third Intermediate Period (1075–656 BC)
D. Faience
H. 3.0 CM; W. 3.5 CM; D. 0.9 CM
E. Frit
H. 3.5 CM; W. 3.8 CM; D. 0.8 CM

Amulet D

From the Third Intermediate Period onwards, the head of Bes alone becomes a separate type of amulet.[4] The head is molded with a flat back, and the loop for suspension is at the top of the head. As is often the case with this type of amulet, the characteristic feather headdress is absent, and only the low modius is present. The whiskers here are a series of straight incised lines, and the mouth with thick lips is slightly open. The indented nostrils of the broad nose are clearly visible, and the cheeks are in high relief, like round balls.[5]

JLH

Notes

[1] Arielle Kozloff and Betsy Bryan, eds., *Egypt's Dazzling Sun: Amenhotep III and His World* (Cleveland, 1992), pp. 226–27.

[2] *Ibid.*, p. 226, notes 1,2.

[3] Compare Carol Andrews, *Amulets of Ancient Egypt* (London, 1994), figs. 37b and d; and W.M.F. Petrie, *Amulets* (London, 1914), pl. XXXIII, no. 188–XXXIV, no. 189.

[4] Andrews, *op. cit.,* p. 40.

[5] *Ibid.*, figs. 15a, d, and Petrie, *op. cit.*, pl. XXXIV, no. 190c–e; Birgit Schlick-Nolte and Vera von Droste zu Hülshoff, *Liebieghaus, Museum Alter Plastik,* vol. I, *Skarabäen, Amulette und Schmuck* (Melsungen, 1990), pp. 225–27, nos. 188–89.

94D

95. Ptahtek amulets

A.
Ptahtek amulet with pendant
Late Period (664–332 BC)
Faience
H. 3.7 CM; W. 1.5 CM; D. 1.2 CM

B.
Head from a Ptahtek amulet
Late Period (664–332 BC)
Bichrome faience
H. 2.7 CM; W. 2.3 CM; D. 1.8 CM

C.
Inscribed Ptahtek amulet
Late Period (664–332 BC)
Faience
H. 6.3 CM; W. 2.0 CM; D. 1.3 CM

D.
Double-faced Ptahtek amulet
Late Period (664–332 BC)
Faience
H. 2.4 CM; W. 1.0 CM; D. 1.0 CM

E.
Ptahtek amulet with flat back
Late Period (664–332 BC)
Faience
H. 2.0 CM; W. 1.0 CM; D. 0.5 CM

F.
Ptahtek surmounted by a scarab
Late Period (664–332 BC)
Faience
H. 5.0 CM; W. 2.4 CM; D. 2.2 CM

G.
Openwork Ptahtek amulet
Late Period (664–332 BC)
Faience
H. 2.6 CM; W. 1.4 CM; D. 1.0 CM

Ptahtek is a late Egyptian amalgam of the Memphite deities Ptah, a creator god, and Sokar, a hawk-headed manifestation of Osiris. Both Ptah and Sokar are associated with craftsmen: Ptah brings forth

95A

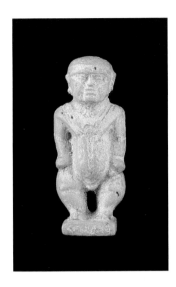

Notes

[1] See George Hart, *A Dictionary of Egyptian Gods and Goddesses* (London, 1986), pp. 173–77; 202–203.

[2] Ola El-Aguizy, "Dwarfs and Pygmies in Ancient Egypt," *ASAE* 71 (1987), pp. 53–60.

[3] An unusual variant has a ram's head and wings that extend from the shoulders to the feet. See Beatrix Geßler-Löhr et al., *Ägyptische Kunst im Liebieghaus* (Frankfurt, 1981), nos. 46–47.

[4] For several examples of Napatan date from el Kurru, see Dows Dunham, *The Royal Cemeteries of Kush,* vol. 1, *el Kurru* (Boston, 1950), pls. L, LI, and LIIA.

[5] For a Ptahtek amulet from ancient Israel, see "An Iron Age Amulet from Galilee," *Biblical Archaeology Review,* vol. 21, January/February 1995, no. 1, p. 44.

96

life through speech, while Sokar magically combines materials to form ritual objects and substances.[1]

By the seventh century BC, Ptah-Sokar underwent a transformation through the adoption of a dwarf-like body, perhaps an allusion to an Old Kingdom association of dwarves with jewelry fabrication.[2] When Herodotus visited the temple of Hephaistos in Memphis around 500 BC, he called statues of these dwarf-bodied cult figures *pataeci*, hence the name Ptahtek.

Representations of Ptahtek can vary considerably. Often he is depicted with a scarab atop his head, thus embracing solar attributes. At other times he holds crocodiles or serpents by their necks in a manner reminiscent of the magical Horus *cippi*. Sometimes the Ptahtek figure is double-sided, that is, the frontal image or another deity is depicted on the back of the amulet. This no doubt added to its overall protective capability.[3]

With its illustrious heritage and apotropaic powers, it is not surprising that Ptahtek amulets were widely produced and worn by the general population. Numerous examples have come from burials in Egypt, Nubia,[4] ancient Palestine,[5] and Phoenicia. In all likelihood, Phoenician merchants were responsible for disseminating these small, portable good luck charms.

YJM

Bibliography

Christie's New York, June 4, 1995.

96. Amulet of Neith

Late Period (656–332 BC)
Lapis Lazuli
H. 4.2 CM; W. 1.0 CM; D. 1.1 CM

The goddess Neith is identifiable by her characteristic red crown of Lower Egypt. Her cult center was Sais in the Delta. She is known as one of the four protector goddesses who are guardians of the coffins and canopics of the deceased.

Her figure is carefully modeled with protruding belly, round breasts and accented pubic triangle. She stands on a small base and is supported by a back pillar, which is pierced side-to-side for stringing.[1]

JLH

NOTES

[1] Compare Carol Andrews, *Amulets of Ancient Egypt* (London, 1994), fig. 20f.

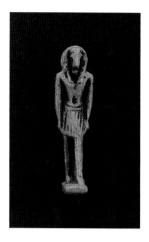

97

97. Amulet of Thoth
LATE PERIOD (664–332 BC)
FAIENCE
H. 2.6 CM; W. 0.6 CM; D. 0.9 CM

THE IBIS-HEADED STRIDING male represents the god Thoth, or Djehuty, the god of the moon, wisdom, writing and magic. The long, striated, tripartite wig helps to soften the transition between the human body and bird head. The short kilt is pleated and the figure stands on a small rectangular base and is supported by a back pillar.[1]

Amulets of this type are very popular between Dynasties 26 and 30.

JLH

NOTES

[1] Compare Carol Andrews, *Amulets of Ancient Egypt* (London, 1994), frontispiece and fig. 20a; Joyce Haynes, *Padihershef: The Egyptian Mummy* (Springfield, Mass., 1985), cat. no. 25; W.M.F. Petrie, *Amulets* (London, 1914), pl. XXXVI, no. 202; Lawrence M. Berman, *Catalogue of Egyptian Art* (Cleveland, 1999), cat. no. 446.

98. Ram-headed deity
LATE PERIOD (664–332 BC)
FAIENCE
H. 3.6 CM; W. 1.0 CM; D. 1.5 CM

THE RAM WAS ASSOCIATED with several gods in ancient Egypt. These include the powerful Theban god Amen-Re, the creator-god Khnum of Elephantine (near the First Cataract), the primordial god Harsaphes of Heracleopolis (in Middle Egypt), and Banebdjedet from the Delta town of Mendes. All were represented in hybrid form, and can sometimes be distinguished by the shape of the ram's horns and the presence of a specific headdress or crown. For example, Harsaphes is shown with horns that extend outward from the body, and often wears the double-plumed *atef* crown of Osiris.[1] Banebdjedet, on the other hand, can have four heads facing in two directions, while the white crown of Upper Egypt is sometimes worn by Khnum. Amen-Re, a relative new-comer to the Egyptian pantheon, is depicted with horns that curl forward onto the cheeks, and occasionally wears a double-plumed crown.[2]

During the Late Period, faience funerary amulets representing Amen-Re and Khnum frequently take the form of a striding, ram-headed man wearing a kilt. Many, including this example, have a back pillar with a widthwise boring to facilitate attachment to the mummy wrappings. The absence of a headdress makes it difficult to differentiate between the two deities.

YJM

98

NOTES

[1] For a very fine example in cast gold from Heracleopolis in the Museum of Fine Arts, Boston (06.2408) that dates to the eighth century BC, see Edna R. Russmann, "An Egyptian Royal Statuette of the Eighth Century BC," in William K. Simpson and Whitney M. Davis, eds., *Studies in Ancient Egypt, the Aegean, and the Sudan*, (Boston, 1981), p. 154, figs. 8–9 and Yvonne J. Markowitz, "Harsaphes Amulet," in *Art of the Ancient Mediterranean World* (Nagoya/Boston, 1999), cat. no. 130.

[2] Carol Andrews, *Amulets of Ancient Egypt* (Austin, 1994), pp. 30–31.

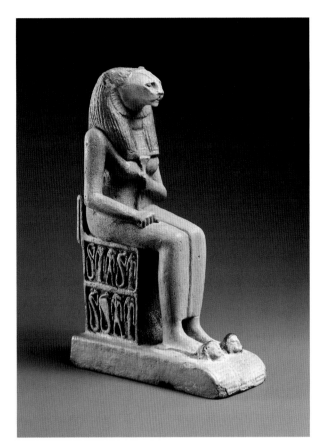

100

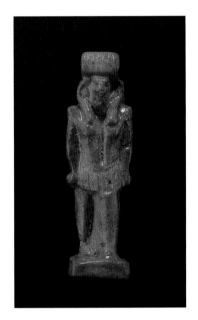

99

99. Amulet of Nehebkau

THIRD INTERMEDIATE PERIOD (1075–656 BC)
FAIENCE
H. 4.5 CM; W. 1.3 CM; D. 1.7 CM

THIS SNAKE-HEADED STRIDING male likely represents Nehebkau. He is commonly depicted on amulets as either a rearing snake or snake-headed human with long snake tail, both with human arms bent under the chin. This full male figure without the snake tail or bent arms is unusual. While other examples exist, they are not common.[1] This figure wears a tripartite wig and short kilt.

JLH

NOTES

[1] Carol Andrews, *Amulets of Ancient Egypt* (London, 1994), p. 26, fig. 22a.

100. Sakhmet

THIRD INTERMEDIATE PERIOD (1075–656 BC)
FAIENCE
H. 24 CM; W. 5.7 CM; D. 15.8 CM

THIS LARGE FIGURE of pale blue faience with purplish black details depicts the lion-headed goddess Sakhmet. The goddess holds a blue lotus and wears a broad collar; a crown or solar disk would have been inserted into a hole in the center of the head. A band of blue lotuses circles her head, blending into her mane. The figure is seated upon a throne with a back panel reaching to the top of the head. A column of crudely executed text is carved into the back of the throne, invoking the goddess by one of her numerous epithets.[1] The base of the throne is of openwork design, with two registers of alternating male, female, and serpent-headed deities. Two roughly modeled heads of foreigners protrude from the plinth in front of the goddess' feet.

Both the openwork throne and the elongated muzzle of the goddess characterize amulets and figurines of the Third Intermediate Period, though the exact function of this piece remains unclear. It is far too large to have been worn or carried as an amulet and probably served as a votive offering.

BTT

NOTES

[1] For a listing of the many epithets associated with Sakhmet, see Henri Gauthier, "Les statues thébaines de la déesse Sakhmet," *ASAE* 19 (1920), pp. 177–82.

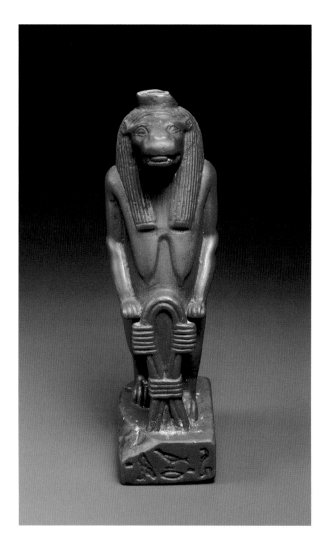

101

101. Taweret

DYNASTY 22–26 (945–525 BC)
BLUE GLASS
H. 9.5 CM; W. 4.0 CM; D. 4.0 CM

THE HYBRID-GODDESS TAWERET stands in her familiar upright pose, almost touching the *sa* amulet in front of her. The modius on her head has a hole for the attachment of a crown, which was probably either a disk and feathers or a disk and horns. As usual, a crocodile skin hangs down her back beneath her tripartite wig. The goddess has a smooth and benevolent countenance: her eyes are long and her snout is comparatively flat with a wide central ridge; her jaws are barely parted to give the slightest glimpse of her teeth and just the tip of her tongue. Flat elongated breasts hang far down on a pregnant belly that is fairly trim for this goddess. Her long arms are strikingly human, with thick biceps and the brachioradialis muscle prominent just below the bend of the elbow, though the paws and lower legs are those of a lion. The legs, tail, and *sa* amulet are fully cut out. A rectangular base was formed as part of the statuette.

Around the four sides of the base, beginning on the front, is inscribed: "Taweret, may she give life, health, a long lifetime, and a great and good old age [to] the royal scribe of Ptah, Pedubast, justified." Slight damage to the base does not affect the reading.

The statuette is made of a deep cobalt-blue glass. Bubbles broken at the surface on the bottom of the base and between the legs indicate the statuette was cast upside down. On removal from the mold, the statuette would have been further cut as necessary and then inscribed. There are small breaks at the front and back right corners and on the edge of the modius, a few pits in the inscription, and some devitrification in crevices.

Taweret, with her avatars Ipy and Reret, was a very ancient goddess, whose breasts and belly emphasize her role in childbirth and nurture. She was very popular since at least the Middle Kingdom. Inscriptions on large statues of the goddess in Paris and Cairo make it clear that by the Third Intermediate Period and Dynasty 26 she had been assimilated to the great goddesses Isis and Hathor, particularly as nurse of the child Horus, and had become a protec-

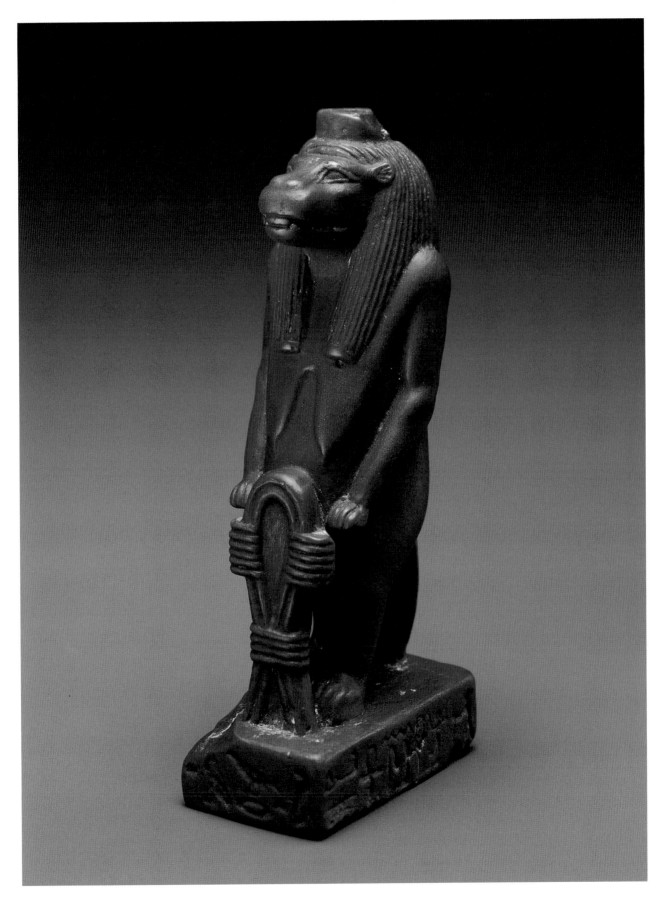

tress in every aspect of existence, from birth to afterlife, for offspring, for career and for property.[1] A statuette such as this one was probably presented as a votive to a shrine of the goddess, like that known to have existed at Karnak.

The name of the offerer, the appearance of the inscription, the sculptural style and deep, rich color of the statuette fit well in the periods represented by the large statues discussed above, so that Dynasties 22 through 26 can serve as a suggested date for the statuette.

The fact that this statuette is made of glass is highly interesting. During the Third Intermediate Period, glass-working activity diminished, although rarely vessels and more frequently amulets and eye or decorative inlays for statuary, coffins, or jewelry were produced. Not until the second half of the sixth century are there well-dated indications that the glass industry had become re-energized.[2] This statuette provides important evidence about the continuation of Egyptian glass-working traditions in the first half of the first millennium BC.

MH

NOTES

[1] Musée du Louvre, Paris, E25479, in Jacques Vandier, "Une Statuette de Touéris," *Revue du Louvre* 1962–65, pp. 197–204; Egyptian Museum, Cairo, CG 39145-7, and for the inscriptions on CG 39145 see Miroslav Verner, "Statue of Twēret (Cairo Museum no. 39145) Dedicated by Pabēsi and Several Remarks on the Role of the Hippopotamus Goddess," *ZÄS* 96 (1970), pp. 52–63. The inscriptions of the latter record that it was dedicated during the reign of Psamtik I by Pabasa, Steward of the God's Wife Nitocris, and that Pabasa was son of one "god's father, Pedubast," but no correlation can be established.

[2] Paul Nicholson and Julian Henderson, "Glass," in Paul Nicholson and Ian Shaw, eds. *Ancient Egyptian Materials and Technology* (Cambridge, 2000), p. 196.

101

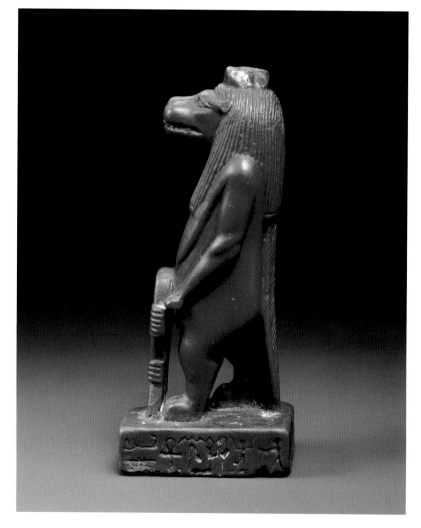

Animal amulets

102. Sphinx amulets

A.
MIDDLE KINGDOM (1980–1630 BC)
CARNELIAN
H. 1.0 CM; L. 1.6 CM; W. 0.7 CM

B.
MIDDLE KINGDOM (1980–1630 BC)
CARNELIAN
H. 0.5 CM; L. 1.0 CM; W. 0.5 CM

102A

AMULETS OF SPHINXES appear in private graves in the First Intermediate Period and become increasingly common thereafter.[1] The image of the sphinx was intimately associated with the king and can be seen as yet another example of non-royal Egyptians using motifs that had previously been a royal prerogative, beginning in this era of social instability.

Carnelian was a hard stone to work with the copper tools generally used during this age, yet the craftsman who produced this tiny amulet was able to render the minute details of the striped *nemes* headcloth and facial features. The modeling of the back and the tail curling around the hind leg are expertly carved. The front paws have broken off and had flanked a horizontal drill hole. The hole, as was usual, was drilled from both ends in a downward slope that broke through the base in the approximate center.

Strings of similar amulets are jewelry types characteristic of the Middle Kingdom. Such hard stones as amethyst, rock crystal, and garnet were used for these amulets as well as carnelian.

PL

NOTES

[1] Carol Andrews, *Amulets of Ancient Egypt* (London, 1994), p. 78.

103. Recumbent lion amulets

A.
PTOLEMAIC PERIOD (332–30 BC)
GLASS
H. 2.5 CM; W. 1.8 CM; D. 4.8 CM

B.
LATE PERIOD (664–332 BC)
FAIENCE
H. 1.1 CM; L. 2.0 CM; W. 0.9 CM

AMULETS IN THE SHAPE of a crouching or recumbent lion have a long and rich history in the Nile Valley. They first appear during the First Intermediate Period,[1] a time characterized by a proliferation of amuletic forms in a variety of materials, including semi-precious stones and gold. The finest examples are incorporated into jeweled ornaments such as the gold and amethyst bracelets[2] of Sithathoriunet, a daughter of the Twelfth Dynasty ruler Amenemhet III. These lions were fabricated from gold sheet over a solid core and have lengthwise borings for stringing. The fine detailing on the animal's face, mane, haunches, and tail was accomplished by chasing with a copper or bronze tool.

Lion amulets dating to the Late Period were typically made of faience and have a suspension hoop along the spine for stringing or attachment to a textile. In fact, a protective spell against snakes from the period calls for incantations over a lion amulet

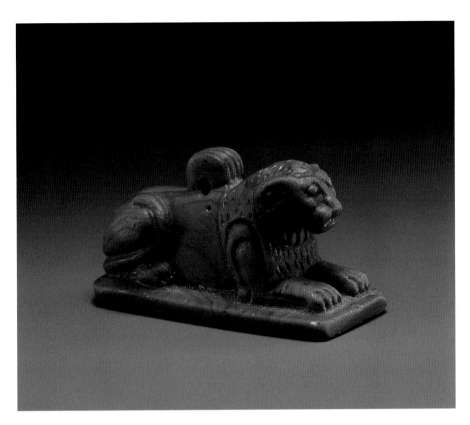

103A

sewn on red cloth.[3] As with early forms, the lion faces straight ahead, paws stretched forward, and the tail wrapped around the right haunch. The base is often a thin, rectangular platform of the same material that is occasionally rounded at the back. In mold-made pieces the details, including facial features, mane, rib cage, and musculature, were often made by hand before firing in a kiln.

The Graeco-Roman Period saw a proliferation of lion representations in the form of monumental sculpture,[4] plaques,[5] statuettes,[6] and amulets.[7] Glass, a substance initially used in Egypt during the New Kingdom, was again a popular material for beads, small sculpture, inlays, and amulets. Cobalt-blue glass may have been imitative of the more precious lapis lazuli, although the unique transformative properties of faience and glass elevated these humble materials in the eyes of the ancient Egyptians.

Lions in ancient Egypt symbolized ferocity, endowing the owner with superhuman strength, authority, and courage. They also had regenerative powers and royal associations.

YJM

NOTES

[1] During the late Old Kingdom, a number of amulets described as crouching quadrupeds (either dogs or lions) were identified at Giza and Naga ed-Deir. See George Reisner, Unpublished manuscript, *Giza Necropolis* II, n.d., pp. 665–68. For several First Intermediate Period examples from Mostagedda and Abydos, see Carol Andrews, *Catalogue of Egyptian Antiquities in the British Museum* VI, *Jewellery* I, *From the earliest times to the Seventeenth Dynasty* (London, 1981), cat. nos. 237–78, 254, pls. 6, 19, 24.

[2] Metropolitan Museum of Art 16.1.14–15. For an image and description, see Carol Andrews, *Ancient Egyptian Jewellery* (London, 1990), p. 40, no. 29.

[3] Carol Andrews, *Amulets of Ancient Egypt* (Austin, 1994), p. 65.

[4] For example, a large, granite lion in Copenhagen (AEIN 1498).

[5] Walters Art Gallery 22.41.

[6] A gold and enamel lion in Boston (MFA 62.1193).

[7] Arielle Kozloff, ed., *Animals in Ancient Art from the Leo Mildenberg Collection* (Cleveland, 1981), pp. 65–66, no. 52.

104. Double-lion amulet

LATE PERIOD, DYNASTY 26 (664–525 BC)
FAIENCE
H. 1.6 CM; L. 2.4 CM; D. 0.7 CM

A DOUBLE-HEADED LION amulet is found as early as Dynasty 6.[1] But it is not until Dynasty 26 that the two foreparts of a lion in the round, on a base, occur as an amulet.[2] In mythological papyri, a pair of protective lions are shown back-to-back, guarding the horizon between them. It is no coincidence that the round loop for suspension is on the center of the back of this amulet, as some double-lion amulets have the sun disk in this position. This would replicate the position of the sun in the horizon flanked by lions,[3] and the wearer would receive the sun's power of regeneration and rebirth.

The two lions have a striated ruff around their face, rounded ears and detailed markings on their outstretched paws. The base is plain.

JLH

NOTES

[1] See the carnelian double lion from Mostagedda in Carol Andrews, *Amulets of Ancient Egypt* (London, 1994), fig. 67c.

[2] Compare *ibid.*, fig. 91a, p. 90, and George Reisner, *Amulets*, Catalogue Général des Antiquités Egyptiennes (Cairo, 1907) pl. XXII, nos. 12361 with sun disk on back and 12362 without sun disk.

[3] T.G.H. James, *Egyptian Painting* (London, 1985) fig. 64, Papyrus of Ani, BM EA10470.

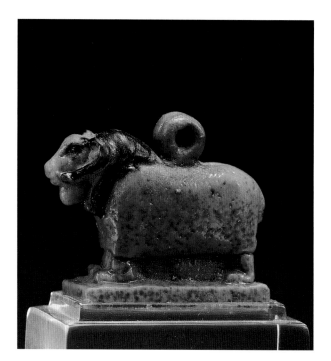

105A

105. Amulet of a ram

A.
THIRD INTERMEDIATE PERIOD (1075–656 BC)
POLYCHROME FAIENCE
H. 2.5 CM; L. 3.0 CM

B.
AMULET OF FOUR-HEADED RAM-GOD BANEBDJET
OF MENDES[1]
DYNASTY 26 (664–525 BC)
LAPIS AND GOLD FUNDA
H. 1.1 CM; L. 1.3 CM; D. 0.6 CM

AMULET A

THIS STRIDING RAM in bright blue faience has details of curved horns, wig and eyes in black. The long tripartite wig hangs over the back and shoulders. The figure stands on a small rectangular base, with a loop for suspension on the center back. The ram was sacred to several deities: Amen, Khnum, Hershef and others. This type of ram has long fleece that hangs down to its ankles.[2] Some detailed images show a decorative pattern on the fleece.[3]

JLH

NOTES

[1] Carol Andrews, *Amulets of Ancient Egypt* (London, 1994), p. 31; see George Reisner, *Amulets*, Catalogue Général des Antiquités Egyptiennes (Cairo, 1907), pl. XXI, nos. 12344, 12345.

[2] W.M.F. Petrie, *Amulets* (London, 1914), p. 44, pl. XXXVIII, no. 211. The fleece is clearly marked in Andrews, *op. cit.*, p. 25, fig. 21e.

[3] For a detailed image of the fleece looking like a decorative covering, see the image from a coffin of the sacred ram of Amen: Andrezej Niwínski, *The Second Find of Deir el Bahari Coffins,* Catalogue Général des Antiquités Egyptiennes (Cairo, 1999), fig. 114.

with none of the tail visible from the front.[2] Fashioned of whitish green faience, the cobra has a well-defined hood, deeply incised eyes, and rests on a small plinth. The coils of the body are carefully indicated, with a suspension hole immediately behind the hood.

BTT

NOTES

[1] Carol Andrews, *Amulets of Ancient Egypt* (London, 1994), p. 76.

[2] *Ibid*, p. 76, fig. 76.

107A

106

106. Uraeus amulet
LATE PERIOD (664–332 BC)
FAIENCE
H. 1.4 CM; W. 0.6 CM; D. 1.0 CM

THE PROTECTIVE POWERS of the cobra (*Naja haje*) were generally reserved for the king, although amulets in the form of a uraeus were typically placed on the torso of a mummy in order to transfer that protection to the deceased. As a funerary amulet, the uraeus also symbolized regeneration, due to the molting cycle of the serpent. The uraeus amulet is attested by the First Intermediate Period, with two distinct types developing by the Saite Period. In one type, the cobra rears against a back pillar with the tail coiled at one side of the base.[1]

This amulet is an example of the second, more common variety, in which the body of the snake undulates behind the hood, rising to the top of the head,

107. Amulets of frogs
A.
NEW KINGDOM, REIGN OF AMENHOTEP III, (1390–1353 BC)
FAIENCE
H. 0.7 CM; L. 1.1 CM; D. 0.8 CM

B.
NEW KINGDOM (1539–1075 BC)
GLASSY FAIENCE
PIERCED FRONT-TO-BACK AT BASE
H. 0.7 CM; L. 1.1 CM; D. 0.9 CM

C.
NEW KINGDOM (1539–1075 BC)
FAIENCE
PIERCED FRONT-TO-BACK AT BASE
H. 0.6 CM; L. 1.3 CM; D. 1.1 CM

AMULET A

THE FROG WAS A SYMBOL of regeneration in ancient Egypt, likely due to the vast quantities of eggs that it lays. It was also an image sacred to the frog-headed Heket, goddess of childbirth. This amulet would have been worn by, and sacred to, women, providing protection for

childbirth. It also functioned in the tomb as a symbol of rebirth.

In the New Kingdom, tiny frogs made of semi-precious stones, glass and faience were very common. They may or may not be pierced for stringing. Some were used as ring bezels and some larger ones as weights.[1]

This carefully modeled piece has clearly defined front and rear legs and outlined eyes. The base is incised with the cartouche of the prenomen of Amenhotep III, *neb maat Re*.[2]

JLH

NOTES

[1] See the frog of Egyptian blue in Cleveland, perhaps used as a weight, in Arielle Kozloff and Betsy Bryan, eds., *Egypt's Dazzling Sun: Amenhotep III and His World* (Cleveland, 1992), p. 430, cat. no. 120.

[2] Compare Carol Andrews, *Amulets of Ancient Egypt* (London, 1994), fig. 28h, p. 32; W.M.F. Petrie, *Amulets* (London, 1914), pl. II, nos. 18m, o; George Reisner, *Amulets* II, Catalogue Général des Antiquités Egyptiennes (Cairo, 1958), pl. XVI, nos. 13373–13377; Edward Brovarski, Susan K. Doll, and Rita E. Freed, eds., *Egypt's Golden Age: The Art of Living in the New Kingdom, 1558–1085 B.C.* (Boston, 1982), pp. 251–52, cat. no. 353.

Funerary amulets

108. *Wedjat* eye amulets

A.
THIRD INTERMEDIATE PERIOD (1075–656 BC)
GLASSY FAIENCE
L. 3.5 CM

B.
THIRD INTERMEDIATE PERIOD (1075–656 BC)
FAIENCE
H. 1.5 CM; L. 2.2 CM; D. 0.4 CM

C. DOUBLE-SIDED *wedjat* EYE
THIRD INTERMEDIATE PERIOD (1075–656 BC)
POLYCHROME FAIENCE
H. 3.3 CM; L. 4.2 CM; D. 0.5 CM

D.
THIRD INTERMEDIATE PERIOD (1075–656 BC)
EGYPTIAN BLUE
H. 1.8 CM; L. 2.0 CM; D. 0.4 CM

E.
THIRD INTERMEDIATE PERIOD (1075–656 BC)
POLYCHROME FAIENCE
H. 1.2 CM; L. 1.4 CM; D. 0.4 CM

F.
NEW KINGDOM–THIRD INTERMEDIATE PERIOD,
(1539–656 BC)
CARNELIAN
H. 0.9 CM; L. 1.1 CM; D. 0.4 CM

AMULET A

THIS FINELY FEATURED *wedjat* eye is in perfect condition. There are several elaborations on this eye. The eyebrow is detailed with a chevron pattern, and the space above the eye is marked with oblique lines. The most unusual feature is the wing with striated feather pattern that extends diagonally from the outer corner of the eye to the end of the spiral.[1] Elaborate openwork designs are most typical of the Third Intermediate Period.

The *wedjat* eye is composed of the human eye and eyebrow and the eye markings of a falcon. In hieroglyphs, *wedjat* means sound or healthy, and the *wedjat* eye refers to the eye of Horus that was ripped into pieces by Seth in battle. The eye was magically com-pleted or restored by Thoth, the god of wisdom and magic. The protection of Horus, son of Osiris, as well as a powerful symbol of regeneration and rebirth would be provided to the wearer of this amulet.

As is customary, the hole for suspension is through the length of the top of the eye.[2]

JLH

NOTES

[1] In some examples the drop line and spiral have been turned into a falcon's leg and wing; see Carol Andrews, *Amulets of Ancient Egypt* (London, 1994), fig. 46a.

[2] For another *wedjat* eye with wing see W.M.F. Petrie, *Amulets* (London, 1914), pl. XXIV, 141a.

108A

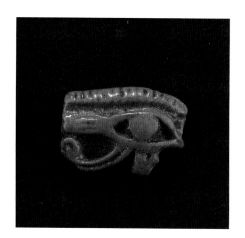

108B

109. Ring bezels in the form of *wedjat* eyes

MIDDLE TO LATE DYNASTY 18 (1390–1292 BC)
FAIENCE
A. H. 1.2 CM; W. 2.0 CM; D. 1.0 CM
B. H. 1.0 CM; W. 1.5 CM; D. 0.4 CM

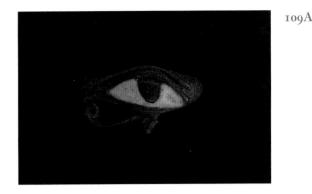

Openwork finger rings with *wedjat* eye bezels were popular during the late Eighteenth Dynasty. The most attractive were polychrome and made of dark blue or violet faience highlighted by white and black inlays.[1] One reason for the ring's popularity was technological, a result of harder faience bodies developed as an outgrowth of the glass industry. This made the wearing of glazed ceramic jewelry practical as well as less costly.[2]

The *wedjat* eye, also known as the sacred eye of Horus, symbolized wholeness and healing. Its meaning derives from the Osirian myth in which Horus avenged the death of his father Osiris. In a fierce battle with his murderous uncle, Horus lost his left eye. The organ was later miraculously restored, and the eye eventually became an amulet with broad protective and restorative powers. At Amarna, the capital city of the heretic pharaoh Akhenaten, *wedjat* eye rings were the most commonly worn finger ornament.[3]

YJM

BIBLIOGRAPHY

Christie's New York, June 4, 1995.

NOTES

[1] For four examples, see Edward Brovarski, Susan K. Doll, and Rita E. Freed, eds., *Egypt's Golden Age: The Art of Living in the New Kingdom, 1558–1085 B.C.* (Boston, 1982), cat. no. 346, p. 249.

[2] For a discussion of the influence of glass manufacture on faience production, see Andrew Boyce, "Notes on the Manufacture and Use of Faience Rings at Amarna," *Amarna Reports* V (1989), pp. 160–68.

[3] Ian Shaw, "Ring Bezels at El-Amarna," *Amarna Reports* V (1984), pp. 124–32.

110. Multiple *wedjat* eye amulet

THIRD INTERMEDIATE PERIOD (1075–656 BC)
FAIENCE

H. 0.5 CM; L. 3.4 CM; DIAM. 2.9 CM

This notched, round double-sided disk represents a multiple use of the *wedjat* eye. If one image was powerful, then the potency would be compounded if many were grouped together. Oftentimes several *wedjat* amulets could be found on one mummy. This piece is composed of four stylized and hastily executed eyes in relief, on each side. It is pierced side–to–side for stringing.[1]

JLH

NOTES

[1] For similar style, see George Reisner, *Amulets,* Catalogue Général des Antiquités Egyptiennes (Cairo, 1907), pl. V, no. 5812; Carol Andrews, *Amulets of Ancient Egypt* (London, 1994), fig. 46d.

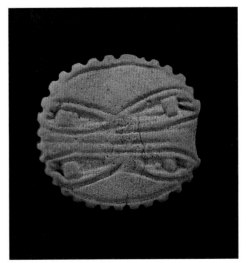

111

111. Multiple *wedjat* eye amulet
Late Period (664–332 bc)
Polychrome Faience, black details over blue-green glaze
H. 0.4 cm; l. 1.6 cm; d. 1.5 cm

This multiple *wedjat* eye is highly stylized. It can be ascertained from the outline that it represents four eyes in total. The upper and lower halves are mirror images, each half representing two *wedjat* eyes facing away from each other. The black dots likely represent the spaces that would be found if these were openwork *wedjats*. There are many different symmetrical groupings of multiple *wedjat* eye amulets.[1]

JLH

Notes

[1] Claudia Müller-Winkler, *Die ägyptischen Objekt-Amulette* (Göttingen, 1987), pl. X, no. 190.

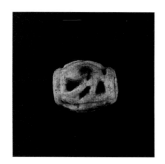

112

112. Openwork *wedjat* eye bead
Third Intermediate Period (1075–656 bc)
Faience
L. 1.5 cm; diam. 1.3 cm

This openwork faience bead is composed of two images of *wedjat* eyes. In the Third Intermediate Period, barrel beads with a pattern of *wedjats* were popular, and especially common in Upper Egypt and Nubia.[1]

JLH

Notes

[1] Carol Andrews, *Amulets of Ancient Egypt* (London, 1994), p. 44; W.M.F. Petrie, *Amulets* (London, 1914), p. 33, pl. XXV, no. 140c; Claudia Müller-Winkler, *Die ägyptischen Objekt-Amulette* (Göttingen, 1987), p. 149, pl. XI, nos. 207–209.

113A

113. Heart amulets
A.
Late Period (664–332 bc)
Black steatite
H. 1.5 cm; w. 1.6 cm; d. 0.6 cm

B.
Late Period (664–332 bc)
Black steatite
H. 1.8 cm; w. 1.2 cm; d. 0.8 cm

C.
Late Period (664–332 bc)
Carnelian
H. 1.8 cm; w. 1.2 cm; d. 0.8 cm

THE ANCIENT EGYPTIANS believed that the heart—the source of wisdom, emotion, and memory—was the most important human organ. Its significance is underscored by the fact that it was intentionally left in place after embalming. If removed accidentally, it was returned and secured to the body. Additionally, several chapters in the *Book of the Dead* are specifically concerned with the heart's survival, while Chapter 29B recommends the wearing of "… a heart amulet of *schert* stone (carnelian)" by the deceased.[1] Carnelian, a form of chalcedony, was one of the hardest stones used by the Egyptians and therefore prized for its strength and durability. Its color, a bright orange–red, undoubtedly evoked the energy and the life-giving power of blood.

Heart amulets were especially popular during the Late Period. Although carnelian was the stone of choice for these funerary ornaments, other materials such as black steatite, haematite, and faience were also used. A complete set of amulets found on the breast of a mummy at Nebesha[2] suggests that multiple heart amulets were sometimes sewn onto the linen wrappings—an attempt, no doubt, to compound the talismanic effect.

YJM

NOTES

[1] Carol Andrews, *Amulets of Ancient Egypt* (Austin, 1994), pp. 72.

[2] Sue D'Auria, Peter Lacovara, and Catharine H. Roehrig, eds., *Mummies and Magic: The Funerary Arts of Ancient Egypt* (Boston, 1988), cat. no. 178, p. 225.

114

114. Headrest amulet
LATE PERIOD (664–332 BC)
HAEMATITE
H. 1.5 CM; W. 1.6 CM; D. 0.6 CM

HEADRESTS MADE OF STONE and wood were used in ancient Egypt to support the head during sleep.[1] They were also included in burials, where they were placed under the head of the deceased.[2] By the first millennium BC, real headrests in the tomb were replaced by miniatures whose function was symbolic.[3] Their role is outlined in Chapter 166 of the *Book of the Dead*. It states that the headrest provided physical comfort and protected the head from injury, particularly dismemberment and decapitation.[4]

Headrest amulets first appeared in royal burials of the late Dynasty 18 and were made of iron.[5] By the Late Period, they were part of the amulet assemblage attached to the linen wrappings of the deceased. While iron ore (haematite) was the preferred material for this talisman, faience examples are known to exist. The finest headrests have inscriptions with textual references to Chapter 166 of the *Book of the Dead*.[6]

YJM

BIBLIOGRAPHY

Christie's New York, June 4, 1995.

NOTES

[1] For example, included in the suite of furniture found in the Fourth Dynasty burial of Queen Hetepheres (Giza G 7000 X) was a wooden headrest covered with gold and silver sheet metal. See Yvonne Markowitz, "Hetepheres Furniture and Inlays," in *Masterworks from the Age of the Pyramids* (Nagoya/Boston, forthcoming, 2001), cat. no. 1.

[2] For an alabaster example from the early Sixth Dynasty burial of the vizier Ptahshepses Impy, see Edward Brovarski, *The Senedjemib Complex, Part 1*, Giza Mastabas vol. 7 (Boston, 2001), p. 33.

[3] Sue D'Auria, Peter Lacovara, and Catharine H. Roehrig, eds., *Mummies and Magic: The Funerary Arts of Ancient Egypt* (Boston, 1988), cat. no. 179.

[4] Carol Andrews, *Amulets of Ancient Egypt* (Austin, 1994), pp. 95–66.

[5] An iron headrest amulet was found in the burial of Tutankhamen. See Howard Carter, *The Tomb of Tut-ankh-amen*, vol. II (London, 1927), pp. 109–10, pl. LXXVII.

[6] Museum of Fine Arts, Boston 1976.128.

115. *Djed* pillar amulet

LATE PERIOD, AFTER 600 BC
FAIENCE
H. 9.2 CM; W. 3.4 CM; D. 1.5 CM

THE *djed* TAKES THE FORM of a tapering shaft with four short crossbars at its upper end. Characteristic of its late date is the grooved patterning between the crossbars and the circular decorations on the shaft; the back pillar is pierced for suspension near its top. As an amulet, the *djed* first appears at the end of the Old Kingdom and becomes possibly one of the most frequently occurring of all funerary types. Of all the amulets placed within the wrappings that enveloped the mummy, the *djed* pillar was one of those few that were expressly prescribed by the *Book of the Dead*: Chapter 155 was a spell to be recited over a *djed* that was to be placed at the throat of the deceased on the day of burial. Most examples, however, when found still in position, lie over the lower torsos of mummies. Although Chapter 155 and its accompanying vignette make it clear that the prescribed material for this amulet was gold, many surviving examples are made, like this one, of blue faience, a color symbolic of new life and regeneration.

The *djed* pillar came to be almost exclusively associated with Osiris, god of the dead, whose stylized backbone with ribs it was thought to represent. Certainly, Chapter 155 makes reference to only that god. Originally, however, it had been connected with the rites performed for Sokaris, the falcon-headed funerary god of the Memphite necropolis at Saqqara, and later with Ptah, the more powerful god of Memphis itself. Indeed, the *djed* first appears as a decorative element at the top of a wall in the building west of the *heb sed* court of the Step Pyramid complex of Djoser at Saqqara (ca. 2650 BC). Since the central element of the rites involved the pulling upright of a gigantic *djed* by means of ropes, in the fashion of a maypole, the form may well have represented originally a tree trunk with stylized lopped-off branches.

As a hieroglyph, *djed* means "stable," "enduring" and related concepts, all of which would help to imbue an amulet in its shape with even greater relevance for the mummy on which it was placed.

CA

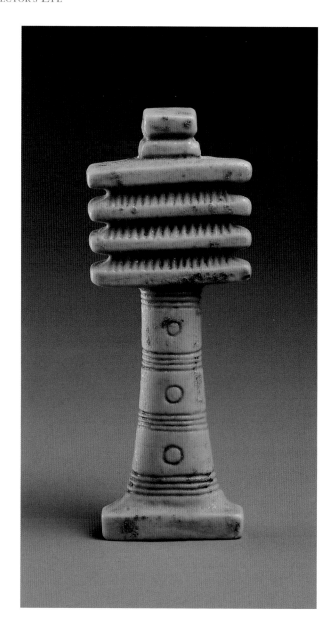

115

116A

feather pattern appear on some amulets of this type, most, including these two fine examples, are stylized or abstract forms.

YJM

NOTES

[1] Carol Andrews, *Amulets of Ancient Egypt* (Austin, 1994), pp. 80–91.

[2] W.M.F. Petrie, *Amulets* (London, 1914), p. 17, pl. IV.

117

116. Double-plume amulets

A.
LATE PERIOD (664–332 BC)
SERPENTINE
H. 1.8 CM; W. 1.2 CM; D. 0.8 CM

B.
LATE PERIOD (664–332 BC)
OBSIDIAN
H. 2.2 CM; W. 1.2 CM; D. 0.5 CM

SEVERAL EGYPTIAN AMULETS take the form of a single or double feather. The single feather with curled tip is an emblem of Maat, goddess of truth, while double-feather amulets are either ostrich feathers or falcon plumes. Ostrich feathers, characterized by circular curls at the top and a central spine, derive from the *atef* crown worn by kings and gods. The double or falcon-plume amulet is associated with the god Amen, whose crown featured two tall feathers rounded along the upper edge.[1]

During the Late Period, double-plume amulets were among the many charms placed on the mummy for protection during the hazardous journey through the netherworld. They were typically made of dark-green or black stones,[2] colors evocative of fertility and rejuvenation. Although carved details outlining the

117. Papyrus-column amulet

LATE PERIOD (664–332 BC)
FAIENCE
H. 5.5 CM; DIAM. 1.3 CM

THIS LARGE AMULET represents the *wadj* or papyrus pillar. It is decorated with an incised zigzag pattern around the lower half of the body, a stylized representation of the basal leaves of the plant. *Wadj* means "to be green" or "flourish," and signifies rebirth and regeneration for the wearer. Chapters 159 and 160 of the *Book of the Dead* request that a green stone *wadj* amulet be placed at the neck of the mummy.[1] While some are made of feldspar, faience is the most common material. The *wadj* amulet was most popular in the Late Period.[2]

JLH

NOTES

[1] Carol Andrews, *Amulets of Ancient Egypt* (London, 1994), p. 82 and fig. 83b, c.

[2] Sue D'Auria, Peter Lacovara, and Catharine H. Roehrig, eds., *Mummies and Magic: The Funerary Arts of Ancient Egypt* (Boston, 1988), p. 182, fig. 129d.

118

shape, style and material are in the collection of the Biblical Institute of the University of Freiburg.[4]

<div align="right">JLH</div>

NOTES

[1] W.M.F. Petrie, *Amulets* (London, 1914), p. 21, no. 72.

[2] Peter Lacovara, personal communication.

[3] Claudia Müller-Winkler, *Die ägyptischen Objekt-Amulette* (Göttingen, 1987), "Aper" Amulet, pp. 472–77; George Reisner, *Amulets*, Catalogue Général des Antiquités Egyptiennes (Cairo, 1907), pl. III, nos. 5551–5559.

[4] Müller-Winkler, *op cit.*, pl. XL, nos. 830–47.

119A

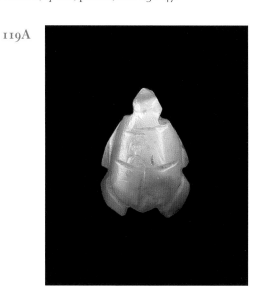

118. *Aper* amulet
DYNASTY 26–30 (664–332 BC)
QUARTZ DIORITE
H. 2.0 CM; W. 1.8 CM; D. 0.9 CM

THIS ENIGMATIC STONE amulet has been described by some as the *aper* amulet, after Gardiner's form Unclassified Aa 20, 𓐬. Others refer to it as the *menkhet*, "clothing,"[1] or even the box portion of the fetish of Abydos.[2] The derivation of the shape is still unclear. The color and type of material are obviously a key to the identity of this amulet. It is unusual that faience was not a popular material for its type. This piece is made of white and black quartz diorite, and has one horizontal and double crossed incised lines on the front. The bottom edge is notched, as is customary. The loop for suspension is at the top, and the back is flat. Most examples of this amulet share these characteristics, and are made of either hard black and gray or black and white stone.[3] Several parallel pieces of this

119. Scarabs
A.
SCARAB FUNERARY AMULET
LATE PERIOD (664–332 BC)
CARNELIAN
H. 0.5 CM; L. 1.4 CM; W. 1.0 CM

B.
HEART SCARAB
DYNASTY 22–26 (945–525 BC)
AVENTURINE
L. 3.5 CM, W. 2.6 CM, H. 1.3 CM

SCARAB A

SETS OF AMULETS WORN on mummies in the Late Period contained a great many scarabs, not surprising given their association with rebirth. Like many of these amulets, this scarab is very summarily modeled.

119B

The naturalistic legs are carved with supports jutting out of the body, making them look like wings. A square projection at the top with a hole for suspension gives the piece a rather unusual shape. This example is pierced for suspension, but many examples are not, and are just held in place by the wrappings.

<div align="right">PL</div>

SCARAB B

THE ANCIENT EGYPTIANS believed that the heart was the source of thought, feeling, and memory. Over the course of history, they also developed the idea that each person is responsible for his or her actions. The interplay of these two concepts is symbolically represented in the judgment scene depicted in the *Book of the Dead*. In the standard vignette, the deceased is presented before Osiris, while his heart is placed in a pan attached to a scale. Seated in the pan on the other side of the scale is the goddess Maat,[1] the embodiment of truth, justice, and virtue. To be judged worthy, or "true of voice," the heart and Maat must balance. A negative outcome had dire consequences—it meant destruction by the monster Ammut and the loss of everlasting life.[2]

To assist the deceased at this dangerous crossroad, the Egyptians relied on the magical powers of the scarab, a symbol of resurrection and rebirth. Placed over the heart and within the mummy wrappings, it rendered the heart incapable of testifying against itself. Scarabs used in this funerary context[3] are sometimes inscribed with a spell that specifically restrains the heart from "creating opposition to him in the realm of the dead."

Heart scarabs were ideally made of a hard, green stone. It was believed that dense stones represented "a heart full of virtue," while the color green symbolized regeneration. This finely-carved, aventurine scarab has wing cases with vertical striations and is uninscribed.

<div align="right">YJM</div>

NOTES

[1] Or her attribute, the feather.

[2] Carol Andrews, *Amulets of Ancient Egypt* (Austin, 1994), p. 56.

[3] Scarabs were also worn as protective amulets by the living and, during certain periods, were used as seals.

120. *Ba*-bird amulet

LATE PERIOD (656–332 BC)
LAPIS LAZULI
H. 2.4 CM; L. 2.4 CM; D. 0.5 CM

THE *BA* WAS ONE OF the human spirits that lived on after death, often translated as the "personality"or "character." One common form it could take was the human-headed bird. The Pyramid Texts tell us that it could fly from the tomb into the heavens and then return to the body in the tomb.

This profile of the *ba* bird has a flat back and, as is often the case, there is no means of suspension. This type is common in gold, faience, lapis or molded glass.[1] The human-headed bird has a long tripartite wig that covers the shoulders and rests on the chest. The front of the feet are missing.

JLH

NOTES

[1] Carol Andrews, *Amulets of Ancient Egypt* (London, 1994), p. 68 and fig. 72a; W.M.F. Petrie, *Amulets* (London, 1914), p. 14, no. 28a; similar to George Reisner, *Amulets* II, Catalogue Général des Antiquités Egyptiennes (Cairo, 1958), pls. VII, and XXX, no. 13417.

Fig. N. *Commemorative medal of David Roberts*
Nineteenth century, designed by
George T. Morgan, and issued by the Art Union, 1875
Diam. ca. 7 cm

Bronze
Recto: Head of Roberts
Verso: "The Letter Writer, Cairo," from *The Holy Land and Egypt,* vol. VI, pl. 117

Luxor Decr 1st 1832